P9-CAO-232

ALMA-TADEMA

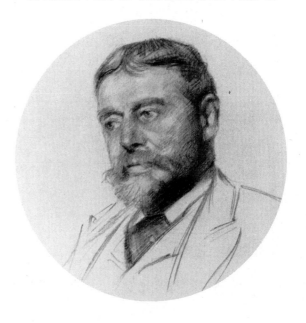

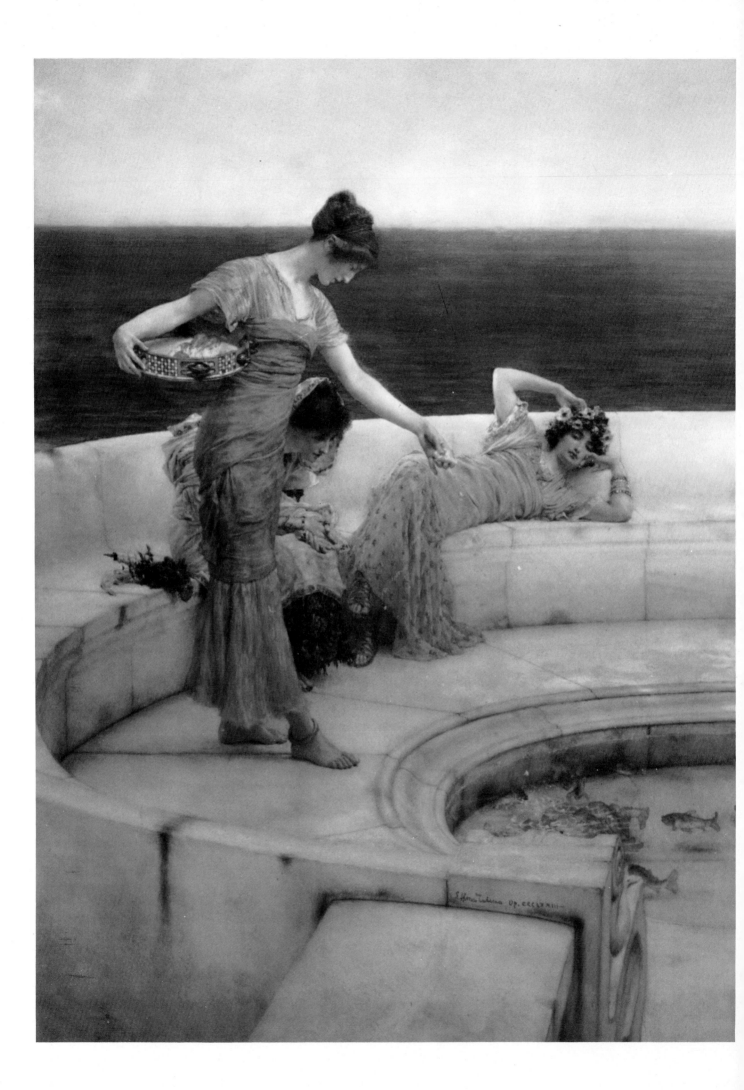

SIR LAWRENCE
ALMA-TADEMA

The painter of the Victorian vision
of the Ancient world

by Vern G. Swanson

ASH & GRANT

To the memory of my wife, Elaine Milne Swanson,
and my son Brett.

Ash & Grant Limited,
120B Pentonville Road,
London N1 9JB

First published 1977

All rights reserved. No part of this publication may be
reproduced, stored in a retrieval system or be
transmitted in any form or by any means, electronic,
mechanical, photocopying, recording or otherwise,
without the prior written permission of the publishers.

Alma-Tadema text © Vern G. Swanson 1977

Designed by Nicholas Maddren, Campion Design,
Baldock, Hertfordshire

Casebound ISBN 0 904069 08 7
Paperback ISBN 0 904069 09 5

Printed by Balding + Mansell Limited, Wisbech,
Cambridgeshire

CONTENTS

ACKNOWLEDGEMENTS

So many people have done so much to make this book a reality, I want to thank all who have shared their time, interest and expertise. Some I would like to mention individually for their special contributions. In the beginning my interest in Alma-Tadema was inspired by Dale Fletcher and later by Dr Westly Burnside, both of the Brigham Young University. Dr Robert Olpin deserves thanks for directing my Masters thesis on Alma-Tadema at the University of Utah. He also spent many hours directing my research and reviewing my manuscript. Without his efforts it is doubtful this book would be in print.

Thanks go to those Dutchmen who contributed information about their countryman: I. Verstratten, Anne Marie Vels Heijn of the Rijksmuseum and especially to C.J.J.G. Vosmaer of Leiden. His help added greatly to the scholarship of this book. Two of the leading scholars on Alma-Tadema, William Dublin in Oakland, California and Russell Ash in London, have gone to great lengths to aid my work. Mr Dubin gave of his valuable research materials and dedicated a great deal of his time to research. In England Russell Ash generously relinquished his plans for writing a similar book and collaborated in many ways to make this the most thorough study of the painter to date.

Many people in 'the trade' have also made their contributions: Judith Landrigan and Polly Notkins of Sotheby Parke-Bernet, Clovis Whitfield of Agnews, and Richard Finnegan of Knoedlers. Thanks are also due to Christopher Forbes for the information he has provided. My researchers have provided tremendous help, especially my brother, Michael Swanson of Central Point, Oregon, who displayed uncanny research abilities, Susan Harrison of Huntsville, Alabama, and Judy Nielson Swanson of Lynndyl, Utah. Thanks also go to my department chairman Professor Charles Hiers of Auburn University in Alabama, who over a three-year period extended every opportunity to me to complete my book. My typists Carolyn Taylor and Jo Foster and my proof reader, Al Switzler, finally brought the book into form. Finally I want to thank my two families, and especially Oscar and Mildred Swanson and Johnny and Thelma Milne, for their encouragement.

INTRODUCTORY NOTE
Alma-Tadema consecutively numbered most of his work using the system 'Op.' (Opus) followed by a figure in Roman numerals. As he often gave the same title to several different pictures, the Opus number serves to distinguish between them and is accordingly quoted after the title. Full details of title, Opus number, date, size, medium and present owner are given in the catalogue on pages 135-141.

INTRODUCTION

Though little known today, in the forty-five years preceding the First World War Sir Lawrence Alma-Tadema was an artistic god. As well known in his day as Picasso is in our own, Alma-Tadema was considered by many as an 'Old Master' before his death in 1912. Yet by the time of his death, assaults upon his beloved Royal Academy had already begun to alter public taste. Within another fifteen years Alma-Tadema was but a dim memory in the aesthetic consciousness of the art world.

Left in oblivion, Alma-Tadema suffered more from neglect than from abuse. From the height of Royal patronage, academic honours and the ability to command immense prices, Alma-Tadema's reputation had so diminished by 1960, in fact, that some of his work was actually devalued by as much as two hundred times its original value. *The roses of Heliogabalus* (Opus CCLXXXIII), for example, was sold for $20,000 in 1888 and again in 1960 for $260. Judged more as an Academician than as an individual artist, Alma-Tadema's fame suffered along with a general decline in the repute of the Academy itself. In 1885 the sale price of an excellent Alma-Tadema was enough to buy all the Monets in existence, but by 1960 the sale of one great Monet might raise enough to buy all the Alma-Tademas.

Who was this artist and, given his dramatic decline into obscurity, why is it important to investigate his life and work today?

In the world of art, new things happen every day and old things become forgotten or despised with changing taste. Each new period creates an atmosphere that seems to threaten the artistic productions of the previous one. Many works are relegated to attics and, if they survive long enough, they may well be rediscovered. Time adds perspective and what was previously considered old-fashioned may eventually gain a certain period charm.

Alma-Tadema is typical of many artists who have gone through the cycle of fame, indifference or rejection and then rediscovery. In the recent past, art criticism has perpetrated some great injustices and of the artists affected, many were the leading academicians of the late nineteenth or early twentieth century. Yet, today this bias against their previous success seems more subdued: witness the sudden revival in popular interest in works by such men as Millais, Bouguereau, and Gérôme in recent years. It is time for a re-evaluation of the work of Alma-Tadema as well. As an arch-academician he may, if given a fresh and unbiased look, provide a way to new appreciation of other academicians heretofore regarded merely as vaguely-remembered relics of a bygone era.

CHAPTER I
SIR LAWRENCE ALMA-TADEMA

When compared with artists such as Vincent Van Gogh, the life of Alma-Tadema was uneventful indeed. It differed greatly from those of the alienated artists of the nineteenth and twentieth centuries. His biographers have pictured him as a lovable, jolly and industrious man. His world was not that of the starving bohemian in an attic garret, but of a wealthy orthodox Academician of the Salon. His life, though lacking in momentous events, conveys an accurate picture of the Victorian artistic establishment in which Alma-Tadema was to become a leading figure.

Childhood (1836-1851)

Alma-Tadema was born on 8 January 1836, in the small village of Dronrijp, which lies about three miles to the west of Leeuwarden in central Friesland. He was the sixth child of Pieter Jiltes Tadema (1797-1840), who had had three sons by a previous marriage, and the third child of his mother, Hinke Dirks Brouwer (c.1800-1863). Hinke Brouwer was the half sister of Pieter Tadema's first wife. Her first child died early and the second was Atje (c.1834-c.1876), Laurens' sister, for whom he had a great deal of affection.

Tadema was an old Frisian name familiar in local legends. There are, however, many conflicting stories describing the manner in which 'Alma' came to be affixed to the family name, Tadema. One of Tadema's biographers, Helen Zimmern, writing in 1886, states that the name Alma was derived from Laurens' godfather Adrianus Alma, who was present at the christening. He adopted the name, she says, 'for the distinction of the family'. Georg Ebers, a good friend of Tadema, states that the prefix was added because of its euphonious sound and partly because the 'T' of Tadema was too far down the alphabet and put him near the end of exhibition catalogues! Ebers also says that the pronunciation is Tadèma not Tadéma. Both statements are contrary to the best evidence today. Percy Cross Standing, Tadema's major biographer, refutes the previous statements of Ebers, saying that the artist had been christened Alma-Tadema. He uses the evidence that at the age of six Tadema signed his drawings 'L. Alma Tadema', although it is unlikely that he ever hyphenated his name— that was done for him by the English, who also anglicized his first name, 'Laurens', to 'Lawrence'.

The area around Dronrijp and Leeuwarden was rich in ancient legends and history. It was not flat like most of Holland, but had undulating, rolling hillocks. Many of these hillocks had been built as burial mounds by the ancient Merovingian and Frankish civilizations. Atop these hills lay Dronrijp, with its picturesque houses and ancient church spire.

But Dronrijp was too small to support Pieter Tadema's growing family. In 1838 they moved to nearby Leeuwarden, where the services of a notary would be in greater demand. This action proved successful and the family prospered. The father, a great music enthusiast, set the pattern for an appreciation of the arts within the family. Unfortunately, in 1840 Pieter Tadema died and left Hinke Tadema to care for all the children.

It had been the father's wish that Laurens should become a lawyer, but the boy disliked the idea. By the time of his father's death, Laurens had already begun to draw. His earliest recorded work was a drawing of *A little caterpillar and some leaves* (1840, unlocated) in chalk. The family would often tell the story about Laurens' precosity when he shared the drawing lessons of his older brothers and sisters. He was only five years old, but he was able to correct the perspective of his drawing master's work. Alma-Tadema told Ebers that 'by five years of age I had acquired artistic intuition'. 'He could draw', said Standing, 'before he had wholly lost the lisp of babyhood'.

Laurens' mother, a quiet diligent woman with infinite energy, also wanted her favourite son to become a lawyer rather than an artist. In Friesland at that time artists were generally regarded as on the same low social level as actors. She had the interests of her son in mind when she enrolled him at the gymnasium of Leeuwarden. Feeling a sense of duty to his family, Laurens accepted his situation and continued to sketch in his free time.

In school Alma-Tadema was a studious and serious pupil. In his Greek and Latin classes he displayed a predilection for languages. Of this period Tadema said later, 'I did not entirely dislike the study of the ancient languages, for they have influenced my art all through my life.' Later he told an interviewer that he hated the Greek and Latin languages, but loved the periods for their mythology and archaeology.

Laurens was a good student, but he longed to be an artist. He became acquainted with mythology by sketching gods and goddesses in the margins of his textbooks. His best friend at this time, Christoffel Bisschop (1828-1904), also wanted to be a painter. They were inseparable, and this closeness made it all the harder for Alma-Tadema to forget his first love. During a school examination, 'in the middle of a Latin speech, the sun broke in lighting up the professor's bald head with liquid gold and touching with fiery light the green curtains that hung beyond'. Tadema forgot all that was happening except this sight, until he was reproached. The boy began to feel the pressures of the conflict between his studies and his real interests.

With great energy he tried to pursue both courses. To gain time to draw and paint, he tied a string to his big toe at night, and ran the string to his mother's bedroom. Every morning at four or five she would awaken him by pulling the string, so that he might begin the day early. Not only would he draw on these early mornings, but he would examine ancient relics or books for greater insights into past civilizations. This interest was again strengthened in 1850 when in a village shop he chanced upon a Dutch translation of Leonardo da Vinci's

Treatise and a seventeenth-century book on perspective. About this time he also painted his first pictures. To the portrait of his sister he gave a number, in the same manner as a composer, calling it Opus I. There are earlier pictures, but none bear Opus numbers. They are: *Portrait of the Hamstra children* (1849); *Portrait of Alma-Tadema's brother* (1849-51); *Portrait of Rika Reijnders* (1851-1852); *Portrait sketch of a woman* (1852).

Eventually Alma-Tadema began to work too hard and suffered a physical and mental breakdown. The doctor diagnosed this breakdown as extremely serious, and gave him only a short time to live. The doctors and his family then agreed that it would be wise to allow Tadema to spend his remaining days doing what he enjoyed most. In a letter of 16 May 1883 he wrote from Naples concerning this period of his life, '. . . got ill and overworked as all spare hours now used for the fine arts instead of playing and resting. My bones consequently never got to maturity and by some lucky suffrainty [sic] of thought my height grew still two or three inches from the age of 27-30. Doctors believed me consumptive at the age of 15 and advised therefore to allow me for the few remaining years of life to pursue art to its fullest extent according to my wishes.' 'As soon as the heavy strain was removed', says Helen Zimmern, 'he recovered as though by magic, and rapidly became the sturdy robust man he has remained all his life.'

This marked a new period in his life. For the first time he was allowed freely to pursue art. He continued to work as hard as before, for he felt he must make up for lost time. The year 1851 marks the beginning of his career in art with the exhibition of his first work in the Gallery in Leeuwarden.

Student Years (1852-1862)

Although Alma-Tadema had considerable experience in drawing, he was unable to gain admission into any of the major art academies in Holland (Amsterdam, Utrecht, and Delft). Laurens' application and portfolio were, however, accepted at the Antwerp Academy. His acceptance was unexpected because at this time the Antwerp Academy had more status than its Amsterdam counterpart. Several factors encouraged Laurens to go to Antwerp. Antwerp was not far from home, it was a large art centre, and the son of a family friend was studying there. The only objection came from Laurens' mother, a staunch Protestant, who had misgivings about letting her favourite son live in a Catholic country. On 2 August 1852, at the age of sixteen, Tadema set off for Antwerp. The route to Antwerp was first by boat from Leeuwarden to his godfather's home in Amsterdam, where he saw his first art gallery, and then to Antwerp by post-cart—a thirty-six hour trip.

The Antwerp Academy was at that time directed by Gustave Wappers (1803-1874), the teacher of the Pre-Raphaelite, Ford Maddox Brown. In Antwerp, the Classicist style of Jacques Louis David had lingered until mid-century. Artists such as F.J. Navez, P. Van Hanselaere, and F.J. Kinson continued with determination the hard, crisp, sculptured manner of David who had died in 1824 in Brussels. Now Wappers, popularly known as 'David's Antidote', sought to end this foreign influence. As the head of the Romantic School, he tried to revive the older traditions of the leading Dutch and Belgian masters.

When Alma-Tadema arrived in Antwerp, these two schools were strongly opposed. By entering the Art Academy under Wappers, Alma-Tadema had inadvertently been directed to the study and representation of early Dutch-Flemish history, rather than classical antiquity. He was also influenced by Wappers' respect for Richard Parkes Bonington and the new examples of Eugène Delacroix and Théodore Géricault. This is

Portrait of my mother (Opus III, 1852) (Fries Museum, Leeuwarden)

Portrait of Alma-Tadema's brother, c.1849. An early finished oil painting, but not included in his list of opused works (Het Nederlands Openlucht Museum, Arnheim)

Self portrait with his half-brother, Jelte Zacharius, his mother and sister Atje, 1859 (Fries Museum, Leeuwarden)

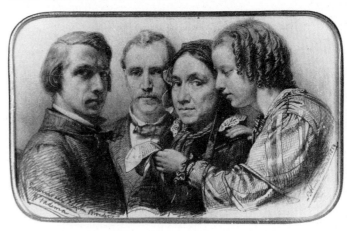

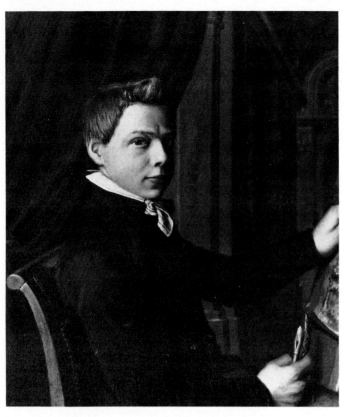

Self portrait (Opus II, 1852) Painted at the age of 16
(Fries Museum, Leeuwarden)

Ford Madox Brown by Dante Gabriel Rossetti, 1852. Madox Brown
was one of Gustave Wappers' most eminent pupils prior to Tadema's
student days in Antwerp (National Portrait Gallery, London)

Georg Ebers, the German Egyptologist who was a major influence
on Tadema's interest in archaeology (Mary Evans Picture Library,
London)

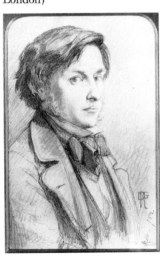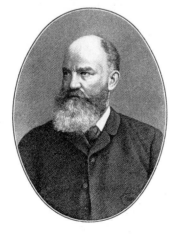

possibly a reason why Tadema's later Greek and Roman
subjects were richer in colour and pigment than the works of
David's lesser followers, though compositionally less classical.

Once in art school Alma-Tadema worked feverishly. 'He did
not work', said a friend of the painter, 'he slaved to make up for
all the precious time he had lost.' After six months Wappers
left the Academy for Paris. He was replaced by Nicaise de
Keyser (1813-1887), who had many of the same nationalistic
tendencies as Wappers. Joseph Laurent Dyckmans (1811-
1888), who also worked at the Academy, had a greater
influence on Alma-Tadema, however, because of his interest in
illustrative historical painting. His work soon attracted
attention from these men.

Tadema's first major independent production came
towards the end of 1856. K. Tigler Wybrandt, a friend from his
home town, had ordered a painting, *The Alm* (Opus IV),
Laurens' first big commission. Ecstatic, he saw the Director,
and told him he was going to leave the Academy school for a
while to fulfil this commission. His reception from de Keyser
was like a shower of cold water, for the regulations of the
Academy stated that an absence of more than three weeks
involved an automatic expulsion. Although realising the
trouble to which he exposed himself if he allowed the fatal time
period to elapse, Tadema said farewell to the Director and
began to work on his new endeavour. He no longer returned to
the Academy except to take several special courses.

Little work remains from this formative period. Alma-
Tadema was hypercritical of his work and often destroyed it.
His third major canvas, completed while studying at the
Academy, *The destruction of Terdoest Abbey* (Opus VI), was
given to his mother's cook as a tablecloth. *Poacher returning
home* (1856), *Cleopatra* (1856), *Faust* (1857) and *Plundering of
Egmond Abbey by the Spanish* (1859) were also supposedly
destroyed. His paintings often hid several different pictures
beneath the final paint surface. This practice kept his pictures
constantly in flux. 'Those who, like myself', said Helen
Zimmern, 'have seen this process have grieved sorely as some
beautiful figure, some dainty little detail, has been, as it seems
barbarously removed.' Other heavily reworked examples from
his student period are his *Still-life with statue by Michelangelo*
(1853-1857), and *The sad father* (Opus X) which was later cut
into at least three sections, one being *The Grand Chamberlain
of King Sesostris the Great* (Opus LXX) after it had been
pumiced-out and repainted.

His mother well understood the great difficulties and
sacrifices Tadema would need to make in order to succeed. In a
letter from her dated 1857 she writes to a member of the
family, '. . . a balance is still not made. I only know to my great
sorrow that everything is progressing so difficultly. A while
ago Laurens delivered a sketch for 50 guilders, and now in a
few days time a painting will be ready that will get 300
guilders, but if he now devotes himself only to painting to
bring in money he will not get any further. He must work for
the exhibitions and develop himself further . . . His joy and
industry and zeal remain with him and that is a great
advantage.' Yet not all was grit and determination, and his
success did not always hinge upon hard work.

He became popular among the artistic and intellectual
elite of Antwerp, and in this connection, he became a member
in 1857 of the 'Cercle Artistique'. They studied German history
and legends, such as those of the brothers Grimm and the
newly rediscovered *Nibelungen Legend*. About this time
Alma-Tadema met Georg Ebers (1837-1898), a noted Egypt-
ologist, who was to have great influence on the artist and
later became one of his biographers.

The German influence had an immediate effect on his
choice of subject with the watercolour *Faust and Marguerite*
(Opus VII), taken from Goethe's *Faust*. Of even greater

influence than Ebers was Louis de Taye, a Professor of Archaeology at the Academy of Antwerp and later Inspector of Art Education in Belgium. It was de Taye who directed Alma-Tadema's attention to the study of the early history of France and Belgium. De Taye introduced Tadema to Augustin Thierry's *History of the Merovingians* (1840) and to Gregory of Tours' *History of the Franks* (590). These two references were then used as source books by the literary-historical minded Alma-Tadema.

His first Merovingian painting was *Clotilde at the tomb of her grandchildren* (Opus VIII). Clotilde was a queen referred to in Gregory's book, but Alma-Tadema was criticized because no such scene had been mentioned. To the statement that this episode was 'entirely without foundation in fact', Tadema replied that 'the faithful Clotilde, having lost all hope of influence by the murder of her grandchildren should have wept at their grave, is but human, and, as such, certainly historic.' It was about this time that Tadema painted his first Egyptian picture, *The sad father* (Opus X), perhaps under the influence of Ebers, and his first Classical picture, *Marius on the ruins of Carthage* (Opus IX).

Alma-Tadema remained a pupil of the Art Academy until 1857, when he moved to the home and painted in the studio of Louis de Taye, for whom he helped to paint *Bataille de Poitiers*. It was also said that Madame de Taye sat for the head and arms of his *Clotilde*, four sketches of which have been preserved in Birmingham University Library. Taye's encouragement prompted Alma-Tadema to depict this period of history, although it was obscure and very rarely portrayed. Carel Vosmaer, a novelist, once asked Alma-Tadema why he, a happy fellow, painted the monstrous Merovingians. 'They are', said Alma-Tadema, 'a sorry lot to be sure, still they are picturesque and interesting.'

Also living with de Taye were the brothers Jacob (1837-1899) and Willem Maris (1844-1910), Dutch painters of the 'Hague School', whose work was somewhat in the Barbizon style of Constant Troyon (1810-1865). It was through these brothers that Alma-Tadema met another important painter, Hendrik Willem Mesdag (1831-1915). Mesdag remained a lifelong friend, pupil and collector of his paintings. Alma-Tadema lived for three years at de Taye's home before he was selected to join the studio of Henrik Leys (1815-1869). He had learned much from de Taye's large library and his discussions with de Taye himself. This experience encouraged his facility to portray history with archaeological accuracy.

Alma-Tadema's 'Continental training' was half over. In Europe an art student was required to attend an Academy for a period of years before joining a studio of a first-rate artist. If the student was not of sufficient merit or otherwise acceptable to the master, he might not be chosen, and his career would be ended. Alma-Tadema was chosen in 1859 to enter Baron Leys' studio, then the most highly regarded studio in Belgium.

Baron Leys was as stringent with others as Alma-Tadema was with himself. Leys added an immense store of historical and archaeological knowledge to that which Tadema already possessed. The student began to blossom under this strict master. Laurens wrote home and asked his mother and sister to come to Antwerp and live with him. With the acceptance into the studio of Leys, his mother realized that her son was going to be successful. Tadema's mother and sister finally overcame their aversion to the Catholic country and came to live with him in 1859.

Leys had deviated from the Franco-Belgian Romantic school. His art assumed roughly the same position as that of the *juste milieu* painters in France—academic in technique but romantic in subject. Like Horace Vernet and Paul Delaroche, Leys' art looked forward to late nineteenth-century

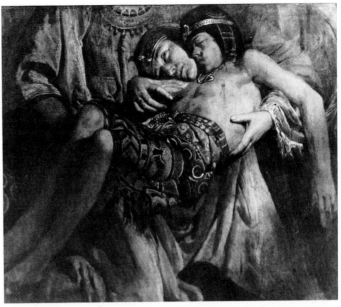

The sad father (Opus X, 1859) Alma-Tadema's first Egyptian subject and the first of several on the theme of the 'death of the first-born' (Johannesburg Art Gallery)

Le droit de cité accordé à Palavicini (AD 1541) One of Ley's frescoes for the Hôtel de Ville, Antwerp, on which Tadema worked as his assistant (Radio Times Hulton Picture Library, London)

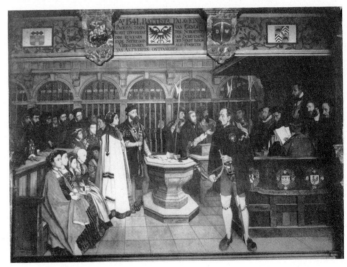

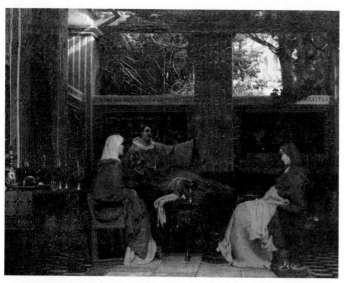

Venantius Fortunatus reading his poems to Radagonda
(Opus XV, 1862) The painting for which Tadema received a gold medal in Amsterdam. In several of Tadema's early works, the bitumen-based paint has cracked badly. Later he adopted a new medium, allegedly a secret one disclosed to him by Gérôme, and his subsequent paintings are remarkably well preserved (Dordrechts Museum)

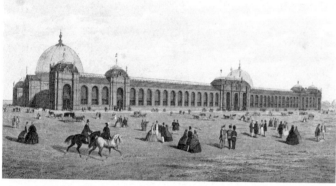

View of the 1862 International Exhibition buildings, which Tadema visited during his first trip to London (Mary Evans Picture Library, London)

The Elgin Room at the British Museum. Tadema was greatly impressed by the sculptures of the Parthenon and later inspired to paint *Phidias and the Parthenon* (Engraving by Radclyffe after a drawing by L. Jewitt: Mary Evans Picture Library, London)

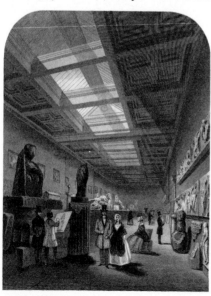

academicism. A list of his students is impressive: Felix de Vigne, Ferdinand and Henri de Braekeleer, Jozef Lies, Pierre Van der Ouderro, and Victor Lagye, a good friend of Tadema.

When Alma-Tadema arrived at Leys' studio, he began a series of 'Migration of the Nations' paintings, of which the watercolour, *The death of Attila* (Opus XI), was the only one finished. He could not complete this series because Leys had asked him to assist with the construction of the perspective and preparation of six frescoes for the Hôtel de Ville in Antwerp. The scenes were to depict the history of the city of Antwerp and they consumed much of Tadema's time until 1862. He also collaborated with Leys on several paintings, including *The Institution of the Golden Fleece* (Antwerp Town Hall), which was Leys' principal exhibit at the London International Exhibition of 1862.

While Leys was painting his picture *The Three Reformers with Luther*, he asked Alma-Tadema to insert a Gothic table. When finished, Leys criticized it. 'It is not my idea of a table. I want one that everybody knocks his knees to pieces on.' On another occasion, Alma-Tadema had just finished his first major painting in Leys' studio, *The education of the children of Clovis* (Opus XIV). Leys severely criticized it, saying, 'That marble is cheese, and those children are not studied from nature!' This particular picture made a sensation when it was exhibited in Antwerp in 1861 and was very highly thought of by critics and artists alike. But Leys was a severe taskmaster, and his criticism of Tadema's marble perhaps prompted him to become the world's foremost painter of marble. This interest had already been aroused as early as 1858 with the experience of visiting a Ghent club which boasted a marble-lined smoking room.

After his triumph with *The education of the children of Clovis*, Tadema, 'feeling that he had found his own path, felt the need of a fresh outlook upon art life'. He subsequently made his first journey outside the Low Countries. He visited the National German Exhibition at Cologne in 1861. Upon returning home, he continued to paint Merovingian subjects in his own time while in Leys' studio. He won a gold medal at Amsterdam for his *Venantius Fortunatus reading his poems to Radagonda* (Opus XV), and was subsequently elected a member of the Amsterdam Academy. With this triumph Alma-Tadema vindicated his rejection by this same Academy nine years earlier.

In 1862 Alma-Tadema made his first journey to London to visit the International Exhibition, a trip which coincided with an increasing independence from Leys' style. His earlier productions had reflected some of the mannerisms of Leys, especially in their hardness and precision. Leys had never encouraged individuality in his students, but Alma-Tadema would ultimately prove to be true to his own goals. He once said of this period, 'If I have obtained any degree of success it is because I have always been faithful to my own ideas, followed the inspirations of my own brain, and imitated no other artist. Whoever wishes to accomplish anything in any career in life must first of all be faithful to his own nature and this I may assure you, I have always been.' Yet Tadema would also be the first to tell of his debt to his master. In a letter of 1883 he wrote, 'I remained a friend and a help to Leys until his death in 1869 and often came up from Brussels where I had settled in 1865 to work for him.'

Carrying a letter of introduction from Leys to a Royal Academician, Philip Hermogenes Calderon (1833-1898), Alma-Tadema was able to meet the members of the artistic circles of London. He also visited the British Museum, where the Elgin marbles made a great impression on him. The Egyptian antiquities also had effect, for within a year he painted his second Egyptian subject picture, *Pastimes in Ancient Egypt: 3,000 years ago* (Opus XVIII).

By 1862 Tadema was very accomplished technically but lacked a wholly formed personal style. This, however, he could develop on his own, and the period 1862-63 marks the end of his student years and the beginning of his Continental career.

Continental Years (1862-1870)

Alma-Tadema's third period can justly be called his 'Continental Period'. In the next eight years he established himself as a significant contemporary European artist. He stunned the public with his prodigious technique, archaeological detail and unusual subject matter—unusual principally in that he chose to portray the domestic life of the ancients rather than important historical scenes. In fact, by the end of the decade Alma-Tadema's art had matured to such a degree that all further developments must in some ways be regarded as but footnotes to themes, techniques and motifs from this period. In England in 1870 he appeared as a fully developed painter of classical genre subjects.

In breaking away from Leys' studio, the hold of Franco-Belgian subject matter was loosened. The artist's personal relationship with the noted Egyptologist Georg Ebers, developing shortly before Tadema's Italian sojourn, helped to shift his interests from the Merovingian epoch to more ancient subjects.

His first Egyptian picture had been *The sad father* (Opus X). The second, *Pastimes in Ancient Egypt* (Opus XVIII), was received spectacularly, winning a Gold Medal at the 1864 Paris Salon. He produced only twenty-six Egyptian pictures during his career but because of their technical quality and novelty at the time they were much discussed. Asked by Ebers why he chose to portray Egypt, Alma-Tadema replied, 'Where else should I have commenced when I first began to make myself familiar with the life of the ancients? The first thing the child learns of ancient time leads him into the court of the Pharoahs, to Goshen in Egypt, and when we go back to the source of the art and science of the other nations of antiquity how often we reach your Egypt!'

Apart from Sir Edward Poynter (1836-1919), no other contemporary painter attempted to render daily Egyptian life in the same manner as Alma-Tadema. Of all Alma-Tadema's pictures, his Egyptian works convey the most emotion. *Death of the first-born* (Opus CIII), with its strong sense of sorrow, *An Egyptian widow* (Opus XCIX), and *The mummy* (Opus XLII) attest to this fact. Within two years, however, Greco-Roman subjects began to dominate his oeuvre to the exclusion of both Merovingian and Egyptian themes. Between 1861 and 1864 Tadema painted six Egyptian or Merovingian paintings and no Greco-Roman subjects. From 1865 to 1867 he painted only one Merovingian scene and thirteen Greco-Roman paintings.

In the autumn of 1863, Tadema married Marie Pauline Gressin, the daughter of a French journalist of royal descent living in Brussels. Marrying into the Dumoulin de Boisgirard family, Alma-Tadema developed French connections which aided his career. On their honeymoon, the Alma-Tademas visited Florence, Rome, Naples and Pompeii, where they spent several weeks. Alma-Tadema had originally gone to Italy with the idea of studying Byzantine and Early Christian churches in order to further his knowledge of the Early Middle Ages. In fact, his *Interior of the Church San Clemente, Rome* (Opus XIX), the only picture he completed in Italy, was of an early church. However, there, for the first time, the painter caught the flesh and blood spirit of ancient times that had eluded him before. He assiduously studied the ancient ruins of temples, baths, amphitheatres and statues. As Ebers wrote, 'He went wild with the thought of the new old-world visions and vistas opening out before him. For him the ugliness and pitiless squalor of Merovingian history . . .' lost its interest.

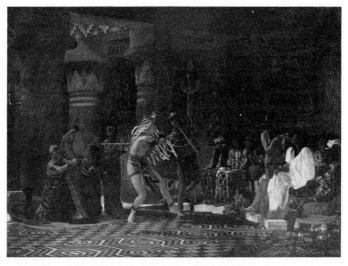

Pastimes in Ancient Egypt (Opus XVIII, 1863) Tadema's second major Egyptian painting, damaged in the Regent's Canal explosion of 1874 and later described by him as a 'wreck of a picture' (Harris Museum and Art Gallery, Preston)

Portrait of Alma-Tadema's first wife, Marie Pauline Gressin de Boisgirard, drawn c.1867-69 (Photo: C. J. J. G. Vosmaer)

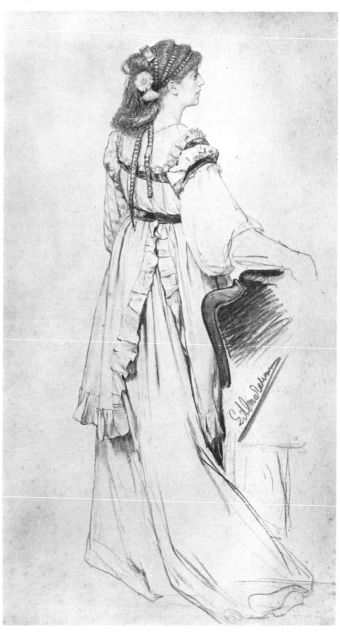

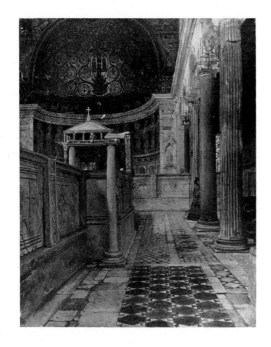

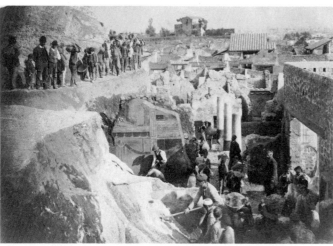

Interior of the Church San Clemente, Rome (Opus XIX, 1863)
Painted during Tadema's Italian honeymoon (Fries Museum,
Leeuwarden)

Excavations at Pompeii. The systematic work carried out during the
1860s and which Tadema visited on his honeymoon uncovered many
buildings and artefacts which initiated his interest in the Roman
world (Mary Evans Picture Library, London)

Alma-Tadema measuring ruins and examining marble at Pompeii,
1863 (Birmingham University Library)

It took the trip to Pompeii to awaken Tadema's earnest
fascination with the Romans and Greeks. He now began his
study of marble with great enthusiasm, wanting to repudiate
Leys' early criticism, 'That marble is cheese.' He studied
marble in every form, type and condition: glistening build-
ings and carefully worked marble statues, Pentelic and
Carrara marbles, marble still in the quarry and the weather-
beaten marble of ancient tombs. Alma-Tadema's unique style,
which relies so heavily on the rendition of marble, developed
during this trip and remained constant throughout his work.

The importance of this first trip cannot be under-
estimated. For Alma-Tadema it was the beginning of a
marriage, a career and the inspiration for the classical
themes for which he is best known. Later, it was said, 'The
famous Dutchman called to life amid the London fog the
sacrifices of Pompeii and Herculaneum.' He may well have
read the very popular book *The Last Days of Pompeii* (1834)
by Bulwer-Lytton, while two important contemporary
publications which undoubtedly had considerable influence
on him were *The Journals of the Excavations at Pompeii* by
Giuseppi Fiorelli (1861-1862) and *Herculaneum et Pompeii* by
Henri Roux (1840 etc.). Tadema's 168-volume portfolios pre-
served in the Birmingham University Library reveal an
occasional cut-out from Roux's book. The Alma-Tademas
remained in Italy until their funds ran out. In early 1864
Laurens was compelled to return to Antwerp in order to find
part-time work to support his family.

Later in 1864, however, Alma-Tadema was in Paris for the
first time, exhibiting *Pastimes in Ancient Egypt*. This was
not his Salon debut, but with the sensation that the
Egyptian picture caused and the subsequent gold medal he
received, it might well have been. The gold medal brought
Alma-Tadema into contact with Jean-Léon Gérôme, who
supposedly revealed to him the formula of his painting medium.
The exact recipe is unknown, but Alma-Tadema used it
throughout his life. While in Paris, he also came to the attention
of the Renaissance revivalist, Alfred Stevens (1818-1875) and
Rosa Bonheur (1822-1899), the great animal painter. Mlle.
Bonheur, whom Alma-Tadema never met personally, told her
friends to keep a close eye on this young painter. She men-
tioned his name to her agent, Ernest Gambart, the 'Prince
and Napoleon' of art dealers and in later life Spanish Consul-
General.

The importance of Gambart was immense. With offices in
several European capitals, and headquarters in Nice he was
highly influential in the Western art world. Every oppor-
tunity to meet him was taken by the art students of Europe,
including Alma-Tadema. Two of his biographers, Zimmern
and Standing, offer differing stories as to how these men
finally met. Standing relates that Victor Lagye, a loyal friend
of Tadema, (though Zimmern says it was Baron Leys), gave
Alma-Tadema's address to Gambart's coachman. Gambart
had intended to go to the Belgian painter Dyckmans' studio,
but was unknowingly taken to Tadema's. 'In the doorway
stood the young painter palpitating with excitement.' Gambart
realized his error immediately but entered the studio any-
way. Standing says that Gambart stood before the picture
Leaving Church in the fifteenth century (Opus XXI) and
asked:

'Is the picture on the easel painted for anybody?'

'Yes,' muttered Tadema.

'Has the purchaser seen it yet?'

'No.'

'Then it is mine!' exclaims Gambart.

Zimmern states that Gambart said, 'Do you mean to tell
me you painted this picture?' There was no reply from the
flustered Alma-Tadema. 'Well', replied the dealer after asking
the price and a few other details, 'turn me out twenty-four

other pictures of this kind and I will pay for them at progressive prices, raising the figure after each half dozen.'

Another biographer, Edmund Gosse, says that the deal was concluded, with the stipulation that at least half of them should be 'antique'; although he remarks that by 1880 the amount which the painter got for each of these works 'did not exceed one-fifteenth what any one of them easily commands . . .' However, it was a sure income and he was freed from the pressure of supporting a family.

To confuse the issue even more, Gerald Reitlinger recently proposed another conflicting story. 'In 1861 the young Friesian was persuaded by Ernest Gambart to exhibit *The Children of Clotilde* at the Royal Academy.' This is an impossible assertion because official Royal Academy records state that the first picture exhibited by Alma-Tadema was in 1869.

Gambart's contract did indeed call for twenty-four pictures, but the price was to be determined by a scale that ascended with each new painting. It took Alma-Tadema nearly four years to fulfil his contract. Six pictures per annum in Alma-Tadema's finished style was a high rate of production, but in 1865 Tadema painted eleven, in 1866 nine, in 1867 thirteen, in 1868 twelve and in 1869 nine. Yet, many of these 'opused' works were watercolours and as such were unsuitable for the terms of the contract. Also, several of the paintings were portrait commissions: *My family* (Opus XLV); *Portrait of Mr A. Bonnefoy* (Opus XLVII); *Portrait of Madame Bonnefoy and Mr Puttemans* (Opus LIV). When Alma-Tadema finished his contract in the latter part of 1868, each painting had earned about £80.

Soon after meeting with Gambart, Alma-Tadema decided to paint more Greco-Roman subjects. Worried about the possible effect on sales, Gambart hesitated in giving his approval but acquiesced after many discussions. 'Although the world of his buyers had to be educated very laboriously into so much archaeology', wrote William Slade in an unpublished memoir, 'he was forced to waive his claim to modern and Gothic subjects and this left the artist perfectly free to follow the bent of his genius'. This education had begun as early as 1864 when Gambart exhibited some of Alma-Tadema's work in England. In 1865, Gambart exhibited *Egyptian game* (Opus XXII) and *Leaving Church in the fifteenth century* (Opus XXI) at his French Gallery in Pall Mall. In 1866 *Entrance to a Roman theatre* (Opus XXXV) and *Home from market* (Opus XXXI) were shown. By 1867 the English were beginning to know of Alma-Tadema and his immaculate archaeological style. An art journal said of his *Tibullus at Delia's* (Opus XXXVIII), 'We cannot close without calling attention to a class of remarkable pictures which, founded on the Antique, seeks to reanimate the life of the old Romans'.

When their contract was successfully completed, both parties realized the worth of the other. Gambart then offered a contract of forty-eight pictures which were to be divided into three classes of importance. The first class would be remunerated at the price of the previous order (about £80) and so on up the scale for the first twelve pictures. The second class would start at £100, the third being set at £120 for the last half dozen. Such a contract was generous to both parties.

Meanwhile Alma-Tadema had moved to Brussels in 1865. Although there had been much interest in his work in Antwerp and Paris, he did not see a future in Antwerp, which he felt was too small, or Paris, which was too large and competitive. About this time his *Queen Fredegonda at the deathbed of Bishop Praetextatus* (Opus XX) was acquired for the Raffle of the Triennial Salon of Brussels and had brought such success that the Tadema family decided upon Brussels, where the artist's budding talent was better appreciated, and where they could be nearer to his wife's family. In this more cos-

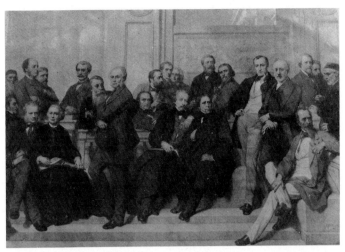

Les grands artists, École du XIXme siècle, 1878, by Nicaise de Keyser. A group portrait commissioned by Tadema's agent, Ernest Gambart, depicting such notable nineteenth-century painters as Gérôme, Meissonier, Frith, Delacroix and Turner. Tadema appears third from the left, behind Millais (Musée Chéret, Nice: Photo: Maas Gallery, London)

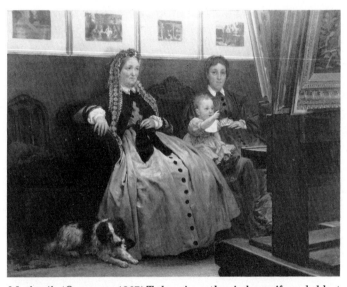

My family (Opus XLV, 1867) Tadema's mother-in-law, wife and eldest daughter. His family and friends frequently served as the subjects of formal portraits and as the characters in his Roman set-pieces. Examples of Tadema's work appear on the wall (Groningen Museum)

Ernest Gambart, Tadema's agent (Maas Gallery, London)

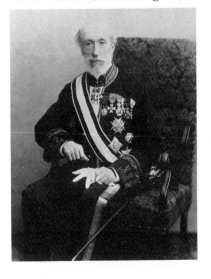

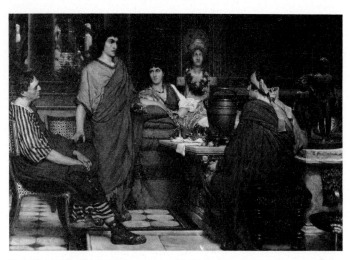

Catullus at Lesbia's (Opus XXVII, 1865) Tadema's first major Roman painting and the first work completed after his arrival in Brussels (Private collection, England)

The death of Galeswinthe (Opus XXXII, 1865) One of Tadema's occasional obscure subjects which did not find favour with his agent or his public. As his more general domestic genre scenes won him increasing critical and commercial success, his output of paintings depicting specific—and sometimes perplexing—historical events declined (Mr Barry Friedman, New York)

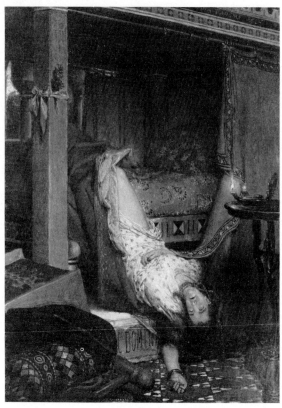

mopolitan city, Laurens soon established his studio at 31 Rue des Palais and began work.

Although he had already painted *Gallo-Roman women* (Opus XXIV), his *Catullas at Lesbia's* (Opus XXVII) can be considered his first full-scale Roman work. It should be noted, however, that two earlier watercolours deal with classical subjects: *Marius on the ruins of Carthage* (Opus IX) and *The death of Hippolyte* (Opus XIII). From 1865 to 1870 over forty-five Roman pictures were painted in his studio, thus attesting to the financial success of the Roman-Classical genre.

Such taste did not prevail in Holland, however. At this time the connoisseur's appreciation of the freer style of the Barbizon-inspired landscapes of the Hague School relegated Tadema's works to pictures which were admired but not bought. Between 1856 and 1880 Alma-Tadema did not earn more than 1,000 florins in Holland. As Ebers remarked, 'The Netherlands knew how to value and praise his art, but they were by no means inclined to make even the smallest sacrifice for the artist.' Throughout his career, he never received commissions from the Dutch King, the Government, or even any of Holland's art institutes, most of his commissions coming from Belgium, England, America and Germany.

His work had progressed considerably in the seven years following his apprenticeship with Leys. His palette was brighter and clearer, his drawing more graceful, his colour more sensitive and his composition less timid. Many of his earlier Belgian pictures were marred by a certain 'Batavian squatness' and heaviness of form. It took time—until about 1870—to draw all the different elements of his art into more perfect accord. In 1866 his work reached a crisis point. He had reached a base level of technical competence but became involved with oddities rather than essentials in his art. Extraneous and novel ingredients threatened to make him a 'mere pedant of the brush.'

The public and Gambart became perplexed by the heavy and dull quality of Alma-Tadema's genre. His subjects were obscure to many prospective buyers. Such works as *The death of Galeswinthe* (Opus XXXII) were difficult to sell. The dealer found it difficult to induce clients to possess a work by Tadema. One rich collector refused a fine specimen saying, 'You see, if you explain to me what it is all about I shall only forget; and a man looks such a fool if he cannot explain the subject of his own pictures to his friends.' Gambart tried again but with little success to persuade Alma-Tadema to paint contemporary genre.

Yet honours now began to trickle in. In 1866 Alma-Tadema was made a Knight of the Order of Leopold by Belgium; in 1868 he became a Knight of the Dutch Lion; and in 1869 a Knight First Class of the Order of St. Michael of Bavaria. He also exhibited twelve pictures at the Paris Exposition Universelle of 1867 and won a Second Class medal there. He hoped to show his *Phidias and the Parthenon* (Opus LX) as well at the Royal Academy in 1868, but the buyer refused to exhibit it. It was probably the chief cause for not finishing the second in a series of historic monuments commissioned by Gambart. His *L'Aya Sofia of Constantinople* was never finished. Nevertheless, by 1868 Alma-Tadema was considered in England to be one of the most famous Continental artists.

The Tademas had also attained much social standing by the late 1860s. In 1868 they were invited by Gambart to visit London and stay at his residence at 62 Avenue Road, St John's Wood. Gambart had been Tadema's dealer since 1864 and had purchased a total of thirty-four pictures up to the time of the visit. Tadema thought that his work had found great favour in England. 'Who knows the consternation Tadema felt', writes Crommelin, 'in observing that his dealer's entire house was papered with his canvases.

Gambart reassured the young painter. In truth he had yet to place the least painting of his protégé, but was not worried. He had absolute confidence in Tadema's merits, and was equally certain that the day would come when his young talent broke through in England and the commissions would come one after another without interruption.'

An unfortunate and prophetic incident occurred during this trip. Pipes for some gaslights had been extended in preparation for a soirée Gambart had planned. The workmen had done their job poorly, causing a gas leak. When one of the maids struck a match, an explosion occurred which killed one person and severely injured several others. Laurens and Pauline, who had been sleeping upstairs, were thrown from their beds. Mrs Tadema, already ailing, suffered a severe shock.

In the midst of professional success, personal unhappiness occurred with the deaths of Laurens' son in 1865 and his wife in 1869. The boy died of smallpox. Despairingly, Laurens cried to the doctor, 'If only my son were alive!', at which the doctor raised the eyelids of the baby and announced, 'Thank God he is dead, the smallpox had blinded him!'

Pauline, who had not been well, finally fell victim to the disease and died at Schaerbeek, Belgium, on 28 May 1869, at the age of 32 years and eight months. Her death left Tadema alone to care for his two daughters, Laurence (1864-1940) and Anna (1867-1943). His sister Atje remained with the family in Brussels to do what she could to help.

In 1870 Alma-Tadema painted *The vintage festival* (Opus LXXXI). Gambart immediately perceived this work as more important than anything he had previously produced, particularly in size, number of figures and design; he therefore paid the third category price for it. Just before the completion of the picture, Gambart decided to give a dinner for 'The artists of Brussels'. As Standing relates, 'Not until Alma-Tadema took his seat at the table did he realize that the "guest of the evening" was none other than himself. In addition to a handsome present of plate (a silver goblet with a flattering inscription) the gratified artist found tucked into his table-napkin a cheque for one hundred pounds, this being the sum in excess of the arranged price for his painting.'

In the winter of 1869, towards the end of the artist's Continental years, Alma-Tadema visited London to consult with a noted physician, Sir Henry Thompson, about a minor complaint. This event seems to have no additional significance since, previous to the visit, he had made all initial preparations for having a house built for him in Paris. When the Franco-Prussian War broke out in July of 1870, however, he was prompted to move to England, as were other artists including Monet, Doré, Tissot, Fantin-Latour, Fortuny, Sisley, Dalou, Legros and Herkomer. So in September of that year Alma-Tadema arrived in a new home which would prove equally fruitful for him and for English painting.

The move to England was prompted not only by the war but by additional considerations of patronage, new-found friendships and the death of his wife. In his own words Alma-Tadema explained, 'I lost my first wife, a French lady with whom I married in 1863, in 1869. Having always had a great predilection for London the only place where up till then my work had met with buyers I decided to leave the Continent and go to settle in England where I have found a true home.'

England—Early Years (1870-1882)

By October of 1870 Alma-Tadema was in London. Accompanying him were his two daughters, Laurence and Anna, and his sister Ajte, who had lived with him since the death of their mother. Alma-Tadema immediately rented the home of Frederick Goodall, RA (1822-1904), while that artist was travelling in Egypt. Goodall's studio was located in the

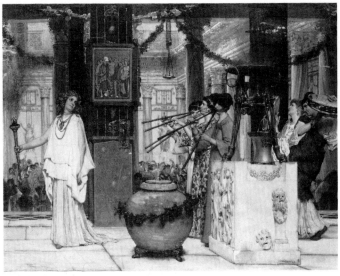

The vintage festival (Detail) (Opus LXXXI, 1870) Regarded by Gambart as Tadema's most important work to date, it was completed just before his move to London (Kunsthalle, Hamburg)

This is our corner (Detail) (Opus CXVI, 1873) Tadema's daughters, Anna and Laurence (Mrs Elizabeth Wansbrough, Lechlade)

Portrait of Sir Henry Thompson, c.1875. Thompson, the doctor who Tadema consulted during a visit to London, later became his pupil and a close friend. This portrait and a companion portrait of his son, Herbert—who also sat for *94 degrees in the shade*—were painted on the door panels of Thompson's houseboat (Fitzwilliam Museum, Cambridge)

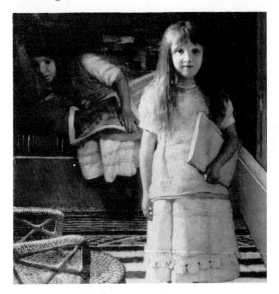

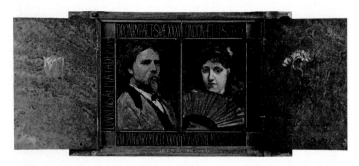

Double portrait of Laurence Alma-Tadema and Laura Epps, painted at the time of their marriage in 1871. The tulip and the rose symbolize the union of a Dutchman and an English woman (Fries Museum, Leeuwarden)

Alma-Tadema, the aspiring gentleman painter, photographed by the London society photographer, Alexander Bassano, in the 1870s (Studio Bassano, London)

unfashionable vicinity of Camden Square in north London. Wishing to become more involved in the London art world, Alma-Tadema moved after six months to Townshend House at 17 Tichfield Terrace, Park Road, on the north side of Regents Park.

To support his family during this period of relocation, Alma-Tadema took on a few pupils. One such pupil was the seventeen-year-old daughter of a London physician, Dr George Napoleon Epps—a member of a family which was famous in the nineteenth century as being prominent in the manufacture of cocoa. On 29 July 1871, Laura Theresa Epps (1854-1909) and Laurens Alma-Tadema were married.

Alma-Tadema's decision to reside in London was well received by the artistic community. For one thing, his particular brand of 'classicism' was not, on the whole, in direct competition with native treatments of this style of painting. Edward Armitage (1817-1896) painted classical history; Frederick Leighton (1830-1896) the Greek ideal; Edward Poynter (1836-1919) still painted historical subjects; and Albert Moore (1841-1893) promulgated his own independent form of aesthetic classicism. Tadema was at that time the only one to paint archaeological domestic genre, and others of that school felt that as a Neo-Grec he strengthened their Neo-Classical position at the Academy. These artists and other Neo-Grecs such as Frederick Walker (1840-1875) and Sir William Blake Richmond (1842-1921) welcomed Alma-Tadema into their circle. To them, he was a valuable addition to a late but growing classical movement.

Though well accepted by this segment of the artistic community, there was some opposition to his style. It came from two influential sources: John Ruskin, the prime Pre-Raphaelite advocate, and Thomas Carlyle, who stood opposed to the 'Greek Prejudice.'

The public, on the other hand, had become accustomed to Alma-Tadema's glowing reconstructions of ancient Greek and Roman life through exhibitions at the French Gallery in Pall Mall and in Gambart's rooms at St James's. There one could view Alma-Tadema's work along with the great contemporary French artists: Gérôme, Meissonier, Troyon, Bouguereau, Bonheur, and Descamps. In fact, to an intensely prudish Victorian society, Alma-Tadema's well-clad fair youths were highly preferable to Bouguereau's provocative nudes. Furthermore, Tadema's paintings of 'the Glory that was Greece and the Grandeur that was Rome' were a perfect mirror of the Victorian self-image. Seeing themselves as latter-day inheritors of empire, many Englishmen were, undoubtedly, taken with an artist who could prove with archaeology and paint that the Romans were not too different from the wealthy merchant class of the United Kingdom—hence the claim that he painted 'Victorians in Togas.'

His immediate application for citizenship and the subsequent 'Letters of Denization' from the Queen in 1873 allowed his complete assimilation into English life. He was proud of being an Englishman, occasionally going so far as to sign his autograph with an attached 'Vive Great Britain!' Many years later a published tribute spoke of his naturalization in these terms:

'Great are your gifts; we in England have had 'em a
Good many years, and we value them much, man.
Lucky the day when you cried, Alma-Tadema
Briton I'll turn; if I don't, I'm a Dutchman!'

Having joined the nation, Tadema proceeded to join its establishments. His increasing reputation as an 'Academy man' was derived gradually as foreign honours accrued. He was made Member of the Royal Academy of Munich in 1871; Chevalier of the Legion of Honour (1873); Member of the Royal Academy of Berlin (1874); elected Associate of the Royal Academy, London (1876); Medal of the Philadelphia

International Exhibition (1876); Medal of the Royal Scottish Academy (1877); Professor of the Royal Academy of Naples (1878); Gold Medal of the Paris Exhibition (1878); Member of the Royal Academy of Stockholm (1878); Officer of the Legion of Honour (1879); Member of the Royal Academy of Madrid (1879); Gold Medal of the Melbourne International Exhibition (1880); Member of the Imperial Academy of Vienna (1881); Prussian Order of Merit (1881); and Order of Frederick the Great (1881). These honours demonstrated an immense international reputation; Alma-Tadema brought much added prestige to the English Royal Academy.

The *Art Journal* saw him as 'The bright painter whom everybody admires... the public for his triumphs of technique and his brothers for the legitimate means by which these triumphs are compassed.' His paintings were a revelation to English gallery visitors. Works such as *A Pyrrhic dance* (Opus LXIX), *Anacreon reading his poems at Lesbia's house* (Opus LXXX) and *The vintage festival* (exhibited at Gambart's gallery in 1871) were sensations. His work combined stunning technique with novel and interesting subject matter, and these traits held much fascination for the English connoisseur. As Wilfred Meynell wrote in 1879, 'Mr Alma-Tadema is not ours by birth, nor by training; he will never become ours by conversion of his talents to British tastes and habits of art. But he can be ours and is fast becoming such by the conversion of the national tastes and habits to him.' The best explanation for his popularity among the English comes from V.W. Crommelin in the 1891 *Elsevier's Geïllustreerd Maandschrift:* 'Although Tadema may be and remain Dutch in his art, he appears to be destined to find a more cordial welcome in London, living in one of the dirtiest places in the world, plagued from morning till evening by smoke and the rattling of vehicles. They want here something different. For one half of the population art is a recovery, a breath of fresh air, for the other part it is a stylish article; it satisfies a need without being exactly spiritual food. Therefore they do not long for a painter who makes art difficult to understand and art which one has to look at often, they do not have time for this in England. "It does not pay." That is enough, give us a painter who jolts us out of the routine of life without having to make us leave our work, who knows how to interest us and fascinate us, who doesn't work under the influence of smoke and dirtiness and whose colours remain clear and fresh in the middle of grime and outside air, who satisfies our feeling for harmony and order, who ennobles a feeling of beauty in our taste.'

The academic milieu which Alma-Tadema entered is an excellent illustration of the complex skein of Late Victorian art. Although some early Pre-Raphaelites became Academicians themselves—for example Sir John E. Millais and James Collinson—the Pre-Raphaelite movement had claimed leadership of an anti-academic group since mid-century, opposing the Academy's lack of moral purpose. Later anti-Academy currents included 'symbolists' and 'aesthetes' such as J.A.M. Whistler, Walter Pater, Aubrey Beardsley, Albert Moore, George Moore and Oscar Wilde, who led the fight against the Academy's literary and sentimental orientation. The butt of the criticism was the Academy itself, yet this prestigious organization, composed of a highly reputable structure of artists working in diverse fields, seemed impregnable. Portraitists, still-life painters, fashionable sporting and genre painters all eagerly sought to attain the status of Academician.

One important aspect of the second half of the nineteenth century was the surprising emergence of the 'classicists'. England had never wholeheartedly accepted strict classicism, but from 1864, the year Lord Leighton became an Associate of the Royal Academy, a strong classicizing movement

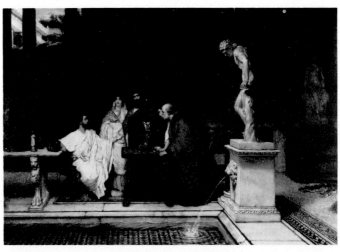

A Roman lover of art (Opus LVII, 1868) One of Tadema's many pictures of art connoisseurs—an obviously appealing subject to the wealthy buyers of his paintings. Tadema himself appears on the far left. His wife, Pauline, stands beside Gambart (Yale University Art Gallery)

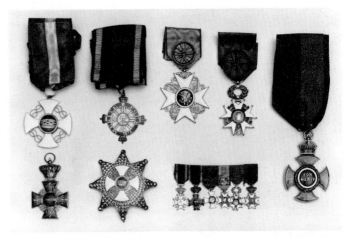

Some of Alma-Tadema's innumerable medals. In an age which judged the quality and status of everything from its confectionery to its painters by the number of medals they had been awarded, Tadema's collection, and his reputation, ranked among the foremost (Royal Academy of Arts, London: Photo: Angelo Hornak)

A Pyrrhic dance (Opus LXIX, 1869) Enormously popular when first exhibited in London, but described by Ruskin as like a 'small detachment of beetles looking for a dead rat' (Guildhall Art Gallery, London)

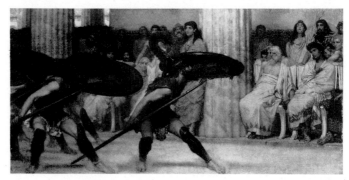

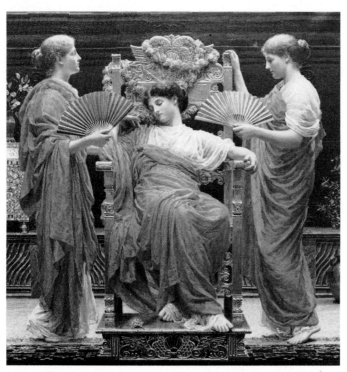

Albert Moore's *Midsummer,* 1887. In certain respects, Moore's subject matter resembled that of Alma-Tadema, but in his work archaeological accuracy was so subordinated to other aesthetic considerations that he painted ancient Greeks playing violins and cellos (Russell-Cotes Art Gallery and Museum, Bournemouth)

The drawing room, Townshend House, 1885, by Anna Alma-Tadema, showing its oriental ornamentation, tapestries and unusual black and white painted floorboards (Royal Academy of Arts, London)

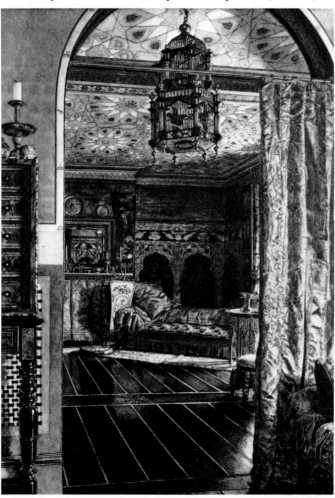

gained momentum. Not since the days of Gavin Hamilton, Benjamin West, Thomas Gibson and Lord Elgin had interest in that stylistic direction run so high. Classicism represented an escape from the present, an escape which was a legitimate concern of the 'Gothicks' as well, but the antique also represented a world of 'cultured education'. Leighton, Poynter and Alma-Tadema did themselves sometimes venture into gothic and medieval legends and history. They had been educated on the Continent and their learning was immense — Leighton spoke five languages, and Alma-Tadema could speak German, Dutch, Flemish, French, Italian and English.

These three were foremost among the classicist group, and they formed close relationships early. Poynter had met Leighton in 1853 in Rome, while Leighton and Alma-Tadema first came into contact in Brussels in 1866. Although Poynter and Alma-Tadema did not meet until 1870 at Burlington House, their art developed along similar lines throughout the 1860s. This brand of classicism 'after an English fashion' might be termed 'academic classicism', or, by Whistler, 'five o'clock tea antiquity', and its exponents also included William Blake Richmond, Edwin Long and John W. Godward. The general goal was to create an exalted didactic art, in a supposedly 'Hellenistic' spirit but, more specifically, without reference to contemporary life, and in this last respect Alma-Tadema was an independent. His belief was that, although eras change greatly in appearance, people change very little. He therefore painted the Romans almost exactly as he would Victorians. As William Gaunt has said, 'Alma-Tadema made the ancient world as bourgeois as a Dutch kitchen.'

Another important classicist was Albert Joseph Moore. Moore, though not as vocal as Whistler, was a classical advocate of 'l'art pour l'art'. Unlike Leighton, Moore attempted no subjects drawn from ancient mythology or history, nor period reconstructions like Alma-Tadema's. Rather, his forms were a peculiar combination of 'fancy dress' Hellenic figures rendered in colours and motifs derived from Japanese prints. His models were largely pretexts for form and design since subject matter played little part in his art. Once when asked the title of a picture he replied, 'You can call it what you like.'

The 'Battle of the Styles' was in full swing. Its hottest battleground was in architecture, with Gilbert Scott's 'Christian Gothic' verses Lord Palmerston's 'pagan classical' architecture. Both sides ignored the new materials and forms of Sir Joseph Paxton's Crystal Palace as a third alternative, just as the painters ignored Whistler's 'aestheticism'. These battles were difficult to define, the Pre-Raphaelites often siding with the Academy against specific 'art for art's sake' stances, and often collaborating; the dining room in the Victoria & Albert Museum, for example, was completed by William Morris, while the frieze was done by Edward Poynter. Yet, the 'classicists' had much in common with 'aesthetic' creeds, since both had a high regard for beauty in its theoretical sense. Though the English art world of the nineteenth century was often in the midst of aesthetic battles, it did not share the ferocity demonstrated by the French. Independent movements in England such as the New English and Camden Town Schools assumed positions more akin to the Academy's 'loyal opposition' than bitter foes.

After buying Townshend House in 1871, the Alma-Tademas began to remodel it. They decorated it with Pompeian motifs, German glass, Mexican onyx, rare marbles, Spanish leather, Chinese lanterns, Dutch silver, Japanese curios and other typical examples of Victorian bric-a-brac. Although smaller than many of the artists' studios in London, none was more famous than the Tademas' for jewel-like charm and interest. One room was decorated in 'Byzantine Revival' style, another in a medieval style; other rooms were inspired by a succes-

sion of exotic influences. All the rooms had the initials 'L.A.T.' and portraits or busts of Lawrence and Laura in them. One nineteenth-century writer described the house in these terms: 'It is not exactly a Dutch house, nor exactly a classic house, though much that is good in both has been pressed in service. It is essentially individual, essentially an Alma-Tadema house; in fact, a Tadema picture that one is able to walk through.'

After three years of decoration the home was almost finished. Then an unfortunate accident occured in the early morning hours of 2 October 1874. A barge loaded with gunpowder and benzoline moved slowly past the house on the Regent's Canal. Evaporating fumes of the benzoline were ignited from the flame of a lamp in the barge's cabin and a thunderous explosion resulted. Many homes were destroyed, and the Alma-Tademas' house was damaged seriously, one account of the disaster reading, 'In all the rooms fronting to the park, the ruin is complete!' The damage caused by the explosion was immense throughout the entire area. Several people were killed, houses demolished, cages of the nearby Zoological Gardens were thrown open. Neighbours armed themselves and the troops were called out to capture the wild animals, many of which were actually too frightened to leave their cages.

The artist and his wife were travelling in Scotland at the time, but their daughters were at home, tended by Mrs Leopold Lowenstam, the wife of Tadema's etcher. Fortunately no one was killed, but the entire structure of the house was shaken. By nightfall Lawrence had returned, and finding everyone safe, began to plan reconstruction. With the help of George Aitchison, ARA (1825-1910), an eminent architect, the unsafe structure was shored up with iron girders, and before long the Tademas were beginning to decorate again.

Meanwhile, Alma-Tadema's reputation as a serious artist had been enhanced by *The death of the first-born* (Opus CIII), selected by the *Pall Mall Magazine* as 'Picture of the Year' in 1872. His first academic honour in England came the next year, when he was elected to the Royal Society of Painters in Water-Colour. It was unusual for an academic artist of classical genre to develop an affinity for watercolour, but Alma-Tadema, who had learned early the use of the medium by copying drawings of flowers by E.J. Elkema, a Friesian artist, enjoyed this second technique. Indeed, his first watercolour, *Faust and Marguerite* (Opus VII), established the painter as one of the few art students on the Continent to employ this medium.

Tadema's work was also becoming widely exhibited. He had already exhibited at the old French Gallery and Gambart's rooms in St James's, when, in 1874, the Durand-Ruel Galleries accepted him. From 1877 onwards he also exhibited regularly at the Grosvenor Gallery.

Several changes occurred in his work during the initial phase of this first English period. First, his type of female figure was altered—particularly since he had married the somewhat heavily-built Laura—to what one critic described as a 'more robust, loftier, nobler stature'. Alma-Tadema also had a different working environment, which had a great effect on his painting. After his move to Townshend House, as his biographer Edmund Gosse states, a 'great improvement in the colour of his picture was noticeable at once, and from this time he threw off the last remains of his conventional Belgian tones.'

The picture Gosse was referring to was one of Alma-Tadema's most famous works, *A sculpture gallery* (Opus CXXV). Exhibited at the Royal Academy in 1875, the painting impelled Ruskin to comment: 'A work showing artistic skill and classical learning, both in a high degree . . . The artistic skill has succeeded with all its objects in the degree of

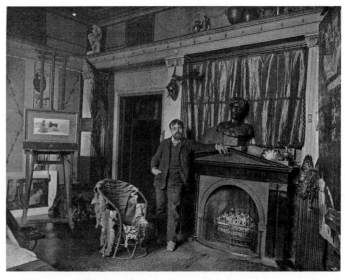

Alma-Tadema at home, 1884, showing a bust of Laura, *Antony and Cleopatra* on the floor behind the easel, *An old story* in progress and the tiger skin which features in several of his paintings, including *An audience at Agrippa's* (From: F. G. Stephens, *Artists at Home*, 1884: Mary Evans Picture Library, London)

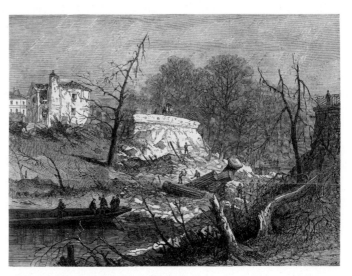

The scene after the Regent's Canal explosion of 2 October 1874 in which Townshend House was the most badly damaged (Mary Evans Picture Library, London)

Death of the first-born (Opus CIII, 1872) Voted 'Picture of the Year' by *Pall Mall Magazine* (Rijksmuseum, Amsterdam)

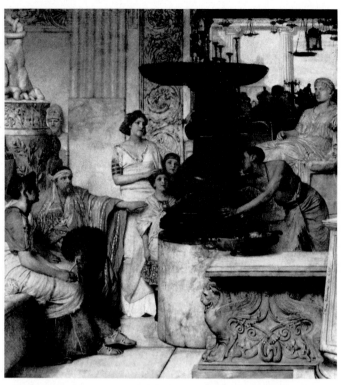

A sculpture gallery (Detail) (Opus CXXV, 1874) An example of work from Tadema's brighter 'post-Pompeian' period, it was praised —with reservations—by Ruskin. It includes a self portrait and representations of his wife and daughters, as well as a woman who resembles his first wife. (Dartmouth College, Hanover, New Hampshire)

A sculptor's model (Opus CLXXIX, 1877) Criticized by the Bishop of Carlisle as 'mischievous', it was painted as a gift for Tadema's pupil, the Hon. John Collier. Taken from a photogravure plate—the original painting was stolen during the Second World War (From: F. G. Stephens, *Lawrence Alma-Tadema,* 1895)

their unimportance . . . The execution is dextrous but more with mechanical steadiness of practice than innate fineness of nerve.'

Two factors contributed to Ruskin's mood. First, his 'anti-pagan' stance precluded any use of classical themes, and second, whereas Alma-Tadema's all-inclusive naturalism should have appealed to Ruskin's rejection of selectivity from nature, the artist's lack of interest in moralistic subject-matter seems to have overcome any potential critical favour on the writer's part. As Ruskin writes, 'and it is the last corruption of this new Roman state, and its Bacchanalian frenzy which Alma-Tadema seems to hold it his heavenly mission to pourtry (sic).' One stout defender clumsily retaliated saying that Tadema's 'Bacchantes had everything except Bacchic frenzy!'

Despite criticisms such as these, in 1876 Alma-Tadema was elected an Associate of the English Royal Academy. In his excitement upon hearing this news, he exclaimed, 'I feel officially employed as an Englishman!' In the same year his *An audience at Agrippa's* (Opus CLXI) was a highlight of the Royal Academy exhibition. It seemed inevitable that he should achieve the status of full Academician before long. Indeed, it seems the only reason that Alma-Tadema had to wait three years for such recognition was the fact that the Royal Academy limited its full-membership to forty at any one time. In 1879 a vacancy occurred and he received his due.

Alma-Tadema's output during this period was amazing: eleven paintings in 1871, thirteen in 1872 and again in 1873, twenty-one in 1874, seventeen in 1875 and another eighteen by the end of 1877. In fact, his first English period marks the zenith of his production in both quantity and, in some respects, in quality.

Spending the winter of 1876-77 in Rome, Tadema began a remarkable series of seven pictures dealing with the gardens of the Villa Borghese. *Four seasons* (Opus CLXXII-CLXXV) and *A question* (Opus CLXXXV) were his most important pictures of 1877, but it was the nude of *The sculptor's model* (Opus CLXXIX) that elicited the greatest response. A perplexed Bishop of Carlisle wrote, 'My mind had been considerably exercised this season by the exhibition of Alma-Tadema's nude Venus . . . (there might) be artistic reasons which justify such public exposure of the female form . . . In the case of the nude of an old master much allowance has been made . . . for old masters it might be assumed knew no better . . . but for a living artist to exhibit a life-size, life-like, almost photographic representation of a beautiful naked woman strikes my inartistic mind as somewhat if not very mischievous.'

Alma-Tadema realized that at least a veneer of respectability was essential in Victorian society. His coquettish Roman girls are always tasteful in the way they bare a breast or raise a toga. Though he himself only occasionally used nude figures, he defended the prerogative of artists to do so. In 1892 Tadema, Ford Maddox Brown, Frederick Goodall and other artists crowded into the Bow Street Police Court in London to hear proceedings against Rudolf Blind (1846-1894), summoned for exhibiting 'an obscene painting of a female'. The expert witnesses all defended Blind's picture because they regarded this court action as an attack on the 'Nude in Art', declaring that if Blind's nude painting was indecent, 'then three-quarters of the pictorial treasures of the world might also be destroyed!' The decision, 'Summons dismissed', was greeted with loud applause.

In mid-1877 Lawrence took for a summer residence a pleasant house and garden on the East Hill, The Rocklands, Hastings. There he joined his family on holiday. He delighted in the old town, the fishermen's quarters, the rocky shore and the steep walk down Ecclesbourne Glen. On one occasion, travelling by train, he visited first Rye and then Pevensey,

searching out traces of old Roman sites, and then returned to the Rocklands on foot. Such fascination with relics and artifacts was a continuation of his childhood interest in Merovingian archaeological finds. At Pevensey he found some antique Roman pots and bronzes, which inspired him to paint *Hadrian in England: visiting a Roman-British pottery* (Opus CCLXI).

In 1878 Sir Francis Grant (1803-1878) died and Frederick Leighton (1830-1896—created Baronet 1886) assumed the office of President of the Royal Academy. Unlike Grant, Leighton was an able administrator and also had exceptional social abilities. Under his administration the Academy flourished, marking a golden age for the living English artist. Alma-Tadema's prices jumped, as did those of a wide spectrum of English painters. It was not unusual for him to receive over £2,000 for one picture. *A picture gallery* (Opus CXXVI) in fact sold for over £10,000, worth perhaps over ten times this sum today.

Again in 1878, he made his customary annual trip to the Continent, collecting awards and honours as he went. He was made an honorary Professor of the Royal Academy of Naples, and elected a member of the Royal Academy of Stockholm. He won a Gold Medal at the Paris Exposition for his *The death of the first-born* (Opus CIII) and then continued on to Italy. While in Paris he usually stayed at the home of the art dealers Pilgeram and Lefevre on the Rue de Lancry. In Rome, the Tadema family would stay at the Villa Albani, which he once described as a 'glorified tea-garden'. Most of his working vacations were spent at the Bay of Naples.

Also that winter (1878-79) he was elevated to the rank of an Officer of the Legion of Honour, and, for his painting, *The siesta*, made a member of the Royal Academy of Madrid. But on 19 June 1879 the prize that Tadema had awaited was finally his: membership as a full Royal Academician. Only his knighthood in 1899 and his Order of Merit in 1905 could compare to the honour that the initials 'RA' brought.

Three years after Alma-Tadema's election by the Royal Academy, the Grosvenor Gallery sponsored the largest exhibition of his work to date. Two hundred and eighty-seven pictures painted between 1840 and 1882 were exhibited, giving critics and the public alike their first opportunity to examine Alma-Tadema in depth. Because of tariff regulations, the American collectors of his work did not participate, but the response among English and Continental collectors such as Sir John Pender, the Marquis de Santurce, Baron J. Von Schroeder, and W. Lee was great.

Criticism was mixed, with most statements following an almost set formula: citation of his astonishing technical ability, admiration for his accurate and detailed archaeology, then despair at finding little passion in the figures. He was praised for his brushwork, colour, drawing, detail and perspective, but condemned for telling us more about the Romans than anyone wanted to know. Then he was criticized for his inability to paint flesh as well as he did his still-life accessories. The *Art Journal* critic commented: 'The general lack of attraction of his figures is due to their complete denial of spirituality. Mr Alma-Tadema has some spiritual passages of living air, spiritual blue skies and seas, and spiritual sunshine, but no spirituality and little intellect in the face of the men and women of his world.'

For the first time the public could see Alma-Tadema's strengths and possible shortcomings. They were overwhelmed by his exhibition of technical skill, which they thought had no equal among contemporary English artists.

Last Years (1883-1912)
Even in the face of negative comment on his figure style, by 1884 Alma-Tadema had declared himself a portrait painter,

Hadrian in England: visiting a Roman-British pottery (Opus CCLXI, 1884) The semi-nude potter was criticized and the painting proved unsaleable. Tadema retaliated by cutting it into three portions which he reworked as new paintings:
(A) *A Roman-British pottery* (Soestdijk Palace, Soestdijk)
(B) *Emperor Hadrian's visit to a British pottery* (Amsterdam Historisch Museum)
(C) *A Roman-British potter* (Centre Georges Pompidou, Paris)

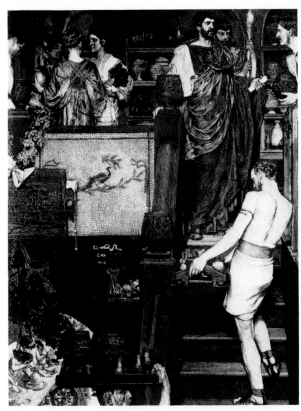

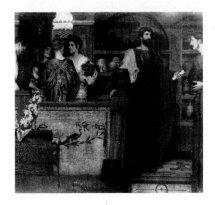

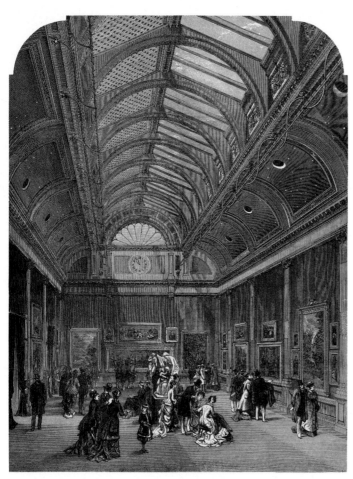

The Grosvenor Gallery, New Bond Street, London, the venue for
Alma-Tadema's major exhibition of 1882 (Mansell Collection,
London)

Ignacy Jan Paderewski (Detail) (Opus CCCXI, 1891) and *Arthur
James Balfour* (Detail) (Opus CCCVI, 1891) Two of Alma-Tadema's
many eminent portrait subjects. Both men were later to become
Prime Ministers of their countries, Poland and Great Britain
(National Museum, Warsaw; National Portrait Gallery, London)

as well as a painter of antique genre. He had painted seven
portraits in 1883, mostly of friends, and until his death in
1912 portraits assumed a greater prominence in his diminish-
ing production. His portraits include such luminaries as
Paderewski, the pianist and darling of London 'lion hunters'
(later Prime Minister of Poland), and the British statesman
Lord Balfour.

However, the total number of his pictures dropped sharply
between his Grosvenor Gallery exhibition of 1882 and 1912,
to an average of little more than five per year, in comparison
to an average of almost twelve paintings per year between
1865 and 1881. Several factors may have contributed to this
situation. Like many of the English academic artists,
honorary and pedagogical functions diverted much of his
working time. He was on the selection committee of the
Grosvenor Gallery, an active participant in all Royal Academy
functions, including teaching and painting classes, the
Selection Committee and Rules Committee, and Chairman of
the New Gallery. Sir Lawrence was also a committee member
of the Chantrey Bequest, and member of the Dutch Club,
Garrick Club, The Athenaeum, and Japan Society. These
activities inevitably drained precious time and strength from
a man who, although in good health, was approaching fifty
and naturally slowing down.

His first English period drew to a close when Alma-Tadema
and his family left the famed Townshend House for a larger,
more exclusive residence at the corner of Abbey and Grove
End Road in St John's Wood, London. It had been the studio-
home of Jean-Jacques Tissot (1836-1902) until the end of 1882
when, following the death of his mistress, Kathleen Newton,
the griefstricken artist left London for France so quickly
that he did not even bother to pick up his paints. The Grove
End Road house lay dormant for two years awaiting a buyer,
until Tadema purchased it after selling Townshend House to
Henry A. Jones.

Tissot had constructed a classic colonnade and other
interesting garden ornamentation which Alma-Tadema
adapted as he gradually drew up plans to double the size of
the house. It was reported that he spent £70,000 on the
residence—approximately the equivalent of £1,000,000 today.

The remodelling of the house took a great deal of time. In
fact, so much of 1886 was spent supervising its renovation
that Alma-Tadema finished only three pictures all year. Most
of the articles on Tadema during this period contain more
copy about his home than his art, the 'Palace of the Beautiful'
or 'Casa Tadema' becoming the most astonishing house in all
London. In many ways it was Townshend House all over
again, but on a grander scale, including among its decorative
features Mexican onyx, medieval Dutch rooms, bronze doors
(after those of the Eumactia House, Pompeii), fountains,
walls of sea-green marble, a mosaic atrium and marble floors
so valuable and highly polished that visitors were requested
to don special slippers before walking on them.

Among the unique features of his home were a copper-
covered entrance with the word 'Salve'—Welcome—above
the doorway, and a 'Hall of Panels'. Composed of 45 panels
painted and donated by his artist friends, they were a uniform
height of 31½ inches, and varied in width from two-and-a-half
inches to eight inches. Beyond being an original and beautiful
element in Sir Lawrence's home, the panels represented the
sort of comradeship which existed among the brotherhood
of artists. Lord Leighton gave a preliminary model of his
famous *Psyche*, in return for which Tadema presented him
with *In my studio* (Opus CCCXIX). Briton Rivière, John
Singer Sargent, Sir Edward Poynter and Tadema's pupil, the
Hon. John Collier, were but a few of the celebrities represented.

His new home featured two studios—a small one in
17th-century Dutch style for Laura and a huge semi-domed

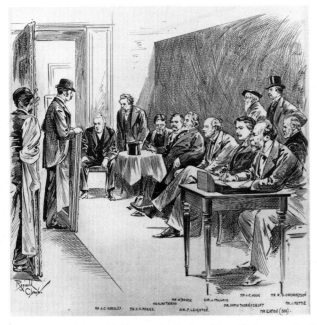

A sketch by Reginald Cleaver depicting Alma-Tadema and other members of the Royal Academy Hanging Committee, 1892 (National Portrait Gallery, London)

James Tissot's *The Picnic*, c.1875, showing the colonnade and garden of Tissot's St John's Wood house which was later acquired by Alma-Tadema (Tate Gallery, London)

Temple at Philae by the Hon. John Collier and *Grecian Moonlight* by Sir Edward Poynter. Two of the 45 panels given to Alma-Tadema by his fellow artists and described by one visitor as 'substantial visiting cards' (Photos: Sotheby's Belgravia, London)

Alma-Tadema's plan for the conversion to the studio front of his Grove End Road house, 1883. Details such as the inscription, 'Salve', above the door were included, but the fanciful notion of a classical statue on the roof was not carried out (Royal Institute of British Architects Drawings Collection, London)

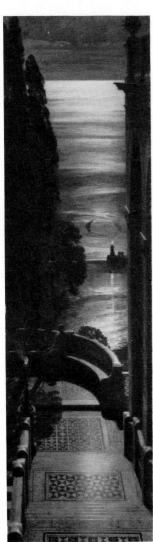

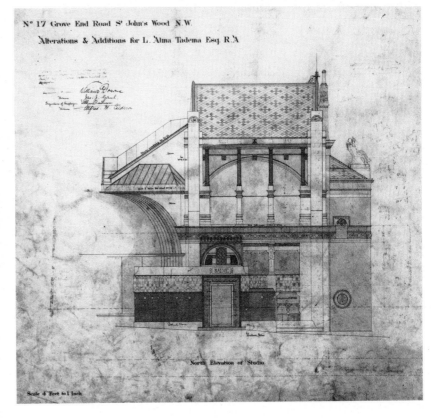

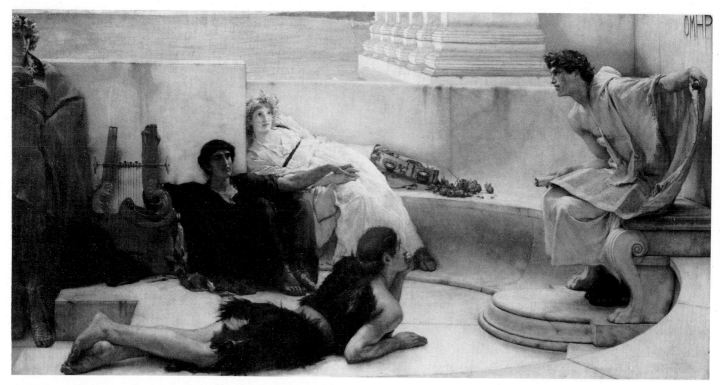

A reading from Homer (Opus CCLXVII, 1885) One of the markedly brighter pictures painted after Tadema's move to his new studio with its light-reflecting aluminium ceiling and regarded by some critics as one of Tadema's finest paintings (Philadelphia Museum of Art)

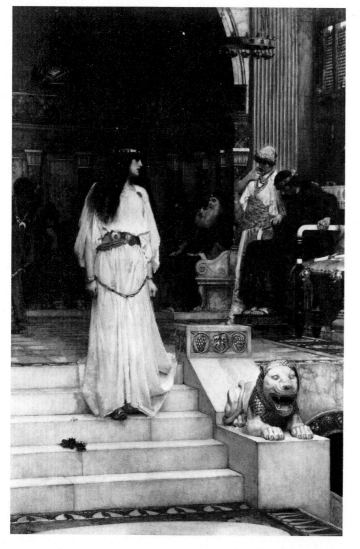

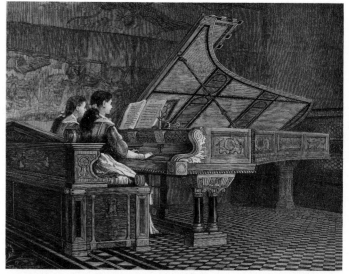

Alma-Tadema's daughters playing his piano in 1879. It was designed by George Fox and made by the firm of Broadwood in 1878. Every tiny brass screw bore the 'LAT' monogram, and it was covered with fine inlay of ebony, mother-of-pearl, tortoiseshell, brass and ivory. The lid contained panels of vellum which many famous pianists autographed. The piano survived the move from Townshend House to Grove End Road and was frequently displayed at exhibitions of British craftsmanship, but it was eventually destroyed by bombing during the Second World War (Mary Evans Picture Library)

Mariamne (1887) by John William Waterhouse (1849-1917). Waterhouse was greatly influenced by Alma-Tadema and constructed the classical background to this painting by incorporating many of the exotic elements of Tadema's domed studio (The Forbes Magazine Collection, New York)

studio for himself. The dome was covered with aluminium, which gave a bright silvery cast to the atmosphere of the studio. This effect is clearly evident in Alma-Tadema's paintings of this period: *A reading from Homer* (Opus CCLXVII) and *A dedication to Bacchus* (Opus CCXCIII) demonstrate the cool white refinement that permeates Tadema's later works.

His house was, remembered one visitor, '... quite literally, like nothing on earth, because to enter any of its rooms was apparently to walk into a picture. Lady Tadema's studio for instance, might have been a perfect Dutch interior by Vermeer or de Hooch. Tadema's on the other hand, conjured up visions of all the luxury, the ivory, apes and peacocks of the Roman civilization with which his art was largely preoccupied.'

Another visitor commented, 'His house is a glimpse of his work, it is his soul seen from the interior. Whoever understands his house learns to cherish his art.'

Sadly, the house no longer stands in its former glory; today apartments have divided the rooms and almost all the rich trappings have long since vanished.

Alma-Tadema gained certain advantages by moving to St John's Wood. In particular, his proximity to other local artists facilitated social interaction with the group known as the 'St John's Wood Clique', a congenial brotherhood of painters which lasted until the end of the century and included such popular artists as W. F. Yeames (1835-1918) and Henry S. Marks (1829-1898).

Social life was very important to Alma-Tadema. He enjoyed the company of his many friends and had an inscription placed above a door reading, 'When friends meet, hearts warm', and over his fireplace the Shakespearian lines, 'I count myself in nothing else so happy as in a soul remembering my good friends.'

At his home in St John's Wood he would entertain royally at Monday afternoon 'At Homes' and intimate Tuesday evening dinners and concerts. Tadema was a brilliant host and his parties played an important and attractive part in the social life of artistic London for nearly thirty-five years. The fame of his 'At Homes' was fostered by Alma-Tadema's hospitality, while his love of music made his unique house the setting for a series of concerts by such notable performers as Enrico Caruso and Tschaikovsky. His list of intimate friends included George Eliot, Edward and Georgina Burne-Jones, members of Queen Victoria's family, Paderewski, Sir Arthur Conan-Doyle, Winston Churchill, Robert Browning and many Royal Academicians, leading politicians, scientists, members of Society and royalty from all over the world.

Perhaps his greatest diversion apart from painting was the designing of stage scenery for Sir Henry Irving: first in 1880 for *Coriolanus* (not actually produced until 1901); then in 1896 and 1897 for Charles Kingsley's *Hypatia* and for *Cymbeline*, and in 1898 for Beerbohm Tree's *Julius Caesar*. His stage sets were designed with the same archaeological detail and accuracy as his paintings. In *Coriolanus*, for instance, Tadema used the more accurate early Etruscan architecture for settings, rather than later and more often used Roman forms. He studied the latest discoveries at Volterra, Vulci and Cerveteri, used the figure of the Etruscan chimera from the Florence Museum and also relied heavily on books, trips to Italy and visits to the British Museum.

His scenery was well received by the public, even if the plays were not. *Coriolanus*, performed at the Lyceum Theatre, had incidental music by Sir A. C. MacKenzie, was produced by Sir Henry Irving, and used sets designed by Sir Lawrence Alma-Tadema. A caustic old stage hand punned after viewing the rehearsal, 'Three blooming knights, and that's all the play will run!' Yet, so impressed was R. Phene

One of Alma-Tadema's watercolour designs for *Coriolanus* (1901), based on Etruscan models (Victoria & Albert Museum, London)

Ellen Terry as 'Imogen' in Shakespeare's *Cymbeline* (1897), wearing costume designed by Alma-Tadema (Mansell Collection, London)

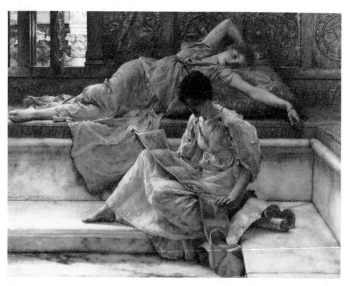

The favourite poet (Opus CCXC, 1888) The exotic costumes depicted in Alma-Tadema's paintings were copied by Liberty of London and other notable manufacturers (Lady Lever Art Gallery, Port Sunlight, Cheshire)

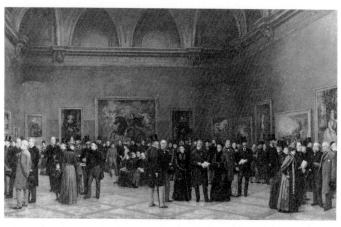

Henry Brooks' *Private View of the Old Masters Exhibition, Royal Academy, 1888,* showing Alma-Tadema in the company of William P. Frith and other contemporary artists (National Portrait Gallery, London)

Conversazione at the Royal Academy, 1891, a watercolour by G. Greville Manton, with Alma-Tadema in the centre, behind Lord Leighton (National Portrait Gallery, London)

Spiers with the scenery that he wrote an article about it, calling Alma-Tadema's work a 'virtual revelation'.

A rift occurred when Irving asked Alma-Tadema to use the work of Jean-Léon Gérôme (1824-1904) as an example. Alma-Tadema wrote in a letter to his friend, the musician George Henschel, 'I am very sorry indeed that we are not going to be associated with *Julius Caesar* at the Lyceum, I too find it incredible that a man like Irving should lack judgment in what is due an artist. He already bothered me to imitate Gérôme's pictures among my scenes *(The Death of Caesar).* As if I could be brought to copy another and make what you rightly call patchwork.'

Tadema also designed furniture and stage costumes. Usually patterned after Pompeian or Egyptian pieces, they could often be found as well in his paintings. One bench was used in several paintings and his costumes were worn by Ellen Terry as 'Imogen'.

Some of his costume designs became the rage in women's apparel. Satin dresses made by Liberty of London 'a la Tadema' were very popular and wealthy American women idled about in 'Tadema togas'. Sir Lawrence also dabbled in illustration, architecture, design and photography, considering all these interests as directly connected to the health of his painting. 'The sister arts,' he once said, 'have always appeared to me indivisible—different parts of a single whole.'

Alma-Tadema's reputation continued to grow, and new honours were showered on him. He received gold medals at the Paris Exposition for *A dedication to Bacchus* (Opus CCXCIII), the Chicago International Exposition of 1893, the Vienna Salon of 1894, the Brussels Exposition of 1898, from the Royal Institute of British Architects in 1906 and the Academy of St Luke, Rome, in 1907.

Academic honours and friendships became very important to Tadema towards the end of his life. He was seen often at many gatherings of London artists in academic circles. In the National Portrait Gallery, London, there is a painting by Henry Brooks showing a group of luminaries at Burlington House in 1889. Within the painting are the portraits of Gladstone, Leighton, Hunt and Alma-Tadema with a group of fellow Academicians. When his friend Edward Burne-Jones resigned his Associateship of the Academy in 1893, it was quite a blow to Alma-Tadema. A letter from Burne-Jones to Tadema explains the artist's viewpoint. 'You see my dear friend, I am particularly made by nature not to like Academies. I went to one when I was a little boy and I didn't like it then, and thought I was free for ever when I grew up. When suddenly one day I had to go to an Academy again— and now I've run away.'

The painter had also been a good friend of Lord Leighton who once said that Burne-Jones' surprise election to an Associateship was the brightest spot in that painter's career and his resignation the blackest. On 26 June 1896 Leighton died; his last words are said to have been: 'Give my love to the Royal Academy.' With such sentiment Alma-Tadema would undoubtedly have agreed. Like Leighton and Millais, he loved that institution, and he could never understand Burne-Jones' rejection of it.

The years of artistic production and cultivation of strategic social relationships finally came to fruition in 1899, when knighthood was bestowed upon Alma-Tadema. He was the seventh artist from the Low Countries to be so honoured, and the first for over a century. (The others were Rubens, Van Dyck, Balthasar Gerbier, Robert Peake, Peter Lely, and Godfrey Kneller.) For such an occasion a large banquet was given on the Queen's eightieth birthday on 4 November 1899, at the Whitehall Rooms in London. Poynter, President of the Royal Academy since the death of Millais (who had briefly followed Leighton in that office from June to August 1896),

was unable to preside because he was travelling in Europe. The Master of Ceremonies was therefore the sculptor Edward Onslow Ford (1852-1901), while the 160 guests included George Henschel, Sir Frank Dicksee, the Hon. John Collier, Britton Rivière, Walter Crane and George H. Boughton. Toasting Alma-Tadema, Ford said, 'Nationality in the world of art counts for very little.' Tadema replied saying that his studies in English art had resulted in a greater understanding of beauty and that he was proud to think that the English and Dutch had laboured in the same field and had had great influence on one another. He remembered how in 1870 he had sat next to Daubigny at the table of Lord Leighton and the French master had said to him that without 'Old Crome,' Turner, and Constable the modern French school of landscape painting could not have existed.

The banquet at this point became emotional, with one Academician leaving his seat to kiss Alma-Tadema's hand and being embraced in return. The whole affair was joyous almost to the point of riot. Comyns Carr, the noted art critic, poet, playwright, and editor, had composed for this occasion a doggerel entitled 'The Carmen Tademare'. Set to music by George Henschel, the chorus goes:

Who knows him well he best can tell
That a stouter friend hath no man,
Than this lusty knight who for our delight
Hath painted Greek and Roman.
Then here let every citizen
Who holds a brush or wields a pen,
Drink deep as his Zuyder Zee
Toooo Alma-Tad-
Of the Royal Acad-
Of the Royal Academeee!

In 1902 Sir John Aird invited Alma-Tadema to accompany his party, which included Winston Churchill, to the dedication of the Assiut and Aswan dams. Tadema spent the six weeks in Egypt sketching continually for various projects. Aird was anxious to possess an Egyptian picture by Alma-Tadema, so the artist gave him three choices of subject-matter. Aird selected *The finding of Moses* (Opus CCCLXXVII), and Sir Lawrence spent two years of hard work on it before 'his wife pathetically pointed out . . . that the infant Moses was two years old, and need no longer be carried!'

Tadema, who could not be counted as a particularly interesting letter-writer, surpassed himself in one letter written from Egypt in January 1903: 'Egypt is funny. The first impression of the people at least for a day or two was that I was at Beerbohm Tree's theatre, and that they were all the "supers" from one of his oriental plays, say *Herod*. It was too funny, and it was funny never to see a woman in the streets of Cairo—all men and then those magenta sunsets, so absurd. I never got accustomed to it, and the blacker the people the more black they wore. I saw on the reservoir two boats full of Soudanese (sic) all dressed in black and their faces were that black that their clothes looked grey, and they must have been blackleaded afresh that very morning. That inauguration on the 10th (January) won't be soon forgotten by me. Fancy standing in the broiling sun in a chimney-pot and black frock coat for a few hours; its enough to play the deuce with my system!' In its own way, this trip to Egypt in 1903 was as rewarding to Tadema as that momentous journey to Pompeii exactly fifty years earlier.

The finding of Moses proved to be extremely popular and in 1905 King Edward VII, who had previously visited Alma-Tadema's studio to see the picture, conferred the newly-instituted Order of Merit on the painter. This rare honour had previously been given only to two other artists, to

The Alma-Tadema Celebration on the occasion of his knighthood in 1899. The photograph of the banquet shows him rising from his chair in front of the toastmaster on the left. The menu was designed by Edwin Austin Abbey and Alfred Parsons, two fellow St John's Wood painters. The guests included almost every important late nineteenth-century artist (From: *The Magazine of Art,* January 1900)

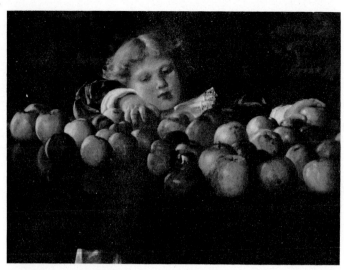

Self-help (Detail) (1885) by Laura Alma-Tadema. Although she was almost as competent a painter as her husband, Laura's choice of subjects seldom conflicted with his (Maas Gallery, London)

Portrait of myself for the R. Academia Romana di San Luca (Opus CCCCVII, 1912) Alma-Tadema's nostalgia for his youth is exemplified by this, his last portrait, in which he depicts in the background his early portrait of his mother (R. Academia Romana di San Luca)

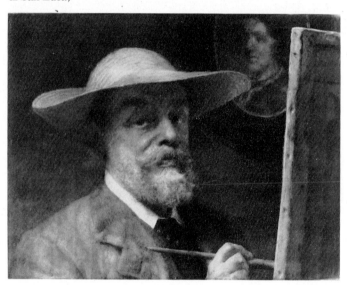

Holman Hunt on the same day, and earlier to George Frederick Watts. Diligence had paid off in full. Energetic and methodical almost to a fault, Alma-Tadema had reaped benefits in the form of honours granted by an adopted country, peculiarly impressed by such qualities.

Sir Lawrence was now almost seventy years old and still in robust health. He now spent more time with family and friends. Though from 1900 to 1912, the year of his death, he painted only 32 oils, the quality and ambitiousness of his work never flagged. Paintings such as *Among the ruins* (Opus CCCLXXII), *Silver favourites* (Opus CCCLXXIII) and *The golden hour* (Opus CCCLXXXVIII) are among the finest he ever painted. Tadema's later work also includes numerous examples of drawings of high quality. In his last twelve years drawings and watercolours make up over a third of his total work. Though his production dwindled, his hand never faltered, as an examination of his fantastically complex *Caracalla and Geta* (Opus CCCLXXXII) demonstrates. In it he portrays in detail over 2,500 people seated in the Coliseum.

When his wife died in 1909, Sir Lawrence began to feel his age. He buried her with her own family at Kensal Green Cemetery and reserved a gravestone for himself beside hers. A memorial exhibition of Laura's works was held by the Fine Art Society in 1910, which revealed to many her productiveness and accomplishment. Laura had always been an ideal mate for Lawrence, active, bright and organized. Never obtrusive, her calmness was a perfect foil for her husband's boisterousness. Her paintings had much of his sensitivity, though she seldom entered his domain of the Romans. She was content to pursue her own brand of family oriented, Dutch inspired genre scenes. Losing her was like losing the wind that filled his sail. Her driving force had kept him full and vital and moving quickly along in his art.

Tadema's health degenerated until, in 1911, he resigned from the Royal Academy Committee. His resignation read, 'There is a time to come and there is a time to go. After thirty-one years my time to go has come.' After Laura's death Tadema painted only a few outstanding pictures. *Summer offering* (Opus CCCCIII), more than any other symbolically mirrors his thoughts at this time. A brightly coloured picture, seemingly without underlying connotations, it depicts in the immediate foreground his two daughters holding luscious festoons of pink, white and yellow roses. They are so strikingly alive that it is easy to overlook another lady almost completely lost in the lower left hand corner. She holds flowers too, but hers are wilted, she does not look bright-eyed into the future; her eyes are almost closed; it is Laura and she is dead. She was gone, most of his friends were gone, and the world of art he knew was already crumbling. He began to lose interest.

He died on 28 June 1912, aged seventy-six, at the Kaiserhof Spa, Wiesbaden, Germany, where—on medical advice, but against his wishes—he had been undergoing treatment for an internal ailment. He had been accompanied there by his daughter Anna. He was buried on 5 July 1912, close by his friends Poynter, Hunt, Leighton, Millais, and Landseer in the crypt of St Paul's Cathedral in London.

He was succeeded by his two spinster daughters Laurence and Anna, then respectively 47 and 44 years old. His estate provided them with only £100 each in cash and assorted items from the house. Much of the estate, worth £58,834, went to his beloved Royal Academy which responded gratuitously by staging a large-scale memorial exhibition of 213 of his works.

Neither daughter married. As Millie Lowenstam, a friend to both said, 'Their father ran off all the boys!' It was rumoured that Laurence, the better-looking of the two women was in love with Paderewski and was to have married

him. Nobody knows why the marriage did not take place. Having become accustomed to the social life of London and high living it was not long before both daughters began to have financial problems. Laurence, an excellent writer, bought a home at Wittersham, Hastings, and Anna, the painter, rented an apartment in Paris. Laurence died in 1940, Anna in 1943.

Personality

What was Alma-Tadema really like? His friends and acquaintances had ready answers. Many, such as Julian Hawthorne, an author, provided a good picture of what 'Tad' was like: '...a rather short, broad, blond personage stood before us: a broad forehead, pale grey eyes with eyeglasses, a big humorous mouth hardly hidden by a thin, short, yellow beard. His frontface was blunt, jolly and unremarkable; but his profile was fine as an antique cameo...he was dressed in a thick velvet corduroy sack coat and trousers of the same soft brown colour, the vitality and energy of his aspect and movements and the volume of his voice were stunning...his great, delighted laugh constantly recurred, resounding through the beautiful rooms from the midst of the group that always gathered about him; he made ordinary people appear anaemic and ineffectual. Withal, he was civilised and fine to the bone, and his utmost boisterousness never struck a wrong note. He won you at first accost as a superb human creature, and by degrees you began to see his pictures in him.'

The occasion for this encounter was, of course, one of Tadema's famous 'Twosdays', so much a part of the social life of St John's Wood. His parties were command performances and generally it was his friends he commanded to perform. Once Alma-Tadema heard Henschel, the noted musician, sing a music-hall song, 'Daddy Wouldn't Buy Me a Bow-Wow!' and from then on, whenever the two friends met, much to Henschel's embarrassment, Tadema would insist upon hearing it again, and would be crying with laughter by the end of the song. Edwin Austin Abbey, an artist friend of Tadema's, once overheard Tadema organize one of his gatherings: 'You could almost hear the echo of his booming voice inviting friends to Townshend House, "And you zhall be dere, Henschel—and my dear vriend Sir Henry Thompson, doo— and ve vill all vear dogas, and haf de real Roman schtyle!!"'

Another artist friend, Frederick Yeames, describes him thus: 'A short sturdily built man with twinkling eyes, cheery smile, hair parted in the middle of a broad forehead, and small tawny beard, would hurry forward with an hospitable handshake, and bustling you into his studio to look at pictures of Greek and Roman ladies reclining on the most marvellously painted marble. Would talk in rapid unfluent English, telling stories quite outside his art, and beaming when he brought a smile to the lips of his guests.'

Not everybody appreciated his assertive personality. Couperus de Tachtiger Lodewijk van Deyssel was one guest who did not find him charming. Reflecting after visiting Tadema's studio for a soirée in 1898, '... (I am) full of praise concerning the studio, but found the master however a disappointment. I had imagined him to be more refined, but he's fairly vulgar!' However, few shared Couperus' opinion. Most thought Tadema and his house a joy to visit, especially the many Americans to whom he was one of the most famous of all British artists. As Helen Henschel, the daughter of the musician, Sir George Henschel, wrote, '... an invitation to one of the celebrated fortnightly Tuesdays was sufficient in itself to bring a Yankee across the Herring Pond!'

There was something appealing about the strange combination of successful artist, music lover, buffoon, scholar, and

ST. PAUL'S CATHEDRAL.

Burial of

THE LATE

SIR LAWRENCE ALMA-TADEMA, R.A., O.M.

Friday, July 5th, 1912, at 12 noon.

ADMIT BEARER TO SEAT UNDER DOME,
Not later than 11.45 a.m.

Enter by North or South Door. W. R. INGE, *Dean.*

Invitation to Alma-Tadema's funeral in St Paul's Cathedral, London (Birmingham University Library)

Photograph of Tadema's daughter, Laurence, by Lena Connell and *Portrait of my daughter, Anna Alma-Tadema* (Opus CCXLVIII, 1883). Both daughters were attractive and talented, but, overshadowed by their father, neither married and both died in relative obscurity and poverty (Author's collection; Royal Academy of Arts, London)

Tadema's whimsical sketches of noted artists as viewed at a Royal Academy Council meeting (From: *Century Magazine*, February 1894)

'Ape' caricature of Alma-Tadema, 1879, for *Vanity Fair*. Himself a devotee of comic drawings, Tadema and his work were frequently the subjects of cartoonists' art (Russell Ash)

graciously rich host that affected all around him. On his sixty-third birthday he danced a gavotte with Lord Yarmouth. Elsewhere it is mentioned that he took part in the festivities of the Institute of Water-Colour Painters as a classic reveller crowned with a wreath of bluebells. For all the quiet charm and learning of his paintings, he still preserved a youthful sense of mischief.

He always celebrated his birthday with a cake and candles and made his male guests wear laurel wreaths. Simple-hearted, Alma-Tadema also loved mechanical toys which Helen Henschel wrote might be called '...Hobble-de-hoyish: he rejoiced in toys of every description and kept a huge collection of them in cupboards in the billiard room. Many a time have I seen him sitting on the floor, surrounded by roaring lions, comic monkeys, all sorts of creatures, biologically recognisable or otherwise, showing them off to some new friend with great roars of laughter. How he would have adored Donald Duck!'

He had a weakness for atrocious puns and jokes. In one of his letters to George Henschel, he wrote, 'Why is Lloyd George like Holland?...because he lies low and is damp all around!' The artist, Sir Luke Fildes' son Val, agreed that Tadema's humour was sincere and juvenile. During the Boer War, when Paul Kruger's army under General Christian de Wet, was losing ground, he asked him '...my dear Wowl (Val), vy does Kruger vear galoshes? I see you do not know! I vill tell you. Kruger vears galoshes to keep de vet from de feet!' Yeames found himself playing 'stooge' to Tadema's comic on many occasions. 'He would turn suddenly upon me, and ask in a sorrowful voice if I had heard about the poor tramp who had caught such a shocking cold from sleeping in a draught in a field with the gate open, or (it was about the time motorcars were first coming into use) of the skunk and the weasel who were walking along a country road when an automobile dashed past. The skunk burst into tears, and the weasel accused him of fear. "No, No," replied the skunk, "It was my dear dead grandmother, the smell of that machine brought her back to mind!"'

Mrs Audrey Rose-Innes, as a child often a guest at the Casa Tadema, would continually be asked if she knew the name of the large brass bell in the shape of a woman with billowing skirt by the outer gateway. Each time the little girl would tactfully say no, then Tadema would gleefully exclaim, 'Isabel!', then pointing up the covered way through the garden to the front door ask the name of it; the answer was always, 'Isidore!', and Tadema would laugh uncontrollably.

Never having mastered the English language or comical sense, Alma-Tadema apparently took delight in the most absurd schoolboy riddles, puzzles, and stories. One of his favourite puzzles was one called 'My Wife—and My Mother-in-Law'. After careful examination both ladies could be seen in the drawing. He also once made a drawing of a Mr Cowen, who is depicted in a profile made from the script of his name. Tadema fancied himself as a raconteur and inveterate story-teller, but would frequently distort the stories he had heard. He would not grasp the gist of the story or would bring out the punchline in the wrong place, expecting everyone to shriek with laughter. 'But his gargantuan enjoyment and explosions of mirth', wrote Helen Henschel, 'were so infectious that one couldn't feel irritated for long.' Arthur J. Balfour was the 'victim' of such a barrage of jokes, when he sat for his portrait in 1891. A friend, Angela Thirkell, described how she had just met Tadema, who had addressed her in an excited and unintelligible garble. She dutifully burst out laughing at what she thought to be another one of his absurd puns. Aghast, Tadema asked, 'What for you laugh when I tell you that Alfred Parsons' mother is dead?'

His strong Friesian accent often rendered his story-line incomprehensible. He might have served as the model for the limerick:

There was an old painter of Ghent,
Who talked and joked as he went,
So loud and so much,
And moreover in Dutch
That no-one could tell what he meant!

Yet Tadema was no fool; he had the often useful ability to remove himself from his profession, and lose himself among friends. His motto—inscribed in his house—was, 'When friends meet, hearts warm', and it was an article of faith by which Tadema lived. His working method was so demanding and tedious that frequent periods of 'letting go' insured his mental and physical stability. But what was he like away from friends, and what was he like to work with? 'Horrible', said Millie Lowenstam, daughter of Sir Lawrence's etcher Leopold Lowenstam. 'He was too much of a perfectionist, and always demanded extra work of Father. He was hot tempered and could become excessively angry if details didn't run smoothly.' A prolific letter writer, Tadema kept in constant touch with Lowenstam, continually shepherding each etching to completion. A harsh taskmaster, Tadema demanded those in his employ to meet the same stringent standards he set for himself. The Lowenstam family have preserved many letters from Tadema; one serves as an example:

'April 6th, 1889

Dear Lowenstam,
When yesterday morning I received a letter from Lefevre telling me that the etching was finished save a few touches after my remarks, I telegraphed to Lefevre in answer to his letter, to come and talk the matter over with me. I cannot feel completely satisfied with the progress of the plate as submitted to me in the last proof and as I wanted to dispel the idea from Lefevre's mind that he could publish and promise the plate shortly...I asked him to speak to you, and to request you the favour of a call if possible at 7 p.m. yesterday. You arrived at lunch time, and being at the time unusually preoccupied with my own work, I preferred not to see you and discuss your work which upset me too much, and I trust you will understand and accept this apology.

It is not clear to me why you complain of labouring under difficulties, in line of a touched up photo. I told you at the time I believe it the better way to leave a photo, which is unusually good in tone and modelling and to give you a good careful drawing of the picture. This drawing in many cases is an outline only, in others it is carried much further, in the left hand of the reading girl for instance. Had you followed my drawing as I repeatedly insisted upon, you'd finish, the plate must have [undecipherable]...and hair like horsehair out of an old sofa...you persist to leave out the hand of the fair girl...you will not look carefully at my drawing, you pay no attention to the modelling in the photo, you accept very little of my comments...you reproach me for having failed in keeping my promise, you are childish and infatuated with your work as to tell to me that under the circumstances you doubt very much whether any etcher could do better.

I am sorry to have to write, Lowen, that I decline to sign such work as it stands, and I trust that our meeting tomorrow at 12 Noon will make you feel that it will be a good thing if you took the plates up again and worked at it with all the might and wish to make it as well as you can.

Yours sincerely,
Alma-Tadema'

Strigils and sponges (Opus CXCVII, 1879) Tadema's watercolour and his profuse comments on a proof engraving of it illustrate his obsessive concern for accurate reproduction of his work (British Museum)

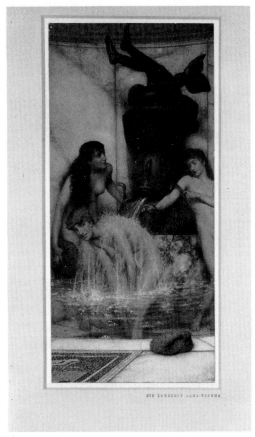

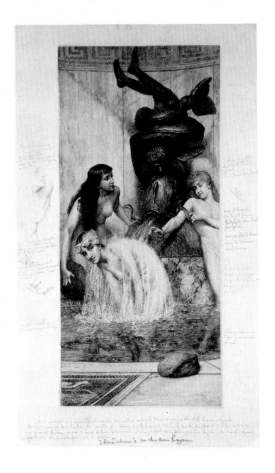

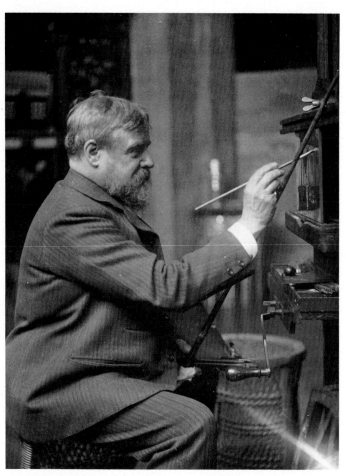

Alma-Tadema in later life. By the turn of the century he was regarded as one of Britain's greatest painters and a prominent figure in the artistic establishment (Radio Times Hulton Picture Library, London)

Tadema tolerated no errors when it came to his profession. The artist's daughters told P.C. Standing that Alma-Tadema was a man who washed his own brushes and would not let them tidy up his studio. 'His library is catalogued and classified by himself, and all correspondence is conducted by him unaided. Woe betide the unwary visitor who calls in the morning hours whilst Alma-Tadema is working. Every hour of the precious daylight is dedicated to his calling when he is at work upon a picture.' However, Frederick Dolman, interviewing Tadema for *Strand Magazine*, elicited these remarks:

'Yes, but I cannot claim to work with regularity of some artists. I never know how much or how little I am going to do. For days I make no progress with a picture . . . There is so much painting out. Leighton . . . able to apportion every part of his day to its allotted task . . . two hours to the model, two hours to the sitter, so much more to the study and so on . . .'

If it seemed that he was a slave driver with others, it was only a reflection of the way he drove himself. Late in life his doctors were constantly imploring him to slow down to at least a 'run'. He had to have things perfect, but usually perfection is elusive. Tadema constantly strove too hard to make his conception a reality. Each painting fell short of his original goal. He would often say, 'Every picture is a subject thrown away', presumably meaning that the final picture never quite fulfilled the promise that the subject offered. He would continually rework passages in his paintings to satisfy his high standards. One visitor to his studio records in an 1880 *Magazine of Art*, 'I have seen Mr Alma-Tadema painting out a thousand pounds!' He was surprised to see him destroy what seemed like saleable stock simply because it didn't meet his demanding specifications.

This is not to deny that Alma-Tadema was a good businessman, for most certainly he was. In fact he was probably one of the richest artists of the nineteenth century. As firm in money matters as he was with the quality of the work of his employees and himself, little slipped through his fingers. Though lavish in his spending on his home, travel and entertainment, he scrupulously counted the costs and the benefits that might accrue from these expenditures. He carefully supervised the ownership of copyright to his paintings, and never allowed anybody to make money from his work unless he was also to benefit. Once his *A harvest festival* (Opus CCXX) was going to be engraved independently by Leopold Lowenstam for another party. When Tadema learned of the situation he immediately wrote and demanded a payment of £25.

He took up portraiture because it was a good money making proposition. He often did portraits of his friends as gifts, such as *Portrait of Ilona Eibenschautz* (Opus CCCXCVI) which was given as a wedding gift, but actually in payment for the many 'command' piano performances the subject gave under the silver dome. His *Portrait of the singer* (Opus CCII) was 'given' to George Henschel for similar reasons. But to others he charged enormous prices. At his peak in the 1880s, Tadema quoted prices to Henschel for a portrait for a friend: '£600 for a portrait like yours, £800 full length', and a finished portrait represented only a few days' work.

His gifts were more like loans, for he always considered them his own. He had a strong strain of possessiveness in him. Sir Laurence Collier, son of Tadema's pupil, the Hon. John Collier, points this out saying that if Tadema gave anything away as a present he still seemed to regard it as in some way his own property: '. . . and when he found, after his wife's death, that she had left to her step-daughter Anna the old Dutch furniture which he had given her for her studio, he was quite annoyed.' Tadema expected to get it all back as a

matter of course. He could be and often was very generous, but at the same time he seemed to exemplify the truth of the couplet:

> In making a bargain the fault of the Dutch
> Lies in giving too little and asking too much!

His bargains were in most cases very profitable for himself, but once the bargain was made, he kept it and always returned to the client his very best effort. Later in life he was often paid in advance for his pictures, sometimes before they were even begun.

At home Sir Lawrence behaved like a patriarch. His presence dominated every facet of life at 'number 17 Grove End Road'. Kind to his wife and children, he was in most ways a loving father, and his wife and daughters clearly loved him. They affectionately called him 'Père', and were among his greatest admirers. Though he was a strict husband and father, he gave every opportunity for his family to develop educationally and culturally. Trips to the Continent were frequent, while music, dancing, acting, writing and language lessons were commonplace in the Tadema household.

Though his mother was a Dutch Baptist and he was on the rolls of the Dutch Reformed Church of the Austin Friars in London, he was in no way religious. He is described in one book as being an atheist, though agnostic would probably suit his position better. Tadema simply could not abide the Calvinistic concept of the depravity of man. A man open to new ideas, he nevertheless rejected the sectarian Protestantism of his day and sought for God more abstractly. Lacking a spiritual perspective in life, Tadema sought to make up for it with family, friends, and his art.

Seemingly, his only observable vices were his indulgence in smoking cigars, and 'taking a little merriment among friends'—he drank port. Later critics have tried to delve deeper into his private mind. One recent writer refers to Alma-Tadema's fondness for 'Sappho', and langorous women in states of repressed emotions, and sees it as a reflection upon the artist's character. The presence in his portfolios of a number of photographs of nude boys amid Roman ruins has been seen as evidence of his sexual proclivities. Such photographs, however, many of which were taken by Baron von Gloeden for avowedly prurient reasons, were collected by many late nineteenth- and early twentieth-century artists as reference pictures. Like Alma-Tadema's, they were more often found among their antiquarian reference material rather than in the secret drawers of bureaux. Other accusations levelled against Tadema—that his sense of the ethereal was a by-product of drug-taking, and that he had a sideline in producing pornographic sketches for such eminent connoisseurs as the Prince of Wales—remain unproven. He remains in all respects, in his professional life, a diligent, if somewhat obsessive and pedantic worker, and in his personal life, an extrovert and remarkably warm personality.

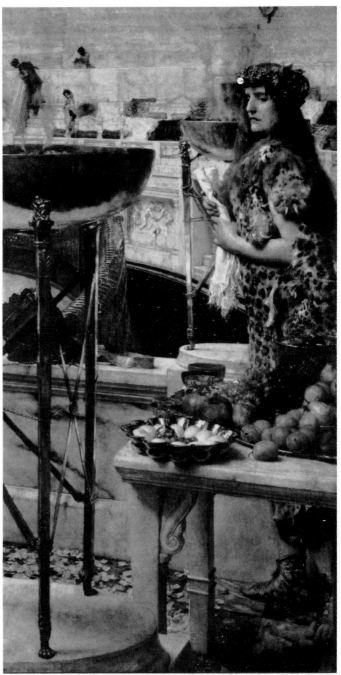

Preparations: In the Coliseum (Opus CCCCVIII, 1912)
Alma-Tadema's last painting (Photo: Sotheby's Belgravia, London)

CHAPTER II
THE AESTHETIC BASIS

Influences

Influences on the aesthetic sensibility of Tadema began to be felt early in his life: when he heard the music of Jacques Vredeman, saw the paintings of the portraitist, Willem Bartel Van der Kooy, or copied the ancient Roman coins that occasionally turned up in a farmer's fields. Another of the continuing influences on Alma-Tadema was that of books and his interest in this direction also developed early.

Books inspired his curiosity for bygone peoples and the meaning of art. As a young boy he had purchased Leonardo da Vinci's *Treatise* as well as a Dutch translation of a seventeenth-century book on perspective. From these books it might be assumed that the foundation of his unerring sense of perspective was obtained. Later, in Antwerp, he was introduced to legends through the stories of the brothers Grimm and *The Nibelungen*. His knowledge of the classics was strengthened by the texts which were read and sketched from in his Greek and Latin classes. Cicero's letters to Atticus and the plays of Terence and Plautus all contributed to his general scholarship. Louis de Taye presented him with Gregory of Tours' *History of the Franks* and Augustin Thierry's *History of the Merovingians*. Each of these books contributed in its own way to certain themes which emerged in his later work.

There is one particular book on which Tadema was perhaps unjustly accused of relying. Smith's *Dictionary of Antiquity* was a handbook used by many classical artists for its references to the Greeks and Romans. Ruskin's criticism was particularly vituperative: 'The actual facts which Shakespeare knew about Rome were in number and accuracy compared to those which Mr Alma-Tadema knows, as the pictures of a child's first storybook compared to Smith's *Dictionary of Antiquity*. But when Shakespeare wrote:
 The noble sister of Publicola,
 The moon of Rome; chaste as the icicle
 That's curded by the frost from purest snow,
 And hangs on Dian's temple:
he knew Rome herself to the heart; and Mr Alma-Tadema after reading his Smith's *Dictionary* through from A to Z knows nothing of her but her shadow.'

It was not in fact Smith's *Dictionary* that was the mainstay of Alma-Tadema's work, but the 168 volumes of photographs he owned, sketches he had drawn and engravings he had collected which record the architecture in Pompeii and Rome. The camera had great influence on the detail which Tadema gave to his canvas. He was also actively interested in the work of Eadweard Muybridge, the photographer of animal locomotion, and eagerly recommended him to lecture at the Royal Academy when he was in London in 1889. 'Photography', he remarked, 'is a great boon undoubtedly to the artist today who has any concern for accuracy of details.' And for Alma-Tadema accuracy was an obsession. It was not

unusual to find a stack of sketches and photographs beside his easel, for almost all his paintings contained architecture or accessories which owed their effect to archaeological exactness.

An important influence on Alma-Tadema was that of the scholars and artists with whom he had been associated. The earliest artistic influence on him had been that of his older brother's drawing master, who had been taught by Willem Bartel Van der Kooy, one of the few painters of note other than Tadema to have come from Friesland. Tadema began by sketching this older painter's work.

In Antwerp, Wappers, Nicaise de Keyser and J. Dyckmans led Alma-Tadema towards a romantic but academic view of art. Henrick Leys' technique and unsentimental attitude increased Alma-Tadema's objectivity and attention to minutiae. By 1863 he had received excellent schooling within the *juste milieu* context. His desire for archaeological exploration was greatly encouraged by two scholars, Louis de Taye of the Antwerp Academy and Georg Moritz Ebers, the professor of Leipzig after whom the 'Papyrus Ebers' was named. De Taye encouraged Tadema into the historical painting of the Franks and the Merovingians, while Ebers interested him in the life of ancient Egypt. Both were greatly responsible for giving his work an archaeological character.

After his first trip to Italy in 1863, Alma-Tadema's world expanded rapidly, for he had the opportunity to view the work of many artists with somewhat similar goals. In 1864 he met Gérôme, who shared his excitement in the artefacts in the Naples Museum. This must have encouraged the younger painter, for in the next year he produced one of his first Roman pictures, *Gallo-Roman women* (Opus XXIV).

Sir Lawrence was also very much influenced by the 'Old Masters', whose work he studied assiduously all his life. Tadema's paint surfaces have been compared with those of Vermeer. Their surface quality and richness are comparable, yet this must have been a late influence, for Vermeer really only came to the public's attention after Alma-Tadema's technique was rather fully developed. Vermeer's tonal quality is rather cool, where, on the other hand, Giorgione and the Venetian school in general influenced Tadema towards a deep, rich, and warm tonal colour scheme. Such works as *Catullus at Lesbia's* (Opus XXVII) and *The discourse* (Opus XXVIII) illustrate the quality of his colour, which continued through to the 1880s.

Stronger by far was the continuing influence of Alma-Tadema's peers. His friends from the Academy both in England and on the Continent had influenced his work from the early 1860s. Comfortable with the styles of the Neo-Grecs in Paris and Italy, Tadema was renewed with every trip to the Continent. In England his own close friends were a source of encouragement: Luke Fildes, Edwin A. Abbey, John Singer Sargent, Val Princep and Andrew Gow, although

Pages from Alma-Tadema's sketchbooks (Birmingham University Library)

The discourse (Opus XXVIII, 1865) An example of the rich tones employed by Tadema during his 'Pompeian period' (1865-70) (Private collection, England)

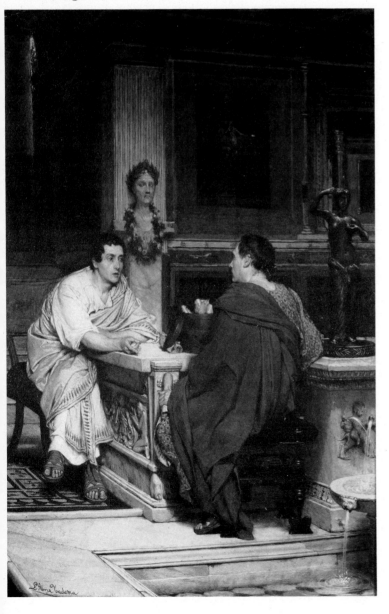

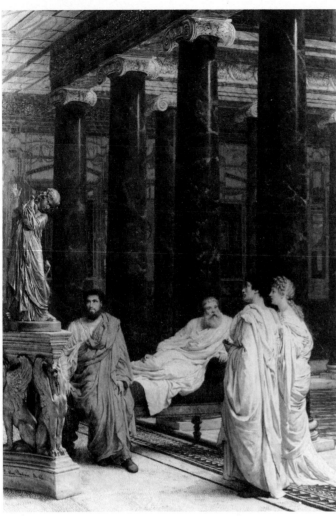

*A Roman art lover (silver statue) (*Opus LXV, 1868) One of many paintings in which the architectural detail is a major feature. This was one of the first two pictures he exhibited at the Royal Academy in 1869 (Glasgow Art Gallery)

a divided group stylistically, were good friends and gave their support to Tadema's artistic efforts.

Travel played an important part in Alma-Tadema's artistic development. His trip to Italy in 1863 was the most influential; the 1864 trip to Paris and his winning of a gold medal was almost as important. He made many visits to Italy and usually wintered at the Bay of Naples, not far from his beloved Pompeii. Pompeii, more than any other single place, influenced Alma-Tadema, especially in his Continental period. Excursions to historical sites in Italy also channelled Alma-Tadema's mind towards architectural rendering and the distinctive light and colour for which he is known. Immediately after these trips, beginning in 1863 and extending to the last years of his life, Tadema felt impelled to work in his architectural fashion. The 1863 trip initiated a classical period known as his 'Pompeian period' (1865-1870) with works such as *Home from market* (Opus XXXI).

His settling in London had other effects. His pupil, John Collier, considered some of them. 'His quite early work is hard, the details are admirable, but the people are often commonplace and the colouring is not always pleasant. It was after he came to England that his feelings for human beauty seems to have developed. The types grow more and more pleasing, but in his later years they sometimes degenerate into mere prettiness. Indeed this is the only sign of failing that appears in his art.' This is exemplified in the changes that occurred after his move to England, when his architectural references became more generalised. Instead of whole buildings designed in perspective, Alma-Tadema now constructed simpler, more abstract architectural elements such as exedrae, plain marble walls, and segments of balustrades. With this in mind we can compare a work such as *A Roman art lover (silver statue)* (Opus LXV), which was finished before his move to England and filled with exacting and specific architectural passages, with *On the steps of the Capitol* (Opus CXXXII), a picture devoid of any but the simplest architectural detail, although such paintings as *The Coliseum* (Opus CCCXXXVI) and *The Baths of Caracalla* (Opus CCCLVI) are notable exceptions. His surfaces of marble also became richer and more lustrous. Vast expanses of Mediterranean sea are seen from the heights of Capri or Ischia. This content was expressed in such paintings as *A coign of vantage* (Opus CCCXXXIII), where three Roman maidens view the arrival of the Roman fleet from a high vantage point overlooking the Mediterranean, and *Silver favourites* (Opus CCCLXXIII), which also depicts three Roman women on a marble exedra feeding fish, with a view of the sapphire Mediterranean below. In these and other similar paintings the artist combined human interest, a dramatic perspective, and a spectacular panorama of the sea. His older Pompeian style with its deep red and black interiors and columns of lapis, prophyry and verd-antique give way to a more brilliant, delicate, and simple style. Comparisons between two paintings illustrate this phenomenon in Tadema's work: *Tibullus at Delia's* (Opus XXXVIII) and *Expectations* (Opus CCLXVI). *Tibullus at Delia's* is rich with dark contrasts, objects and colours, while *Expectations* is higher in colour value and uses a more refined and brilliant mode of presentation.

Yet, though travels were important to Alma-Tadema's development he is known at least once in 1860 to have refused an offer from a friend of his mother of a sum of money which would have enabled him to go on a long course of travel. 'I declined the kind offer. It seemed to me', he said, 'that a young artist whose style and individuality had yet to be formed was more likely to be harmed than benefitted by going to Venice, say, and studying Titian, to Rome and studying Michelangelo, to Spain and immersing himself in Velasquez.' When he did visit Italy he had already achieved

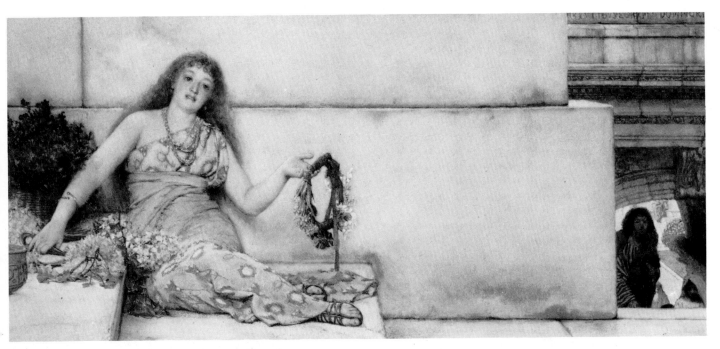

On the steps of the Capitol (Opus CXXXII, 1874) Here the architectural element is of the simplest kind, but vital to the composition (Private collection, England)

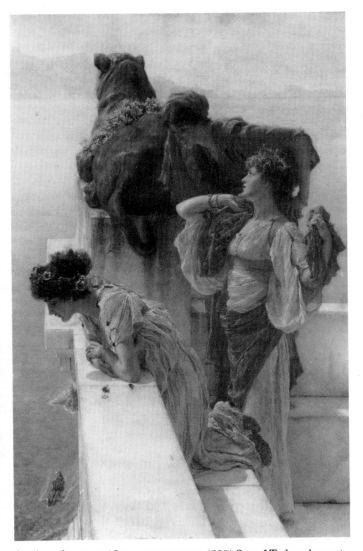

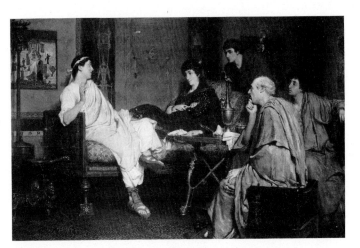

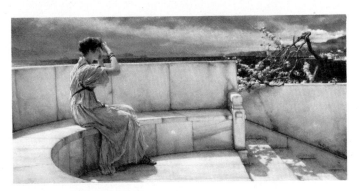

Tibullus at Delia's (Opus XXXVIII, 1866) and *Expectations* (Opus CCLXVI, 1885) illustrate Tadema's move from sombre Pompeian interiors into outdoor scenes so brilliant that shielding the eyes seems the most natural response (Boston Museum of Fine Arts; Private collection, Japan)

A coign of vantage (Opus CCCXXXIII, 1895) One of Tadema's most famous works, it is typical of many in which dazzling white marble and a deep blue Mediterranean are contrasted, here with the addition of remarkable perspective (J. M. S. Scott Esq, London)

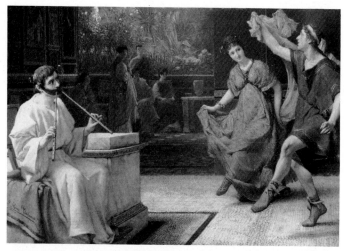

Roman dance (Opus XXXIX, 1866) An example of Tadema's placing
of subjects at the edges of his paintings (J. Mason Esq, England)

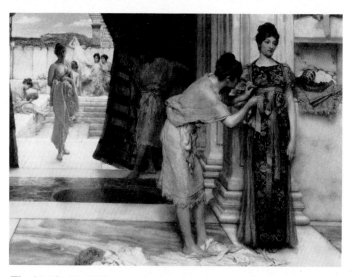

The frigidarium (Opus CCCII, 1890) A more traditional composition,
but one regarded by a contemporary critic in *The Athenaeum* as
'exceptionally complex, difficult and successful' (J. B. Panchard,
Vaud)

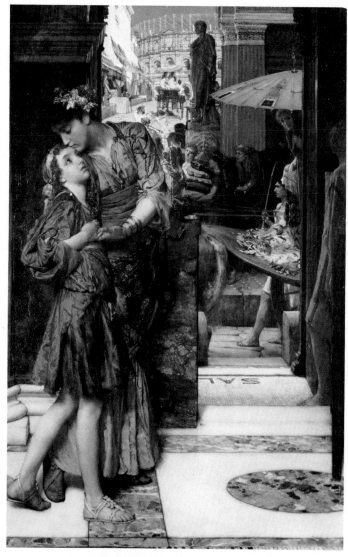

The parting kiss (Opus CCXL, 1882) One of many of Tadema's
paintings in which the viewer is invited to glimpse through a
doorway to a second set of images beyond. (Private collection,
Japan)

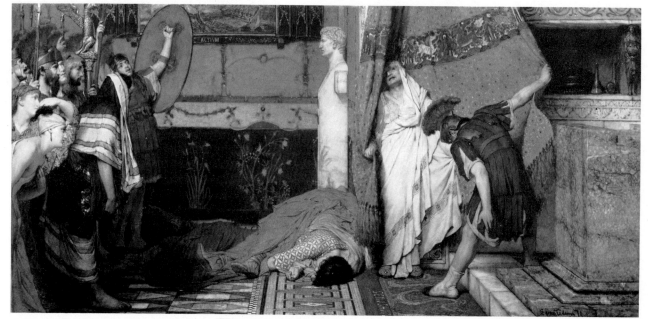

A Roman Emperor (Opus LXXXVIII, 1871) One of several paintings
the almost photographic detail of which have resulted in Tadema
being regarded by some critics as a fringe Pre-Raphaelite (Walters
Art Gallery, Baltimore, Maryland)

some measure of success and could then approach the 'Old Masters' as student rather than disciple. 'To study according to the model of others and copy is the death of art', said Tadema. 'One acquires only the methods and the fads, nine times out of ten the apprentice acquires none of the good qualities of his model, but only his faults.'

Beyond the influences of artists, books, and travels lay the complex skein of the nineteenth century, a vivid rich tapestry of styles and ideas. Stylistic pluralism often resulted in contradictory conceptions existing side by side. Terms like Victorian, Wilhelmine, Grunderzeit, Second Empire, and Fin-de-Siècle do not nearly describe the complexity of even the most general of styles. The great battle of the nineteenth century was no longer Classicism versus Romanticism, as it had been. It was now a battle between the avant-garde innovators and the recalcitrant academicians. Unlike Ruskin, Tadema saw no division between the Classicists and the Romantics, 'on the contrary', as Amaya comments, 'he attempted to unit the two in a marriage of style and content.' It has been said, in fact, that he painted classical subject-matter in a gothic manner not unlike the Pre-Raphaelites. In 1892, Henry Quilter, the author of *Preferences in Art and Literature*, described a French view of such a compromise: 'No French artist would care very greatly for his work if only for its gothic character, its stolidity would offend a Gaul as much as it would delight us Anglo-Saxons.' The amalgamation was amply demonstrated at the Grosvenor Gallery exhibition of 1882 and the 1913 Winter Exhibition at the Royal Academy. With 287 works in the 1882-3 Exhibition and 213 works in the 1913 show, Tadema displayed his synthesis of classical and romantic forces. Compositionally he would often place figures about the periphery rather than at the centre of his pictures, as in *A Roman dance* (Opus XXXIX), allow sharp angles to cut his paintings diagonally, as in *A coign of vantage* (Opus CCCXXXIII), disperse objects and figures in a cluttered unconcentrated fashion, as in *The roses of Heliogabalus* (Opus CCLXXXIII) and permit the surface plane to be broken by deeply set vanishing points, creating what might be called in Tadema's work 'glimpses' into distant views, as in *The parting kiss* (Opus CCXL). On the other hand, Alma-Tadema usually painted his figures with classical reserve, such as in *The frigidarium* (Opus CCCII), utilized classical subject-matter, and approached his work with a studied concern for realism, exemplified by *An audience* (Opus CCXXVI). The synthesis referred to came naturally to Alma-Tadema and it would be a mistake to make too great a point of the distinction between his classical content and romantic style.

In matters of spatial composition, technique, and other formal values, Alma-Tadema was somewhat avant-garde; otherwise he was thoroughly a traditionalist. The chief stylistic movements that Alma-Tadema faced were French Impressionism and Italian Macchiaoli group of painters. The second movement, in many ways, was a distant cousin to the English Pre-Raphaelites in that both employed vivid, bright, detailed pictures, notable for certain archaisms in the figures. Alma-Tadema adopted some of these mannerisms during his first trip to Italy. His *The armourers' shop in Ancient Rome* (Opus XLI) is vivid in colour and detail and is slightly archaic in its manipulation of the figures.

Though in no way connected with the Pre-Raphaelite Brotherhood, Alma-Tadema was often accused of 'Pre-Raphaelite tendencies'. This was true especially after he had settled in London and exhibited *A Roman Emperor* (Opus LXXXVIII). In this painting, his consummate labour on botanical as well as architectural detail connected his work in a distant way with the Ruskin 'birdnest' school, so-called after the faddish attention to detail of its exponents, but if

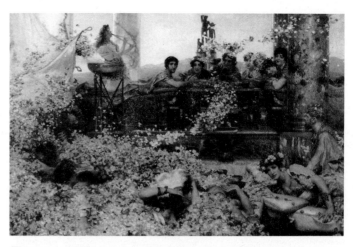

The roses of Heliogabalus (Opus CCLXXXIII, 1888), in which the subjects are scattered without apparent regard for formal composition (Private collection, France)

An audience (Opus CCXXVI, 1881) Although he was sometimes accused of painting lifeless subjects, Tadema's figures were often captured with the frozen realism of a snapshot (Walters Art Gallery, Baltimore, Maryland)

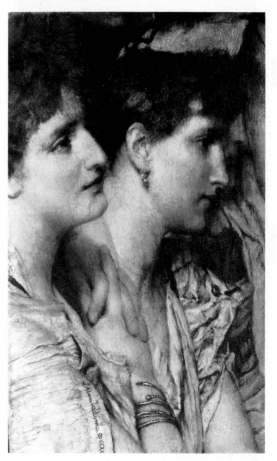

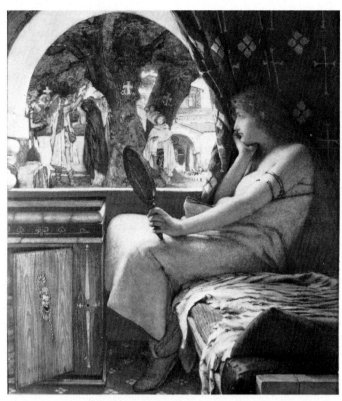

The tragedy of an honest wife (Detail) (Opus CXLVII, 1875)
Based on a subject from the work of Gregory of Tours, the medieval
content and style suggest affinities with the Pre-Raphaelites, but
their artistic aims and those of Tadema were worlds apart
(Fogg Art Museum, Boston)

James McNeill Whistler's *Rose and silver: The Princess from the
Land of Porcelain* (1864), a Japanese-inspired work containing
obvious parallels with Tadema's *Portrait of Laura Theresa Epps*
(Opus XCIII, 1871) (Courtesy of the Smithsonian Institution, Freer
Gallery of Art, Washington, D.C.; Mesdag Museum, The Hague)

Alma-Tadema had painted with a duller palette, no one would
have suggested any connection. Beyond superficial likenesses
a great gulf separated the Pre-Raphaelites from Alma-
Tadema. Although Medieval in theme, a painting such as *The
tragedy of an honest wife* (Opus CXLVII) is a work that
hardly relates even to Holman Hunt's highly detailed early
pictures in any but superficial ways. Whereas Hunt's work is
symbolic and moralistic, that of Tadema is narrative and
melodramatic.

To a greater degree he is related more closely to the
aesthetic cult of 'Art for Art's Sake'. Like others involved,
Tadema was concerned with the apprehension of truth and
beauty through design and formal values, but unlike the
aesthetes, he associated the idea of beauty with an ideal and
moral purpose. To men such as Walter Pater, Oscar Wilde,
James Whistler, and Aubrey Beardsley, such associations
were unthinkable. Even though Wilfred Meynell in 1879
insisted that Alma-Tadema professed '. . . the doctrine of art
for art's sake' and 'made pictures for the eye alone', an
analysis of Tadema's own words and works convinces one
that he was a true Academician, and therefore was full of
idealist theory and moralistic rhetoric. Yet in Pater's early
work, *Studies in the History of the Renaissance* (1873), moral
purposes are shunted aside by the doctrine of 'Art for Art's
Sake.'

Pater's new aesthetic emphasised exquisite, individual
and momentary experience sensed through form and plastic
values. Severing art from its tradition of propagandistic
purposes, Pater concluded that what man desired most was a
'quickened sense of life' and that art was the chief means of
achieving it. He and others of his school felt that art comes
'proposing frankly to give nothing but the highest quality of
your moments as they pass, and simply for those moments'
sake'. This transience stands in opposition to Tadema's
frozen still-life. Though both writer and artist sought
aesthetic beauty in form, Tadema found it in actual objects
whilst the artists of the aesthetic movement sought it more
abstractly. However, in the Grosvenor Gallery Exhibition of
1882, in the words of Amaya, 'he had successfully straddled
the critical fence by proving he was not only a painter for the
Establishment, but one for the Aesthetes and the Pre-
Raphaelite avant garde as well.'

Another less often noted influence was that of Japanese
art: 'He is ready to recognise beauty wherever he meets it
and with his marked appreciation of what is peculiar, even
finds great pleasure in the paintings of the Japanese and has
used numerous Japanese subjects in the decoration of the
artistic interior of his house in London.' In his paintings,
certain colour schemes and designs may owe more to Japanese
prints than they do to, say, the Pre-Raphaelites, the *Portrait
of Laura Theresa Epps* (1871) and *Portrait of Tine Son-Maris*
(Opus CCCLI) demonstrating an almost Whistlerian reliance
on Japanese forms and colours.

In both of these pictures, separated by nearly three
decades, the use Tadema made of Japanese and Whistlerian
design and motif can be seen. In the earlier *Portrait of Laura
Theresa Epps*, the model poses in a long flowing gown of light
beige, holding a fan and a photograph of a Japanese print.
In his later painting of Tine Son-Maris we again see the
Japanese fan and there is also a Japanese screen in the back-
ground; this time Tadema catches the tonal feeling of Whistler
while keeping both his own bright oriental colours, and free
handling of paint. This quality is also conveyed in the earlier
picture, but only by virtue of its unfinished state. Once
Whistler himself referred to Tadema's work as 'symphonies
and harmonies.'

Another tendency learned from the Japanese was to
'dismember' his figures. This was, as Helen Zimmern states,

'not certainly to the detriment of a realistic effect, but most certainly to the detriment of composition as classically understood.' In what might otherwise be termed a classical composition, his *Roman art lover (the runner)* (Opus LXXIX), displays such tendencies with its decapitation of a group of connoisseurs to the left side of the picture. Zimmern concludes, 'This tendency no doubt results from his love of Japanese art, an art that has had a visible influence upon his methods of disposing his composition.'

Alma-Tadema's relationship to 'modernist' influences seems a tenuous one. His paintings *Landscape near Munster* (Opus CXXXV), *Haystacks* (Opus CLVI) and *94 degrees in the shade* (Opus CLXIV) are superficially Impressionistic. Yet in their sketchy brushwork these are exceptions to most of his work. Both he and the Impressionist painters certainly approached light in an investigative manner and attempted to capture the effect of sunlight, but that is the extent of the similarity.

His early works display grey and often gloomy light, but after his Italian trips he gradually acquired a celebrated mastery of direct and unobstructed sunshine. Gosse correctly analyzed Tadema's light: 'No mist of vapour reduces the intensity and rectilinear shadow which his walls and trees throw from the sun and we cannot at this moment recollect a single example of his art in which the weather is not brilliant enough to suit the constitution of a lizard.'

The general direction of modern art during the period was toward the breaking down of absolutes in art, tenets long held by the Academy. By 1912, Alma-Tadema had seen the rise of Impressionism, Post-Impressionism, Fauvism, Cubism and Futurism, of all of which he heartily disapproved. As his pupil, the Hon. John Collier, wrote, 'If there are any principles in it [modern art] at all it is impossible to reconcile the art of Tadema with that of Matisse, Gauguin, and Picasso.' One modern critic has dubbed him 'The Norman Rockwell of the Pagans'.

Tadema's influence on other painters was not great, for he took few pupils, and has never been regarded as an innovator. His greatest contribution to twentieth-century art may have been less to painting than to the film. Although his pictures were small, 'the minutiae of detail', as Romijn points out, 'exaggerate the actual size of the picture space.' In 1968 Mario Amaya published an article in *The Sunday Times* entitled, 'The Painter Who Inspired Hollywood', arguing that, 'his emphasis on personal drama, his wide-angle perspective, and the huge scale of his works set the scene for the epic film industry.' Certainly the great spectacles of Cecil B. De Mille and D.W. Griffith, such as *Ben Hur* and *Intolerance,* owe much to the panoramic, photographic and archeological vision of Alma-Tadema. It is known that certain scenes in De Mille's *Cleopatra* (1934) and *The Ten Commandments* (1956) were derived from such paintings as *Spring* and *The finding of Moses,* prints of which were consulted by De Mille's script writers and designers.

Vision

'Now if you want to know what those Greeks and Romans looked like, whom you make your masters in language and thought, come to me. For I can show not only what I think, but what I know.'

This quote from Alma-Tadema is substantiated by almost three hundred paintings from antiquity that are marvels of knowledgeable archaeology and draughtsmanship. His curiosity about the Ancients was insatiable and the knowledge he acquired was soon converted into paintings.

To Tadema the difference between the Ancients and the Moderns was minimal. 'I have always endeavoured to express in my pictures', he said to Dolman in an interview, 'that the

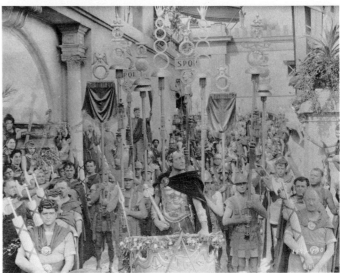

Stills from *Intolerance* (1916) and *Cleopatra* (Paramount, 1934) show the influence of Tadema's panoramic reconstructions of the Ancient world (National Film Archive, London)

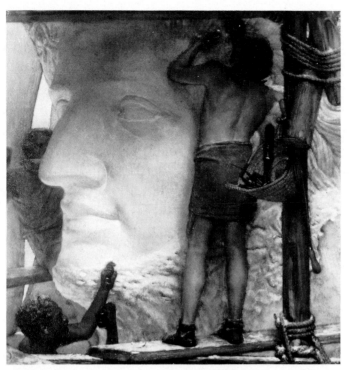

Sculptors (Opus CLXXX, 1877) An evocation of Tadema's respect for the engineering and artistic achievements of the Egyptians, Greeks and Romans (Mr George Wildenstein, New York)

The convalescent (Opus LXXI, 1869) A typical example of Tadema's attempt to re-create, on canvas, the everyday life of Ancient Rome. The surroundings are archaeologically accurate, but the characters are clearly 'Victorians in togas'—in this picture, probably members of his own family (Location unknown)

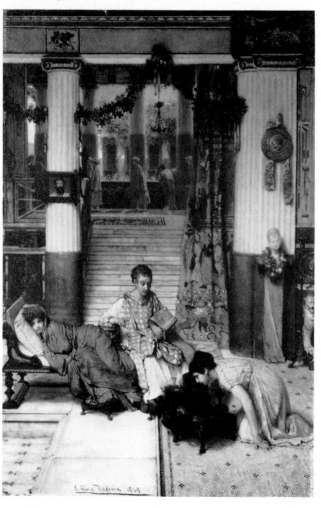

old Romans were human flesh and blood like ourselves, moved by the same passions and emotions.' He respected the Romans and Greeks as honest, pious and hardworking people, this opinion based on his view of their accomplishments. He saw them as being very much like his English contemporaries, and he was often criticised for making his figures too English. Alma-Tadema took this to mean that his reconstructions of antique life were 'alive'.

With limitless patience and manipulative skill, Alma-Tadema tried to invest antiquity with the familiar gestures, movements and attitudes of his day. He attempted to put the antique into slippers and evening gowns, without sacrificing archaeological accuracy. 'If I am to revive ancient life, if I am to make it relive on canvas, I can do so not only by transporting my mind into the far off ages, which deeply interest me, but I must do it with the aid of archaeology. I must not only create a *mise-en-scène* that is possible, but probable.' It is small wonder he was called 'the archaeologist of artists'.

Alma-Tadema was averse to guessing: absolute knowledge of the ancients was required to fulfill his aim. His success is attested to by noted archaeologists who could find little fault in his scholarship. Tadema presented his scenes as they might appear to a modern observer, with all the wealth of detail that modern archaeology and science could muster.

An example of his archaeological predilection is *The Baths of Caracalla* (Opus CCCLVI). The picture depicts many facets of Roman life and architecture, including tesserae floors, variegated marble columns and decorative cornices. The many figures are dispersed over the canvas most naturally, all in appropriate dress. An anonymous critic for the *Art Journal* in 1899 wrote, 'Mr Alma-Tadema has once more built up a fascinating picture of Roman life, wonderful in its classical faithfulness and truth to archaeological detail. He has restored, on canvas, the famous bath of Caracalla...'

Such an unusual aim could not go without criticism. A.C. Brock, for example, writing in *The Burlington Magazine* described his painting as an attempt 'to produce a new kind of art which we may call the "prose of things not familiar and the genre of a life not seen"'. Courbet in 1861 felt similarly when he said, 'No age can be depicted except by its own artists, that is, by those who have lived in it.' Indeed, art and archaeology make a difficult mesh. Possibly Sir Lawrence would have been a better artist if he had not been so archaeologically-minded, or a better archaeologist if he had not made such a relentless attempt to relate that field with art. Yet, often his aim was to infuse pagan joy, delight and gaiety into his paintings. And, in the Victorian age this representation of joyous and unfettered existence could more easily be depicted in the settings of two thousand years ago, than in scenes made ridiculous by contemporary garb and environment. W.P. Frith's and Thomas Faed's contemporary moralizing genre had no part in Tadema's strictly sensuous style. In other words, he sought to paint a life of serene happiness, wishing to depict the utmost refinement and delicate luxury, indeed anything of merit or interest that the world had ever possessed. Unfettered by puritanical moral persuasions, Tadema seldom, if ever, felt compelled to paint moral lessons or anecdotes. Thus freed, his art took up the less provocative though more novel idea of using archaeology to dress his scenes of Imperial Roman high-life.

Alma-Tadema's optimistic and eccentric artistic personality was narrow, but he expressed it with singular clarity and precision. His technical brilliance was used not only to depict minute detail, but to release desired expressive qualities. As one journalist writing within a year of Tadema's death put it: 'The more perfect the craftsmanship which serves as a medium [of expression], the more absolute the

transmission, and so one is loath to believe that Alma-Tadema, unrivaled in his command of the grammar of form and colour, should have failed to give utterance to that which he had it in him to say.' In fact, any criticism of Alma-Tadema that arises on this score does so because of the excessive clarity of his visual enunciation.

There are in his work no veils to be withdrawn, no mysteries to be solved, no secret rites into which the viewer needs to be initiated. Alma-Tadema's vivid, practical, straightforward art suggests that self-doubt did not play a strong part in his character and that his paintings hid nothing of their meaning behind symbolism. Analysis of them must begin from different assumptions.

'Pour maintenir le culte du vrai et perpetuer la tradition du beau.' Thus Ingres' words express Alma-Tadema's artistic raison d'être. To propagate beauty was the artist's true concern. A favourite motto of Alma-Tadema was 'As the sun colours flowers, so Art colours life.'

Merely to create was not enough; the artist was responsible for creating beauty in its truest forms. Alma-Tadema was fond of quoting another Dutchman, M.J. Vriendt, who said, 'The soul of the artist must be the looking glass in which the beauty of nature is reflected.' The physical world was the source for Tadema's conception of true beauty. He was able and willing to copy nature when nature gave him what he wanted, but he was just as disposed to dispense with natural objects when his pictures demanded it.

His work often seems overly tied to particular objects as they are found in nature, but actually he forces nature to conform to his preconception of the beautiful. That conception was not theoretical as was Leighton's, but concrete like his archaeology. His search for beauty led him to paint the beautiful forms he saw in life. Filth, grime, tragedy and horror were not possible in his work, because they were not beautiful.

In a world filled with ugliness, Alma-Tadema ferreted out beautiful objects. It was an obvious and actual type of beauty—beautiful women, lovely flowers, glittering jewels and charming vistas. Although he seldom invested the objects with the highest qualities of 'abstract beauty' (in terms of either idealization of stylization), he often added some significance of beauty through composition and through technique. Alma-Tadema rejected the idealization of the human figure through abstract formulae, and in this he was true to his Dutch bourgeois origins. According to Ellen Gosse, 'He could paint nothing that was not possible. He had no visions, no illusions; his pictures must represent life ... not the life of today, but a life just as real only more beautiful.' His pictures bridge the gap between the realist and idealist.

In the middle of the nineteenth century no viable alternative to subject painting had been found. Only in the late nineteenth century did wholly abstract paintings gain acceptance. To express emotion, aesthetic or otherwise, the artist was obliged to rely upon the subject, and at this time almost all art critics judged art not on formal values but on the artist's success at narration of literature and history, or expression of sentimental anecdote. The visitors to the Academy demanded little stories, easily understood allegories, or well illustrated and familiar incidents. One writer aptly commented that 'his art bears the same relation to history as does the anecdote to serious narrative'.

Alma-Tadema did not feel that it was art's purpose to serve literature. In fact, to paint a story which words could tell better or which words had already told had had little interest for him since his first influential trip to Italy in 1863. He was not, however, averse to allowing literature to serve art, this corresponding to his declaration that painting should first appeal to the eye and the intelligence rather than

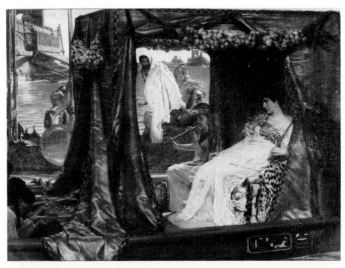

Antony and Cleopatra (Opus CCXLVI, 1885) Alma-Tadema frequently illustrated well-known historical and literary scenes, although usually those containing minimal action—he did not, for example, paint battle scenes. He most commonly depicted scenes of daily life, with which all his admirers could readily identify (Galerie Royale, Canada)

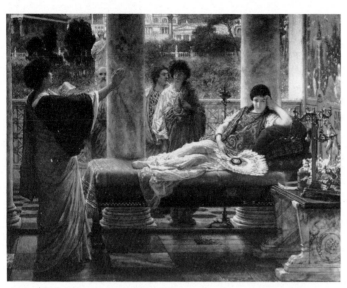

At Lesbia's (Opus LXXX, 1870) The emotionless subjects of his paintings were often criticized, and it is evident that Tadema deliberately subordinated the figures to the detail of their setting or the portrayal of some familiar domestic event (Private collection, England)

Caracalla and Geta (Opus CCCLXXXII, 1907) A photogravure print of one of Tadema's largest and most spectacular paintings. He calculated that 2,500 spectators in the Coliseum would be visible, and proceeded meticulously to paint every one. The present location of the original painting is unknown (Russell Ash)

to the emotions and sentiment. Indeed, most of his compositions have some literary interest, though such interest is subordinated to more formal values as a rule. In this connection, Mrs Alice Meynell, Alma-Tadema's good friend and art critic, went so far as to say of him: 'Professing the doctrine of "Art for Art's Sake" and desiring apparently to free his own art from all the adventitious literary interests—from tragedy, and comedy, and morals and religions which have legitimate expression in other ways—he seems to have sought out a time and country in which life as it passed on made pictures for the eyes alone.'

Yet Alma-Tadema was not, of course, strictly in the 'Art for Art's Sake' group. Neither was Lord Leighton, who held similar views, although one can hardly tell it from either man's discourses. Only Albert Moore of the Classicists might be put into that category. For his part, Alma-Tadema imbued his works with subdued literary content, but not didacticism, banished excessive emotion, but not 'delight'. His subjects are not fully related to the world of feelings, but are rather learned revivifications of the past, delightful in their scholarly accuracy and in the dream world of light and colour he created.

Christopher Forbes remarks in *Victorians in Togas* that Alma-Tadema's work often seems emotionless. 'The beautiful, if expressionless Lesbia (*At Lesbia's*, Opus LXXX) reclines on her couch in a sumptuously appointed loggia while a young poet (Anacreon) declaims to her. In this picture one can see that Alma-Tadema's skill at rendering objects frequently outstrips his ability of capturing emotions.' 'But Tadema was', counters Sir Laurence Collier, 'fundamentally a genre painter and as such he excelled in representing static figures against a detailed background: these could express emotion . . . it was not emotion expressed through movement; but emotion nevertheless.'

Tadema defended his position in another way: 'Everything which concerns my art is the expression of an idea: my pictures represent different subjects, but in them I have but

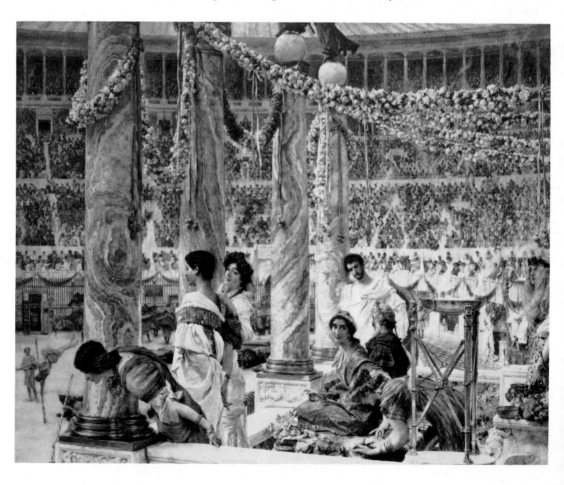

expressed a homogeneous artistic research.' The differentiation between vision and conception is a narrow one. Both are present at the same time and in the same place in every work. Whereas Alma-Tadema's conception of art was toward beauty, scholarship, and formal values, his vision decided the *exact* form his conceptions would take. Alma-Tadema painted what he saw, but he chose carefully what he wanted to see. Whatever vision Alma-Tadema used, it was tempered by deep scientific and scholarly knowledge of his subject. He seldom relied on memory and to some degree this was a limitation to his work.

This might seem to preclude any imagination, but the contrary is true. It was less an emotional than a constructive imagination, less vehement and romantic than analytic and realistic. But if imagination is the power of realizing that which is unknown, then Alma-Tadema possessed it in abundance. He would say, 'Art is imagination and those (who) love art love it because in looking at a picture it awakens their imagination and sets them thinking, and that is also why art heightens the mind.'

Tadema ventured only occasionally into the realms of tragedy, but during his lifetime his tragic works were considered among his best (e.g. *The death of the first-born*, Opus CIII; *A Roman Emperor*, Opus LXXXVIII). Yet one feels that he was not fitted for such work. As a 1913 *Connoisseur* critic states, 'He lacked the dramatic instinct and had a wholesome dislike for dirt and ugliness, and tragedy has a knack of containing both.'

Yet, though he did not possess tragic or dramatic inclinations like Michelangelo or Rembrandt, his vision and conception of the world was not dissimilar in sensuousness from the one that Renoir created. Disregarding obvious differences in subject matter, both attached great importance to the physical world about them. Each used bright and colourful techniques with surface animation, and neither tried to delve into the private minds of their models to any great extent.

This is not to say, however, that Alma-Tadema was devoid of perception. His scholarly and methodical mind, in fact, was aided by a vision that was intense in its ability to render subtle change. But this was an intensity of vision almost totally directed towards the character of objects rather than their spirit. The most delicate variegations of porphyry, the intricacies of draperies, and the smallest leaves of every branch did not elude his gaze. It is surprising to find, on close inspection, that all these crowded details are curiously loose, almost blurred in focus. This differs from the contemporary work of Meissonier whose work is microscopic at close range. Tadema's work, on the other hand, focuses at about 3-10 feet. Not a mindless set of investigations in minutiae, however, it could be rightly said that his work most closely fits Balzac's definition of art as 'condensed nature'. Tadema's employment of multitudinous details, in other words, was to animate and harmonize his accessories into an energetic and telling whole.

Yet, in this attention to archaeological detail, Alma-Tadema seemed to differ from the Neoclassicists of the preceding century. As a contemporary article states: 'The last century classical artist did not attempt to obtain accurate knowledge and seemed not to care for it, their only aim was to paint something sublime and if they did not succeed there was nothing left to interest the spectator.' At the very least, attention to detail and technical dexterity hold a fascination over most people and Alma-Tadema's abilities in reproducing surfaces, his completeness in execution, have always commanded admiration.

'Genius is perseverance,' as one critic stated, and it was Alma-Tadema's motto that 'nothing is to be done except by close application'. The incredible efforts he took to complete a work were well known. Often he challenged himself with tasks of monumental proportions. *Caracalla and Geta* (Opus CCCLXXXII) is a case in point, where close application and ambitious plans were brought together with great intensity. Tadema stated, 'I have from the very outset counted the number of my spectators as I painted them in and have now reached a number approximating 2,500. Allowing that the columns and garlands hide as many more, this would give a total of 5,000 figures for that seventh part of the Coliseum which is shown... and for the entire building 35,000, the number actually believed to have found accommodation in the auditorium.'

Alma-Tadema's adherence to such deliberate procedures was a limitation on his art. Sometimes, indeed, such precision and clarity make one long for a respite from the crowded detail. But Alma-Tadema would not have such indulgence. 'I love my art too much to see people skimp it; it makes me furious to see half-work and to see the public taken in by it and not know the difference.' Once when painting azaleas with characteristic precision, he told an onlooker, 'The people of today, they will tell you that all this minute detail that it is not art! But it gives me so much pleasure to paint him (sic) that I cannot help thinking it will give at least someone pleasure to look at him, too.'

It is obvious that Tadema enjoyed his way of working, and it is to his credit that he created in such an individual and original manner. As Cosmo Monkhouse wrote, 'He does not raise you to Olympus or give you photographs of the Strand: he takes you to the Palace of Pharaoh and fills the streets of ancient Rome with fresh-drawn life.' In other words, the magic lies in his extraordinary ability to bring vitality to a dead subject, to delight and charm us with unforgettable qualities that transcend period interest.

CHAPTER III
CONTENT AND STYLE

Subject Matter

Alma-Tadema's Greek and Roman paintings far outnumber his contemporary, Merovingian and Egyptian subjects. 'I will find Beauty even if I have to go back to Greece and Rome for it', he said. His vision of the ancients, beyond anything he might express about their reality as human beings, gives him the excuse to bedazzle with illusions of 'material' in terms of paint. Lovely fabrics, exquisite flowers, bronze vases, and gleaming marbles, along with resplendent costumes, ornate furniture, and marvellous elaborations of architecture: these rather than his figures were often Tadema's real subjects.

He could, in fact, be called a still-life specialist in many instances because of his extreme attention to accessories. As a 1912 issue of the *Fine Arts Journal* stated, 'In a sense Alma-Tadema was simply a wonderful still-life painter, the marvellous renderings of marble surface . . . have rarely been equalled by any painter of any period.'

Of marble, Tadema once said, 'its wonderful whiteness and atmosphere made an extraordinary impression upon me.' So synonymous did the two become that he was sometimes called 'Marble-Tadema'. Only by rare exception does marble not appear in any of his genre work. His work was simply 'marbelous', quipped *Punch*, which also remarked that he should have been made a KCMB—'Knight of the Cool Marble Bath'.

A journalist from *The Strand Magazine* interviewed Alma-Tadema about this situation. 'The public won't let you paint much without blue sky and white marble?' Alma-Tadema answered, 'That is true, but it only increases, I think, the strain upon the artist. I have attained . . . excellence in a certain groove of art. I must continue to work in that groove, but at the same time I must not merely repeat myself. In this groove I have to find fresh features of interest, new points of achievement. This makes for artistic effort, although in a sense I may be able to paint very blue skies and very light marbles better and more easily than anything else.'

One writer to Alma-Tadema exclaimed, 'We all dream that we dwell in marble halls when you are mentioned.' The Pre-Raphaelite, Edward Burne-Jones who, although a friend of Alma-Tadema, was aesthetically opposed to him, admitted, 'No man has ever lived who has interpreted with Tadema's power the incidence of sunlight on metal and marble.'

Often the figures suffer in comparison with the superlative quality of his still-life. To some it might seem that Alma-Tadema substituted statistics for aesthetics in his factual recordings. 'The result is that all the properties in his pictures look like documents . . .' said A. Clutton Brock. 'A "tableau vivant" in an elaborately restored Pompeii, that is the kind of reality Tadema represents for us and as we could interest ourselves in such a "tableau vivant" only by pretending to ourselves that it was real . . . If we remember that they have no authenticity whatever they become as tiresome as a forged

diary, or rather they have the interest of a diary that is skilfully forged.'

Sometimes his pictures contained striking inconsistencies in their related accessories. Once he put sunflowers into an antique picture (*Sunflowers*, Opus CXLIII), believing that they were found in the Ancient World, only learning later that they were indigenous to the Americas. His famous *Sappho* (Opus CCXXIII) reclined on a seat that postdated Pericles by two hundred years, and certain inscriptions were spelled incorrectly. Another time he painted the flower 'Clematis Jackmanii' before realizing that its creator was Mr Jackmann, his contemporary. Finally, Alma-Tadema came to the conclusion that his use of archaeology need be accurate only insofar as a specific painting demanded it. He eventually avoided this problem by depicting the later Roman period in which the palaces and baths were filled with accumulated booty from distant lands and eras.

Few other painters have employed flowers as decorative elements in their pictures as much as Alma-Tadema. Nosegays, brilliant parterres, bouquets, garlands, wreaths and growing flora in every conceivable combination appear frequently. He often used them to aid him in colour and compositional difficulties. Whenever a problem developed that eluded other solutions, Tadema would often settle it with a mass of splendid blooms, as in *Unconscious rivals* (Opus CCCXXI). While painting this work he added a blossoming azalea to enliven and balance an otherwise dull and poorly composed picture. Sometimes, in fact, the flower became the central theme, as in *The flower girl* (Opus LXI) or *The roses of Heliogabalus* (Opus CCLXXXIII). Many times the living figures that inhabit Alma-Tadema's refurbished palaces were criticised for being 'dead', but the organic life of his flowers was never questioned.

The same conscientiousness in paint-handling occurs here as it does everywhere in his work. ' "You must not think that those roses look like roses because I niggled at them", he says, and he gives us,' writes Meynell, 'a magnifying glass which shows us how uncramped and impulsive the handling of them is.' Alma-Tadema's technical virtuosity permeated every rose in his 1911 work, *Summer offering* (Opus CCCCIII). Every subtlety of light and colour was recorded with decisive brushwork.

Besides his reputation for still-life and accessories, Alma-Tadema was a major painter and designer of architecture. In 1906 he was awarded the Gold Medal for the promotion of architecture by the Royal Institute of British Architects—the only non-architect to be so honoured. Tadema had a unique gift for architectural composition. He could balance extremely complex architectural designs with all the multitudinous elements of his pictorial schemes. Sometimes the balancing of an architectural framework with figures and accessories gave unity to an otherwise chaotic composition.

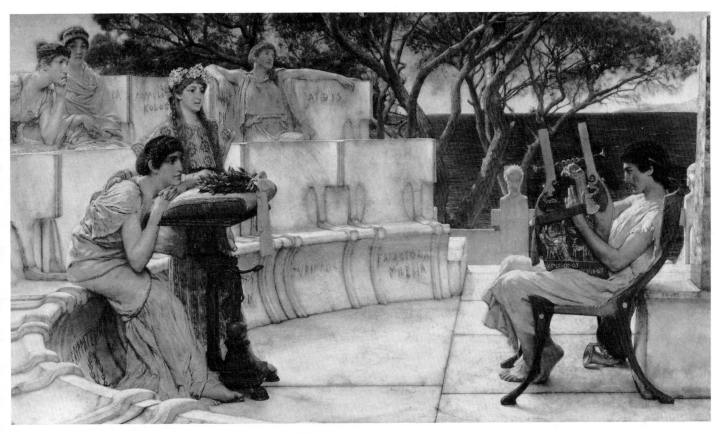

Sappho (Opus CCXXIII, 1881) One of the few paintings in which
Alma-Tadema is guilty of serious anachronism (in the furniture) and
inaccuracy (in the Greek lettering). Usually his pictures are
historically precise, and his appellation as 'the archaeologist of
artists' is appropriate (Walters Art Gallery, Baltimore, Maryland)

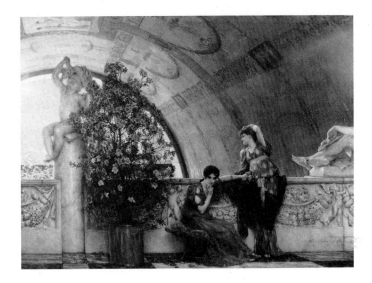

Flower studies, from Alma-Tadema's sketchbooks. His particular
interest in flowers is displayed in many paintings in some of which,
such as *Unconscious rivals* (Opus CCCXXI, 1893), the blossom is a
key element in the composition (Victoria & Albert Museum,
London; Bristol City Art Gallery)

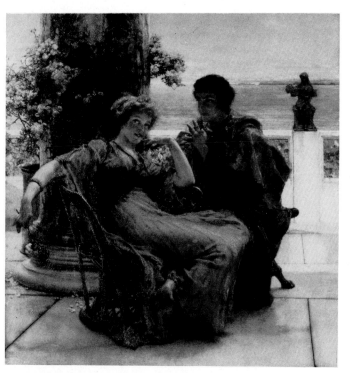

The proposal (Opus CCCXV, 1892) One of several works by Tadema in which the balance between the column and the figure is integral to the structure of the picture (Brighton Art Gallery)

His knowledge of the incidentals of ancient buildings came from museums, especially the Naples National Museum, private collections, such books as Baring-Gould's *Tragedy of the Caesars* and from visits to Pompeii, Rome, Vulci, and Cerveteri. From these sources he extracted certain themes that ran throughout his work, and certain self-imposed problems which he used as a creative stimulus. One problem of particular interest was the relationship of the column to the human figure and the juxtaposition of both within the picture. In an interview with Frederick Dolman of *The Strand Magazine*, he used his painting of *The proposal* (Opus CCCXV) to discuss this point. In this more than in any other picture he balances the column with the figure, and as usual he sets them off with a touch of colour from wild roses. Though of little consequence in itself, Alma-Tadema used such problems to keep his art in trim.

Explorations and experiments with different themes and compositions also enabled Tadema to maintain interest and a healthy outlook in his work, which might otherwise have devolved towards meaningless potboiling. Early in his career he began a series of 'studio' pictures depicting scenes within the artist's working environment. *A sculpture gallery* (Opus CXXV) and *Antistius Labeon* (Opus CXXXVI) are two famous examples of almost twenty works dealing with this theme, painted mostly between 1867 and 1877.

About the time he moved to England he began to produce a long series of bacchante and balneatrix pictures. These paintings represent the most sensuous of his work. *After the dance* (Opus CLVIII), *'There he is!'* (Opus CLII) and *In the tepidarium* (Opus CCXXIX) are among the most appealing works within this genre. *In the tepidarium* is the most frankly sexual of these. The dewy silkiness of the woman's flesh, painted with exquisite perfection, stands as a testimony to Tadema's underestimated figure painting abilities.

Perhaps the most satisfying of Alma-Tadema's themes appears in his 'exedra' pictures. (An exedra is a semi-circular marble bench, usually situated out of doors.) Alma-Tadema utilized it to its utmost as a scene where langourous women reclined, lovers argued and children played hide and seek. *Silver favourites* (Opus CCCLXXIII) depicts a beautifully draped woman finding fish in a basin surrounded by an exedra with a high vantage over a sapphire Mediterranean. Another exedra painting is his famous *The Coliseum* (Opus CCCXXXVI) depicting young ladies watching a procession from the Coliseum from a lofty exedra. Here the architecture of his exedra paintings is much less ostentatious than in pictures like *A Roman art lover (silver statue)* (Opus LXV) and *Caracalla and Geta* (Opus CCCLXXXII), which contain a less pleasing excess of architectural detail.

Certain objets d'art crop up time and again in his pictures: 'nostra genori' statues, chased bronze tables, carved Pompeiian or Egyptian couches and antique vases. Other themes often employed are the 'departure' series, 'Gardens of the Villa Borghese', 'The Question' series, and 'Balcony over the Mediterranean' series. Each theme or accessory would be used between five and thirty times.

Style

Alma-Tadema's genre style, unlike that of many academic artists, relied heavily on such elements as sky, sea, sun and architecture. His style echoed the enthusiasm of all men who loved the ancients and expressed a nostalgia for those vanished peoples. If Tadema's style was not classical, at least it was not altogether pseudo-classical. His keen sense of beauty penetrated beyond Ruskin's criticism of his art as not being 'classical' enough, reducing such thoughts to insignificance. As one perceptive modern critic, John Woodward, writing in 1962 in *British Painting*, has said, 'One ought not

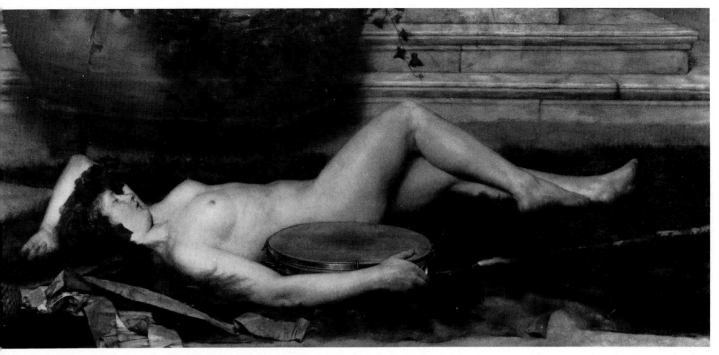

After the dance (Opus CLVIII, 1875) Tadema's most obviously
sensuous works usually escaped attack by Victorian critics because
they were 'classical'. The removal of the archaic trappings would
undoubtedly have invoked severe censure (Private collection, Japan)

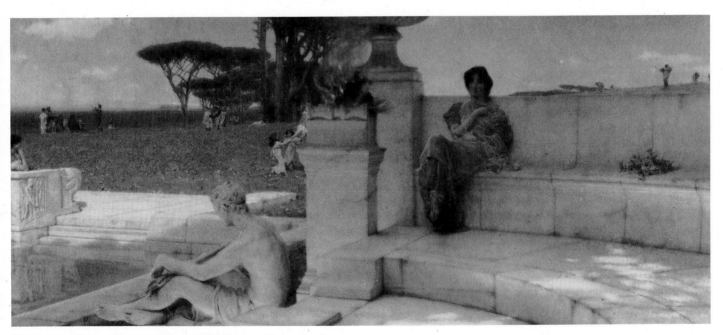

The voice of Spring (Opus CCCXCVII, 1910) The marble exedra, here
elaborate in its detail, but often of the simplest design, featured
strongly as a recognizable classical setting and versatile
compositional element in many of Tadema's paintings (Mr and
Mrs Joseph Tanenbaum, Toronto, Canada)

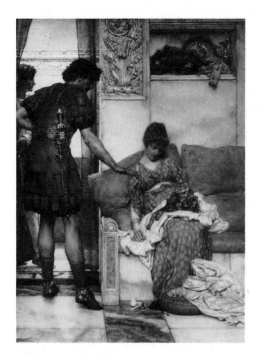

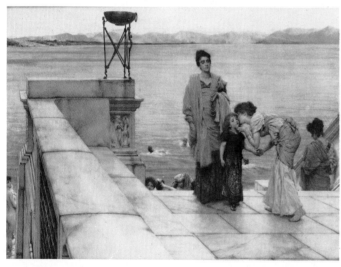

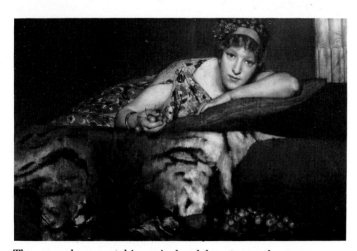

Themes such as courtship, arrival and departure and women reclining in luxurious surroundings are among a range of themes employed by Tadema in a variety of ways, here seen in *A silent greeting* (Opus CCXCIX, 1889), *The kiss* (Opus CCCXII,1891) and *The cherries* (Opus CXIV, 1873) (Tate Gallery, London; Location unknown; Koninlijk Museum Vor Schone Kunsten, Antwerp)

to reproach Tadema's anachronisms but marvel at his pictorial version of a great literary convention.' In the light of the best aspects of his work, criticism of his brand of classical academism should be re-evaluated. The individuality and appeal of Tadema's style undermines the importance of defining him as a classicist, romanticist or realist. The truth is that his work is a hybrid concoction, utilising elements of Classicism and Romanticism, presented by the vehicle of academic realism.

Examination of the ingredients that made his style appealing is more worthwhile than dogmatic debate, and sometimes his contemporaries show more understanding of this than later authors. M.H. Spielmann wrote in 1896 in the *Magazine of Art:* 'his originality, his easy confidence and knowledge of effect, the brilliancy of his colour, his juggling with the falsehoods of painting so as to make them artistic truths, his scholarship which while always learned is never pedantic, his skill in animation of textures, his daring which sometimes almost amounts to audacity and his perfection of finish are a sufficient justification of the pinnacle on which he has been placed.' Further justification of his style is pointless, but a description is in order.

In his figure type there is much originality, but little depth of emotion. Seldom does one find more expression than a thoughtless gaze. *'Her eyes are with her thoughts, and they are far away'* (Opus CCCXLV) and *Wandering thoughts* (Opus CCCXLVI) are excellent examples of this condition. Leighton had better taste for beautiful women, Alma-Tadema's often being of the homeliest variety. Often they were bored patricians, or langourous bacchante figures, seen in idle luxury. His figures tended to be moody and introspective rather than explicitly emotional. His female figures have a slightly bored pleasure-seeking attitude, as if they were pampered courtesans. His Italian models, Gaetano Meo, Alessandro di Marco and Antonia Cura were well known in London. Marion Tatershall was a popular English model to whom Alma-Tadema was close and who influenced his female type greatly. Most often Tadema would use his wife and daughters for models, particularly when a painting was in its final stages and he needed models constantly. Perhaps it is the langourous quality of many of his female figures which led reviewers to criticise them for a lack of expression.

His figures were described as boneless, fleshless, and wearisome. Oscar Wilde, when reviewing the Grosvenor Gallery Exhibition of 1878 wrote for the *Dublin University Magazine,* 'I and Lord Ronald Gower and Mr. [John] Ruskin and all artists of my acquaintance hold that Alma-Tadema's drawing of men and women is disgraceful. I could not let an article signed by my name say he was a powerful drawer.'

The most distinctive element of his style is the colour which affects his skies, atmosphere and light. A brilliance of colour flowed from his brush. The azure blueness of his skies became more pronounced as he continued to visit the Mediterranean area. 'As a colourist', Meynell claims, 'this artist stands alone...he is inventive inasmuch as by the power of his altogether exceptional gift he brings tint unimagined before out of a narrow little gamut of colour with a full intelligence of expressiveness that is distinctively that of happiness.' The light that permeates his pictures also colours it, for he painted light with colour.

To obtain this infusion of light and colour, Tadema used a similar technique to that used by the Pre-Raphaelites: he painted from a white canvas towards his darker colours. Although he did not paint on a wet canvas, nor with thin transparent paint, he did reverse the traditional process of painting from mid-tone to light. His palette was often as brilliant as that of any of the Impressionists.

So delicate was his feel for light and colour that he could

never paint by artificial light. His brand of indoor 'plein-airism' resulted in Amaya's accolade: 'Perhaps Sir Lawrence's greatest and most admired talent was in rendering light reflecting surfaces and the light intensity in his canvases reached a high pitch of luminosity.' It is true that Alma-Tadema not only thought of light and colour as being synonymous, but also light and detail of surface texture. The luminosity to which Amaya refers was the result of careful study of the textural properties of certain objects such as marble, and how light was affected by texture.

The abilities of a colourist require a certain visual sensitivity while the abilities to render texture in terms of paint require a particular technical skill. The charming tints and cool half-tones were the result of skilful collocation of colour and value. The sweet brilliance of Alma-Tadema's refined colour sense is admirably demonstrated in his *A dedication to Bacchus* (Opus CCXCIV). There one finds the most subtle gradations of half-tone without discovering dull colour pigments. This work represents the sense found in most of his pictures: unmuddied tints of delicate shades of colour, and the use of varied nuances of pastel touches of coloured pigments which tend to shimmer on the picture surface. Unlike some artists he did not eschew the use of many pure colours in order to achieve a tonal unity. And though Tadema was singularly immune from the charms of atmospheric illusion, he was devoted to textural illusion through the play of light and colour over surfaces.

Any estimate of his abilities as a colourist must include at least some description of his palette. Pale neutral tints are best revealed in his floral painting; roses, violets, hyacinths, jonquils, and acacias are accented with these most delicate hues. Lemon yellows, scarlet and auburn lake, the deepest ultramarine blues and large quantities of white gave range to his palette. Like Whistler, white was Alma-Tadema's favourite paint, and he used it to great effect. 'The most careful study of antiquarian detail is united to an artist's vivid recollection of the colour and sunshine of the south, so that his Romans are not only dressed in their own costumes and surrounded by their own things, but they live in Italian light and breathe Italian air.'

Beyond Tadema's stylistic abilities as a colourist, or 'antiquarian in paint', an examination of his design or composition is essential to the understanding of the manner in which he integrated other styles into his pictures. His mature composition developed from his early academic training, Japanese, Pre-Raphaelite and modernist influences, the camera, his technical procedure and of course his own personal artistic character.

Alma-Tadema's mature pictorial style was not entirely pre-determined by his subject; he often contrived his subject to meet spatial needs. In the 1886 *Art Journal* he confesses, 'of course, the subject is an interesting point in a picture, but the subject is merely a pretext under which the picture is made . . . One of the greatest difficulties in art is to find a subject that is really pictorial, plastic.' Undoubtedly the plasticity Alma-Tadema was referring to was the arrangement of the different formal elements within the picture space. Within Tadema's work these arrangements took several forms, one of these being the use of a sharp diagonal, usually a balustrade, railing, cornice or wall, leading into the painting from its outer edges. This formal device seems to be used in almost half of Alma-Tadema's work and has the effect of drawing the spectator directly into the depiction, thus adding to the immediacy of the scene. This diagonal is seldom of great length; in a work such as *Hadrian in England* (Opus CCLXI) the diagonal takes the form of a stair railing and tends to unify the events that occur at the two ends of the diagonal. The action sweeps from the Romano-British potter

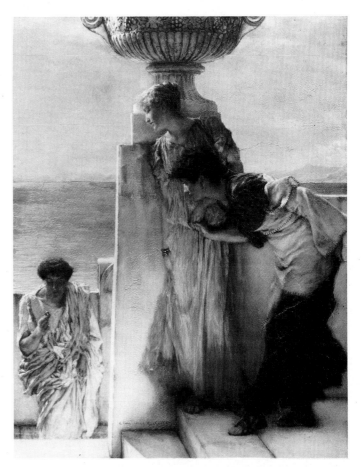

A foregone conclusion (Opus CCLXXIII, 1885) An example of Tadema's 'split level' composition (Tate Gallery, London)

Atossa the cat, a drawing showing Tadema's outline technique (Ashmolean Museum, Oxford)

Thalia's homage to Aesculapius (Opus CCCLXXVI, 1904) Tadema's drawings have the same highly finished quality as his oil paintings and watercolours (Centre Georges Pompidou, Paris)

'Tesselschade at Alkmaar', etched by Tadema as the frontispiece for Edmund Gosse's *Studies in the Literature of Northern Europe* (1879) (Russell Ash)

in the lower left of the composition up the stairs to a second stage of action where the Emperor is going about his business. This type of local perspective has little to do with the linear perspective of the early Renaissance, because its distant vanishing points are not easily discernible, nor do they culminate within the picture frame.

A better example of this latter type of perspective might be his picture, *An apodyterium* (Opus CCLXXIV) which has the typical Renaissance lines on the floor tile and walls converging to a vanishing point within the picture space. When Tadema utilizes this format for his composition, he almost always places a wall somewhere in the middle distance, thus blocking our view of the lines finally converging. Then he punctures the wall or architectural background with an opening (window, door, or breaks in the architecture) to allow a glimpse of sky or the Mediterranean. *An apodyterium* amply demonstrates the device of the 'glimpse', common in the oeuvre of his English period.

In both the above-mentioned pictures architecture played a prominent role. Indeed, almost all of his work displayed a balance between figurative and architectural elements. This 'fitting' of figures into an architectural framework was one of the problems with which Alma-Tadema dealt throughout his life. He must have prided himself on his technical ability, because he came back to this problem again and again. Whether an interior or exterior picture, this reconciliation formed the major dialectic in his art: planear and linear forms in white and soft, organic shapes in colour. The balancing of forms and shapes was his chief concern in bringing about an orderly picture until, as Tadema told Baroness Von Zedlitz in 1895, '...I am absolutely satisfied with the composition of the "tout ensemble".' His *A foregone conclusion* (Opus CCLXXIII) forms an interesting case in point. A very simple composition where the balance is easily seen, the figures accentuate the architecture, the latter adding pictorial unity to the composition. This synthesis is highly satisfactory aesthetically.

Another interesting compositional device which Tadema employed was the placing of figures on different levels so as to make the juxtaposition between them very unusual. *A foregone conclusion* again is an excellent example of two figures on eye level awaiting a suitor who is ascending a flight of stairs, the high vantage pointing off into a distant view. This latter device enabled Tadema to monumentalize his figures by having them dominate vast expanses. *Silver favourites* (Opus CCCLXXIII) is an example of this type; the artist has obliterated the middle-ground and the foreground is abruptly juxtaposed with the distant horizon. The dramatic effect is startling and most effective.

Often the edges of the frame would crop figures at odd angles by the edge of the frame. Such peripheral placing of the figures was not a traditional classical device, but tended to be anti-classical in that it created a less stable composition. The obtrusive cropping usually infringed upon the dignity and ideality of the human figure, but Tadema allowed unusual spatial extravagances for the sake of originality. He repeatedly rejected the classical compositional device of a centred pyramidal figure arrangement. Robert de la Sizeranne sums it up thus: 'It might be described as a lens turned on to a corner of antique life, to catch by chance all that is contained within the limits of the plate. It matters little if a head appears at the bottom of the canvas without a body; if a breast is cut lengthwise in half, if a hand is stretched out with no sign of the sex of its owner. The impression of life caught on the wing is none the less well given.'

The character of his style is closely interwoven with his technique. In most instances they were inseparable. The fidelity to nature that is exemplified in all his work was the

stylistic trait that the visitors to the Royal Academy exhibitions could appreciate.

Technique

Unlike many of the academicians of his time, Alma-Tadema had expert ability in several mediums. He was an adequate draughtsman, although many of his sketches bear little resemblance to the delicacy of his finished work. In fact, their bold outlines and inattention to detail is quite surprising.

His *Atossa the cat* drawing and *Figure study for Phidias and the Parthenon* (1869) both suggest a preference for long silhouetted lines and a primary concern for capturing the 'shape' of the object depicted. Perhaps this sense of outline is the cause of the two dimensional 'layered' feeling many of his paintings have—*The parting kiss* (Opus CCXL) for example. Though his sketches have an unfinished quality, his finished drawings are as immaculately detailed and precise as any of his paintings. Tadema's *Thalia's homage to Aesculapius* (Opus CCCLXXVI) looks as though it could be an oil in a black and white reproduction, or his *Design for the Royal Institute of British Architects* (c.1905) could pass for one of his photographic watercolours. However, most English connoisseurs of his day could not consider the over 500 architectural drawings now preserved in the University of Birmingham Library on the same aesthetic level as those of Lord Leighton or Poynter. Both were illustrated by drawings in *Studio, Portfolio,* or *Art Journal* more often than Tadema.

Alma-Tadema did some printmaking, especially lithographs and etching, such as his lithograph *Amo-Te, Ama-Me*, his etching *Tesselschade at Alkmaar*, his frontispiece to Edmund Gosse's *Studies in the Literature of Northern Europe* (1879), and two etchings illustrating Firdausi's poems. He is, however, better known for his exquisite watercolours. Most of his watercolours resemble his oils, and only on close examination can the difference be observed. The watercolours were popular but as a medium they held second position to oils. The purpose of most of his fifty-one opused watercolours was to serve either as a preliminary study for a more ambitious oil, such as *A nurse* (Opus LXXVIII), or as a copy of a popular work *(A declaration,* Opus CCLVIII and *Xanthe and Phaon,* Opus CCLIX), or to correct artistic problems. Yet, though he was a member of the Old Water-Colour Society and the Royal Society of Painters in Water-Colour, Alma-Tadema was really never considered an important watercolourist.

Oil painting was his forte, and he used it to great advantage in his most typical works. The technique he brought to this medium has seldom been equalled. His popularity to a great extent rested on the visual impact of his paintings. Thus he satisfied in some measure much of the tastes of a tasteless society. The average 'spectator is not spellbound under beauty,' observed Beavington, 'but with cold curiosity counts up the details, admires accessories and stands wonderstruck at the painter's cleverness and sleight-of-hand.' It may be supposed that his completeness of execution was the result of labour added to still more labour, but this found warm sympathy within a class that believed a work of art to be good when it had been obviously difficult to do. Examples of Tadema's technique in progress are rare—most of his work is quite finished, and thus his working procedure is hidden. One example of his unfinished work is his *Exhausted maenades/After the dance* (1875). No traces of a preliminary charcoal sketch have been found on the prepared ground which in many areas is left exposed. The deletion of a preliminary charcoal drawing was a departure from academic training and tended to allow Tadema greater leeway to juggle his positioning of figures about the canvas.

Alma-Tadema often produced several versions of the same painting, sometimes using a different medium, or re-used details from one painting in a new work. Here a portion of *Sunday morning* (Opus LXVIII, 1869) is reworked as the watercolour, *Sunday morning* (Opus LXXVIII, 1870). The nurse reappears with the woman at the window in a third (oil) version, *Sunday morning* (Opus XCVI, 1871), and a different setting in *The nurse* (Opus CV, 1872) (Victoria & Albert Museum, London; Walker Art Gallery, Liverpool; Tate Gallery, London; Private collection, England)

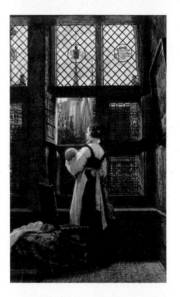

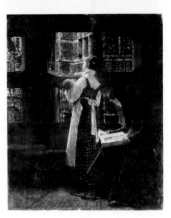

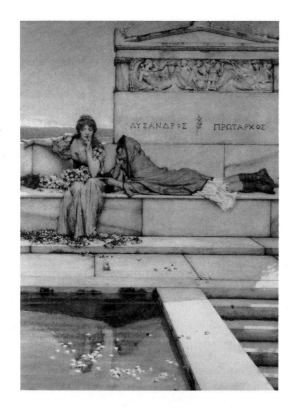

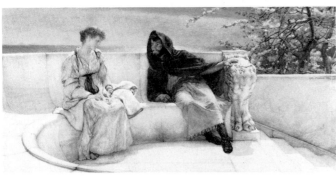

Xanthe and Phaon (Opus CCLIX, 1883) and *A declaration* (Opus CCLVIII, 1883), both watercolour versions of popular oil paintings (Walters Art Gallery, Baltimore, Maryland; British Museum)

Exhausted maenades/After the dance, 1875, an unfinished work with no evidence of a preliminary sketch (C.J.J.G. Vosmaer)

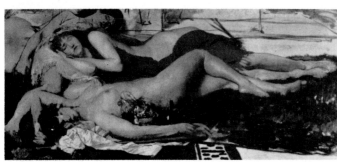

Another oil sketch, *Head study*, shows very plainly the charcoal drawing beneath. The oil seems to be spread arbitrarily without great concern for his preparatory sketch.

Usually he worked directly into the white canvas with siennas, earthgreens and ochres, trying to form groups of figures and spatial relationships. This process continued in a state of flux until Alma-Tadema was satisfied with the composition.

The vitality and formal qualities which marked his work began in this earliest stage. The second stage or 'ebauche' was done with stronger and darker paint. With thin neutral oil, he outlined and drew from the model, photographs, still-life, or nature to bring his original conception into focus. Extreme care was taken to get all details and drawing as correct as possible. 'Nothing', Alma-Tadema would often say, 'can be done well without taking trouble; you must work hard if you mean to succeed.'

As a part of this process, coloured paint was introduced between the dark lines, as in a piece of cloisonné enamel. These pigments approximated the final colours to be used and the tones and shades prepared the canvas for thicker paint. At this point if there were any elaborate architectural schemes to be worked out, a professional draughtsman, one used by several London artists, would usually sketch the building on paper the same size as the canvas. Alma-Tadema would then alter the draughtsman's plans to fit his own conception. It is interesting to note that though sometimes imaginary, all the buildings he painted were technically capable of being constructed.

For the 'executive' finishing of a picture, he required the objects to be constantly before him. If engaged in painting elaborately draped or coiffured ladies, Alma-Tadema might stop painting in order to make quick sketches. Although he was not a purely imaginative painter, his mind and spirit were continually sparked by some new and fascinating aspect of nature. It was difficult for him, either by habit or by nature, to paint extemporaneously. But evidently he could paint from memory when circumstances demanded it. There is a story about the time that a portion of *The roses of Heliogabalus* was painted on Varnishing Day at the Royal Academy while the picture hung on the wall and the artist, pipe in mouth and without a model, was keeping up a lively conversation. When asked how he could do such a thing, he answered, 'Why not? It was all thought out before!'

Alma-Tadema's paint quality for the 'executive' stage was a very thick and rich 'demi-paste'. It was very different from the drier paint that he had employed in his student days. Tadema was careful about his pigments, never allowing mineral or vegetable oils to mix. His view was that this would be perilous to the future condition of the work. Judging from their condition today, Alma-Tadema knew the chemistry of his oils very well. His paint quality is still evident and offers a feast for the professional painter. One such painter, after closely examining many of his paintings, wrote, 'As far as I can make out he painted direct. I could see nowhere that he had used glazes, although his marble seems to have an inner glow as if he scrumbled over a dark brown.' A letter from Alma-Tadema to Henschel confirms that he never used glazes or varnishes. Other writers tried to explain his paint quality. 'The pigments are a little opaque as if the artist had carried in his mind the ancient practice of tempera.'

To keep his works from degenerating into potboilers, the artist set problems to solve, as has been discussed earlier, and he allowed a picture to remain in a state of flux for an extended period. He was never satisfied with his work, and every picture underwent continual change. Alma-Tadema scraped *Spring* (Opus CCCXXVI) several times and each time a multitude of exquisite details was lost. He would erase,

usually with pumice stone, anything that would not work well within the total picture. Very often there were two or three pictures on a single canvas before it neared the intention of the painter. Allen Funt relates the story of how one of his Tadema paintings had fallen from its nail, and the face of the girl was damaged. While at the restorer it was discovered that another face had been painted by Tadema beneath. Anxious to view the earlier work, Mr Funt and the restorer removed the final layer of paint. Much to their disgust the under-painting proved to be a hideously ugly woman. Then, hoping to recover the value of the painting, the restorer repainted the original face.

Alma-Tadema always had several pictures under completion simultaneously. 'I am obliged to—otherwise I should become too much absorbed in one subject. I must turn from one picture to another for quickness and freshness of interest.' It is also known that Alma-Tadema would sometimes turn his pictures upside down to work on them.

This all-over approach to painting broke up the more traditional idea of a central focusing point. *Caracalla and Geta* is a mass of detail in scintillating colour and brushwork; the interest is diffused throughout the entire picture. Each action seemed of equal importance and was painted in the same scheme of values. Alma-Tadema was criticized for this, because it was supposed that when one looked at a picture the detail of the central focal point would be focused but all the other parts of the picture should be somewhat blurred. Alma-Tadema countered saying that as one looks at a picture one's eyes focus and refocus many times as we scan the painting surface. Therefore all the detail should be of equal sharpness. Even if this makes the picture difficult to concentrate on, it does make it an imposing *tour de force*.

Alma-Tadema was an experimental painter in the sense that his pictures had a way of never being completed. 'You do not know how difficult it is to paint pictures,' Alma-Tadema would say, and he would quote Swinburne, 'for the end is hard to reach.' The *Strand* interviewer reported an instance where such striving for perfection was Tadema's undoing. Seeing a half-finished picture in the silver-domed studio, Dolman asked what plans the artist had for it; whereupon Tadema answered, 'I have had this picture in hand for nearly two years and I am afraid I have now forgotten what I originally intended to put in the upper part!'

Often seemingly simple parts of his compositions would give him problems. He claimed that little glimpses of sunny sea or sky gave him as much trouble as the rest of the pictures. His lack of satisfaction with his own work and constant striving for perfection led him to become overly fastidious as he grew older. Alma-Tadema had a clearly defined idea of how his final work should look. If the sea did not dance, he would paint over it until it did. Often the encrustations of many layers became expressive in themselves. Not until the sensitive manipulations of his brush conformed with his mental picture, was a painting considered finished. Tadema in 1885 told Zimmern, '. . . that art is [not] sacerdotal; that every artist should efface and work again and again at the same theme until he has in some slight degree approached the truth'. Sometimes he would repaint some of his canvases even after they had been exhibited. His good friend F.G. Stephens wrote an interesting anecdote that illustrates this point. Stephens '. . . found Tadema studiously at work on a picture I had seen only the day before at the private view at the New Gallery . . . The picture was already sold, but the artist brought it back from the exhibition and had been working since five o'clock in the morning to add those finishing touches which he considered improvements. This was an instructive scene and we doubt whether there are many men younger and still anxious to win reputations who would show equal conscientiousness.'

If sheer labour could make an artist, then Alma-Tadema would indeed be a great master. Otherwise, it at least made him a consistent if not always an inspired painter.

THE CHANGING CRITICAL VIEW

Public Opinion

Occasionally hack artists are exalted by the public and critics alike as being equal to the great masters. Sometimes the reverse happens and centuries go by before an artist receives his just recognition. When Alma-Tadema was alive, he was considered among the world's leading artists. Since 1913 his star has plummeted, and as Amaya wrote in 1962, 'It seems significant that Sir Lawrence Alma-Tadema is the most ridiculed painter of the nineteenth century.' The vehemence of this ridicule reached epidemic proportions only after the 1913 Winter Exhibition at Burlington House, which drew only 17,000 visitors. Reviews of that retrospective show were damning; it seemed that most of the critics were desperately afraid of being considered old-fashioned. The reviewer for *The Sun* newspaper wrote: 'His painted anecdotes considered from the angle of amiable criticism are about worthy enough to adorn bonbon boxes!'

Such criticism had plagued Alma-Tadema from the beginning of his career, but never before had the public listened. Yet Alma-Tadema was now 'in Bad Taste'. The *Boston Transcript* in its obituary of Alma-Tadema took the opportunity to deprecate his style: 'Educated England took the mansion under the gilded palette weather vane as seriously as it took Whistler's "Peacock Room" frivolously. Against the glorious eclecticism of the villa let an occasional sulfitic heathen rage. Let Whistler himself after one of the masquerades in which Sir Lawrence appeared as an "ancient Roman" in toga and eye-glasses (pince-nez) epitomize his distinguished contemporary, "Amazing with his bare feet and Roman-Greek St. John's Wooden Eye".'

Such jibes and ridicule persisted and still persist today for the most part. They are mentioned here, because in Alma-Tadema's case his popularity among the public and collectors is much higher, at the present time, than among the critics. Often it is the picture-buying public that is avant-garde, while critics and tastemakers eventually follow suit. Popularity is often the result of two factors: either the artist has hit upon something that is fashionable or has undeniable talent and merit. The taste for Tadema seems to rely on both of these factors.

One can always tell an artist who is highly esteemed; his works will be on exhibition. Exhibitions are important: they tell us whether his art was considered worthy of valuable wall space and what kind of exposure the artist was getting. Very often a large percentage of a museum's or gallery's stock of works is stored in vaults, for want of exhibition space. Only a few museums have exhibited Alma-Tadema's paintings. However, many museums are now planning to exhibit his paintings, perhaps because Tadema is often classed in a general way with the Pre-Raphaelites. The American galleries, museums, and collectors have shown much more genuine interest in him than the English, who have only

recently rediscovered him. Yet the English pay significantly more attention to him than do the Dutch, who still have little love for their countryman.

The artist considered the 'Nouveau Riche' of America the best picture buyers of his day. About thirty per cent of his work found its way to America, because Ernest Gambart cultivated wealthy American industrialists in much the same way that Joseph Duveen did in the next century. The Marquands, Carnegies, Walters and Vanderbilts paid huge sums for his paintings. Sometimes they would spend 2,000 guineas for a painting not much larger than the cheque with which they paid for it!

The inflated prices he obtained for his work during his lifetime were out of proportion to his merit as an artist. It is hard to believe that, while Alma-Tadema commanded, and got, 'Duveen' prices, Van Gogh was starving. Such inequalities have a way of righting themselves, and eventually an artist's prices will begin to reflect his artistic importance and quality; Alma-Tadema's peaked about 1903. After his death, prices steadily declined. During the Depression his prices dipped still more and again in the 1950s and early 1960s. Since the 1962 Robert Isaacson show in New York, however, his pictures have been on the upward sweep.

Isaacson remembered after his exhibition of 26 Alma-Tadema pictures that 'most things went for $2,000 or $3,000 and my insurance premium for the whole collection only came to 37 dollars'. Charles Jerdein, the Fine Art Society, Agnews and Leger Galleries in London, and the Spanierman, Graham and Shepherd Galleries in New York have led the way to resurrecting Tadema's paintings. But it was the New York collector, James Coats, who bought most of Alma-Tadema's work at bargain prices and assembled them in a neo-Tadema setting in a Madison Avenue penthouse. These dealers realized a basic tenet of the art market called Laver's Law. 'Artists who once were famous will regain their money value as Old Masters dwindle from the market.' Another guiding principle called the 'Grosvenor Tenet', that influenced dealers to bid on Tadema paintings was the idea that when an artist is famous during a certain art period, he is valuable to the understanding of that period. Even the worst exponents of the academic machine are valuable if they were at one time the leaders of their period. General period interest leads most collectors into buying all the major artists in that period. It is a great deal like stamp collecting: the collector must own an Alma-Tadema to make his nineteenth-century English Classical school collection complete.

As is so often the case, a single collector initiates the market for a particular artist or school. The collector in this case was Allen Funt, the creator of the television programme 'Candid Camera'. Funt says, 'I didn't even know the name until a dealer in London asked me one day if I wanted to see a picture by the worst painter who ever lived. I saw it, thought

the dealer was wrong, and bought it. And I haven't been able to stop buying.' With over thirty-five works by Alma-Tadema, Allen Funt was the world's greatest collector of his pictures until he was forced to auction them after his accountant embezzled his funds. On 6 November 1973, Sotheby's Belgravia hammered out the Funt sale. The sale began slowly but as each new Tadema came up, excitement rose until all modern records for his work were broken. The final tabulation was a record $570,000. Funt had paid only $264,000 for these works between 1967 and 1973.

As prices rose, old fakes and copies of Alma-Tadema's works began to reappear from the vaults, basements and attics, where they had been thrust during his decline. Works by John W. Godward, Johan Reinhard Weguelin, and Henry Ryland again parade as original Alma-Tademas. Most of these works are listed in auction catalogues as simply 'Alma-Tadema', denoting the auctioneer's doubts as to their authenticity. Many are signed and numbered CCCXXXVIII. The 'Master of 338' produced a large body of work in the style of Sir Lawrence. Signed in block letters instead of Tadema's flowing script, paintings by this forger are occasionally confused by collectors as being by the master himself.

Rudolf Dircks' catalogue list of 400 of Alma-Tadema's works states that Opus CCCXXXVIII is a *Portrait of Miss Onslow Ford* (1896) and therefore all other pictures with this number could only be fakes. In fact Tadema foresaw that because his works brought incredible prices, copyists would attempt such a manoeuvre. To counter this phenomenon, Alma-Tadema numbered each of his works with an Opus number. An invention of his methodical mind, he opused his first painting, *Portrait of my sister Atje* (Opus I) when he was only fourteen years old, and his last picture, *Preparations in the Coliseum* (Opus CCCCVIII) when he was seventy-six. It is possible, in fact, that this idea occurred to him only just before his move to England and may have been inspired by Whistler's similar system. Although he kept lists of his paintings, he had lost track of the titles of some and the *Portrait of my Sister* was merely the one he numbered first. There are earlier works of equal finish which are not recorded on Dircks' list. Tadema did not begin to number the paintings beside his signature until 15 November 1872, when he numbered *Greek wine* as 'Opus 106', and only later did he begin to use Roman numerals.

The only reason why the 'Master of 338' might have felt that he could by-pass this system of Tadema's, was that it was rumoured that Miss Ford had destroyed her portrait. Perhaps thinking that this was an opportunity to paint pictures to fill the gap that was thus created, he was foiled, however, with Dircks' published list. Recent studies have concluded that the 'Master of 338' is a minor English painter, Arthur Hill. There are several other hands involved in Tadema forgery. One is the 'Master of 328', whose works seem to be slapdash and formless compared with '338', and another artist who paints somewhat in the manner of Joseph Coosmans of Brussels.

Occasionally works by Laura Alma-Tadema are confused with those of her more famous husband, because she signed her work, 'L. Alma-Tadema' or 'Laura T. Alma-Tadema' and often opused them. However, her work is easily distinguished from Sir Lawrence's because she usually painted in a Dutch genre style, which her husband almost totally avoided. Most imitators failed to apply the same accuracy of archaeology, richness of pigment and colour, or to fully understand Alma-Tadema's unique style. Generally their fakes are hard, crisp, muddy and lack sophistication and luminosity. There is a certain delight in craftsmanship which always makes works like those by Tadema stand above more tawdry productions.

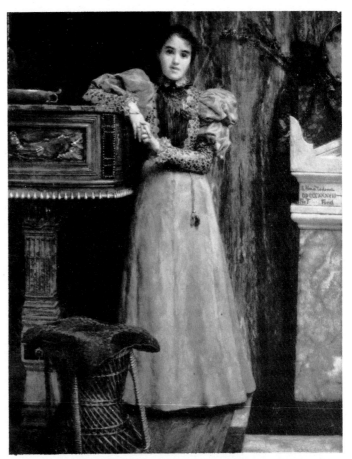

Miss Onslow Ford (Opus CCCXXXVIII, 1896) The rumour that this painting had been destroyed led to the adoption of its opus number by the prolific faker, the 'Master of 338' (Private collection, England)

A fake Alma-Tadema bearing the Opus number CCCXXXVIII

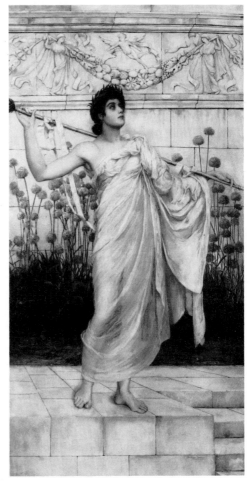

John Ruskin, one of Tadema's most severe opponents, as a saintly art critic in a caricature from *Once a Week,* 1873 (Mary Evans Picture Library, London)

The Critics' Appraisal

Critics are sometimes regarded as the tastemakers in modern culture. Their power is pre-eminently in the written word. The relationship between the approval of the critics and the captivation of the public is always crucial to the artist. While criticism was largely favourable, those people who appreciated the kind of art Tadema produced felt confident in owning works by him. But when critical reviews unanimously attacked Alma-Tadema's aesthetic contribution, his public abandoned him. By studying the variations in the appraisal of an artist by critics, and by grouping those opinions into broadly defined time periods, it is possible to form an idea of the era in which he lived. Alma-Tadema can then be placed in an aesthetic context and historical perspective.

First Period (to 1883)

In London during the period immediately after the end of the Franco-Prussian war, English critics had a new figure to discuss and analyse. In 1874 G.A. Simcox, writing for *Portfolio*, haltingly praised Tadema for his qualities of originality and technique, but the tenor of his appraisal is generally quite negative. Speaking of Alma-Tadema's goal to echo life in Ancient Rome, Simcox claimed that such was difficult 'to recover and less delightful when recovered'. A perceptive observer, this writer anticipated many hostile invectives to be levelled against Alma-Tadema in subsequent criticism.

The bitterest tirade against Alma-Tadema's painting style during the period came from the most famous critic of nineteenth-century England, John Ruskin. In *Academy Notes* of 1875, he describes *The Pyrrhic dance* (Opus LXIX) as like a 'small detachment of beetles looking for a dead rat'. Ruskin, in other instances, was capable of harsh ridicule with overtones of faint praise. A similar example occurred in the *Dublin University Magazine* in which Oscar Wilde, a friend of Tadema, wrote a review of the Grosvenor Gallery show of 1877, with comments on Alma-Tadema's work. Although Wilde was opposed to committing himself with regard to Alma-Tadema's ability to draw, the Dublin University editors had wished to publish a favourable review. Wilde would not sign the article, so the editors merely rewrote it and printed it a year later.

The same year (1879) Wilfred Meynell wrote his first article on Alma-Tadema for the 'Our Living Artists' section of the *Magazine of Art*. At this early date the author linked Alma-Tadema with the 'Art for Art's Sake' movement of Walter Pater, celebrating Tadema as a painter lacking in pedantry, as a colourist, and attributing to him the desire to express 'delight'. Meynell esteems the artist's work highly, as does his next important critic, Edmund Gosse, a cousin of Laura Epps, the second wife of Alma-Tadema. Gosse's work was published in 1882 and entitled *Lawrence Alma-Tadema, R.A.,* forming part of the Dumas Series on contemporary artists. Generally praising Alma-Tadema, Gosse dwelled upon the archaeological and antiquarian aspects of his work in a very positive way. He also included an early guide to Tadema's home, Townshend House.

Although the first period was not remarkable for either quantity of quality of criticism, Simcox, Ruskin, Wilde, Meynell and Gosse offer an interesting mixture of criticism for and against Alma-Tadema's style. With this phase ending on a generally favourable note, something of a reaction developed in the next.

Second Period (1883-1912)

The second period began with the major Grosvenor Gallery exhibition of 1882-1883. Critics who reviewed the exhibition went away with at least one unanimous opinion: Alma-Tadema was the greatest 'paint-handler' in England, a quality admitted to by friends and foes alike. A.J. Beavington, writing

in *Blackwood's Magazine*, took Lawrence to task for his faulty anatomy, boring archaeology, over-cleverness and eccentric vision. Yet, the author concludes, 'if we have used the free pen of criticism, we should show unjustice to ourselves and him alike did we deny him a high position among the few really great painters of Europe!'

Then, in 1884, John Ruskin again berated Alma-Tadema's whole concept of Classical art in *The Art of England*. Criticizing Alma-Tadema's pictures of antiquity he writes abrasively, 'And this is just the piece of classic life which your nineteenth century fancy sets forth under its fuliginous and cantharoid disfigurement and disgrace.'

In contrast to such treatment, Georg Ebers glorifies the artist in his book, *Lorenz Alma-Tadema: His Life and Works* (1886). As the artist's friend and a noted German archaeologist, Ebers felt qualified to discuss Alma-Tadema's scholarship and it is with great sympathy that he praised every minute aspect of the painter's work. So strong, in fact, is the praise that an anonymous critic for *The Nation* felt compelled to take exception. In 'The Archaeologist of Artists', he criticizes Ebers' book for its lack of discernment and states that Alma-Tadema only seems like an archaeologist because his reconstructions were copied from photographs. Pointing out that Alma-Tadema often made mistakes in scholarship, the writer continued, 'Archaeology has no "raison d'être"; and one cannot help suspecting our English cousins who tell us that Tadema has all Antiquity put away in pigeon-holes in his studio, and can produce you anything at a moment's notice.'

Another contemporary monograph on the artist is Helen Zimmern's *The Life and Work of L. Alma-Tadema*, an *Art Journal* supplement of 1886. She was also a friend of Alma-Tadema, but unlike Ebers she was an experienced art critic as well. Zimmern felt that Tadema had skill as a technician, but wished that he would add more emotion to his figures which seemed to her to be less alive than his still-life. Like most authors at this time, she devoted a fair portion of her book to his home in St. John's Wood. In 1902 Zimmern again featured Alma-Tadema in a small volume, largely a revision of her previous book.

In 1892 Philip G. Hamerton, editor of *Portfolio*, wrote *Man in Art*. Hamerton deals with Alma-Tadema as an archaeologist, and states, 'It is much for an artist who attempts to revive the past to have in his own idiosyncrasy the tastes of the vanished race, and how much this sympathy as to material things has done for the truth and interest, as well as the beauty of Mr. Tadema's work.' Harry Quilter's book of the same year, worked from a different frame of reference. He severely criticizes Tadema's *The roses of Heliogabalus* (Opus CCLXXXIII) for not depicting the scene from a moralizing position. Such pictures should not be painted, he insisted, if the artist was incapable or unwilling to moralize on the subject of depravity. In 1894 R.H. Hutton's book, *Artists of the Nineteenth Century*, reviewed several newspaper accounts of Alma-Tadema's work. One letter to the *New York Times*, dated 14 June 1877, remarked, 'The Tadema school with its yellow-haired women in impossible attitudes, its flat interiors, and its Pre-Raphaelite exaggerations, encourages a flashy artificial style.' Associations between his work and the Pre-Raphaelite brotherhood had haunted Tadema since the mid 1870s when the similarity was pointed out by James Dafforne.

Between 1895 and 1897 three major articles were written by Cosmo Monkhouse for *Scribner's Magazine*, M.H. Spielmann for the *Magazine of Art*, and F. Dolman for *The Strand Magazine*. Monkhouse, as a friend of the artist, was prejudiced. He does admit, however, that sometimes Alma-Tadema used flowers to hide compositional problems that

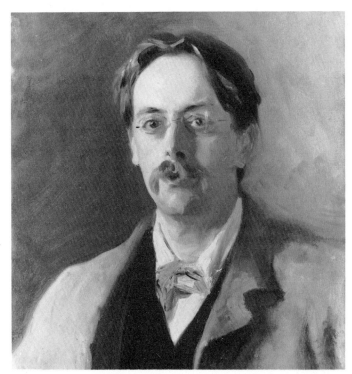

Edmund Gosse, a notable critic and biographer of Alma-Tadema. Portrait by John Singer Sargent, 1886 (National Portrait Gallery, London)

Alma-Tadema at work in his studio. He almost invariably painted both human and inanimate subjects from models or reference illustrations, but could paint equally well from memory when circumstances required him to do so (Mansell Collection, London)

Recent exhibitions of Tadema's work in Britain, Holland and the USA have revived popular interest in an artist who suffered from fifty years of neglect (Sheffield City Art Gallery)

The Hon. John Collier, Tadema's leading pupil and a staunch defender of his art during the generation after his master's death (Mansell Collection, London)

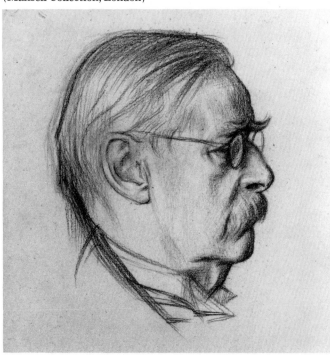

might arise in his paintings. Spielmann presented some pithy facts, including such points as Alma-Tadema's attitude towards copiers of his work: 'That such a master has attracted imitators in crowds is hardly to be wondered at. I do not mean accidental repeaters of subjects whose treatment is totally different... I remember once calling the artist's attention to an unblushing piece of Plagiarism... but Mr Tadema merely shrugged his shoulders philosophically as he quoted the artistic axiom that "those who follow will never see but the master's back".'

Frederick Dolman's article for *The Strand Magazine* (December 1899) is one of the most interesting written about Alma-Tadema. Dolman and Alma-Tadema sat in Tadema's studio smoking cigars and 'talking shop'. Dolman wrote, 'Of about the middle height, Sir Lawrence looks lithe and strong, and although his rather shaggy hair is partially grey, and the pince-nez looks like a fixture, you would never take him to be a man who had seen sixty-three years and painted more than three hundred important pictures.' They talked about marble painting, models, plays, working habits, and many other subjects.

Perhaps the best book written about Tadema was Percy Cross Standing's *Sir Lawrence Alma-Tadema, O.M., R.A.* (1905). The late date of the work, by a close friend of Tadema, makes it more complete than any study until then, although Standing, neither a student of art criticism nor a recognised historian, failed to evaluate Tadema critically. Rudolf Dircks' work, *The Later Works of Sir Lawrence Alma-Tadema, O.M., R.A.* (1910), is more critical than Standing's. Dircks appraises Tadema as an artist whose fame would last, indeed increase with each succeeding generation. Despite this erroneous assessment, his book included many fine illustrations and catalogued four hundred numbered paintings by the artist.

The period from 1883 to 1912 was the most important in terms of quantity and quality of critical appraisals on Tadema's career. It contains major articles and the only contemporary books on Alma-Tadema; although the quality of criticism varied, most of the literature was definitely in Alma-Tadema's favour. With his death, that bias changed.

Third Period (1913-1962)

The dark period was about to begin for Alma-Tadema. Fortunately for him, he was not alive to be humiliated. A writer in the January 1913 issue of *Nation* said, 'I think Tadema himself realized that his greatness was a little dimmed in the eyes of the world before he died. He could sometimes be so bitter that it was clear he heard with apprehension the younger generation of critics and artists knocking at the door.'

After his death at Wiesbaden, Germany, on 25 June 1912, many papers carried derogatory obituaries denouncing his work. The August 1912 issue of *Fine Arts Journal* stated that his pictures were 'learned-up affairs... the merely beautiful execution of Tadema has been relegated to forgetfulness.' The Royal Academy held a large retrospective of Alma-Tadema's work at Burlington House from January to March 1913. *Connoisseur* reviewed the exhibition and discovered the 'raison d'être' of Alma-Tadema's art: it satisfied the personality of the artist himself.

In reaction to the over-abundance of damning criticism, John Collier, Tadema's pupil took up his defence, and tried to stem the tide of modern criticism against Tadema. In exasperation Collier exclaimed: 'His fame will survive their attacks. And when I recall the pictures that they admire I think I am glad they have not praised my dead friend.'

It was eight years before Alma-Tadema's name re-emerged. Then William Starkweather's 'Alma-Tadema: Artist and Archaeologist' in *Mentor* (March 1924) praised Alma-

Tadema. He wrote about his studio, and how its colours affected his paintings, of his stage sets, the numbering of his paintings and his lack of sentiment. This article included the last praise Tadema received for many years. In 1928 Walter Pach wrote his book *Ananias or the False Artist*. It helped to undermine the faith of Alma-Tadema supporters, and finally to turn public opinion against him. Pach says of Alma-Tadema, 'One does not reproach Alma-Tadema for his naturalism... What gives his work its grovelling futility is his failure to imagine any quality beyond naturalism... It represents human skill applied to the poorest purposes ever known.' The reputation of Alma-Tadema goes from dismal to bleak and for the next twenty-two years almost nothing was written about the painter: an amazing eclipse for anyone of Tadema's former stature.

The school of the Classicists finally received the scholarly examination they had lacked since Alma-Tadema's death in William Gaunt's book, *Victorian Olympus* (1952). The book did not wholeheartedly praise Tadema, but it did credit him as a sensitive and skilful artist. By this time Tadema was virtually forgotten. Writing in *The Listener* in 1954, Philip Carr had to explain that despite his strange name, Alma-Tadema was not a woman. During this time, the lowest ebb of Alma-Tadema's reputation, scorn was invariably the dominant note whenever the artist was mentioned at all.

Fourth Period (1962-1977)
Interest in Tadema revived with the appearance of an American art dealer, Robert Isaacson, a collector, James Coats, and their friend Dr Mario Amaya of the New York Cultural Center. Amaya wrote 'The Roman World of Alma-Tadema' for *Apollo* (December 1962), the first major article about the artist since 1924. His appraisal of the English master in the light of modern criticism was penetrating and accurate. Balancing praise with criticism and thoughtful insights, Amaya tried to explain the reason why the 'Alma-Tadema phenomenon' could happen in Victorian England.

Victorian Painting (1966) by Graham Reynolds devoted one chapter to the Classicist school of England. Tadema figures prominently in this chapter, but not in a flattering way. 'Alma-Tadema is one of those artists whose work has to be taken at its absolute peak to be acceptable.' Reynolds, however, did approach the study of this school in a scholarly fashion, and it would have been considered reckless in 1966 to have given any more than tacit approval to Tadema's work.

Sir Lawrence was beginning to be studied more intently.

Jeremy Maas' *Victorian Painters* (1969) offered an interesting appraisal 'It was Alma-Tadema's intention to attempt in the light of available knowledge to reconstruct a view of the antique world in which an aspiring middle class could see themselves reflected.' The previous year Amaya's second article on Alma-Tadema had appeared in the London *Sunday Times Magazine* (18 February 1968).

In the 1970s the re-evaluation of Alma-Tadema continued to shed more light on the artist. Christopher Wood, then Christies' specialist in Victorian painting, commented, 'Alma-Tadema is very unfairly ridiculed as the epitome of Victorian bad taste. It is encouraging that dealers and collectors are beginning to challenge that judgment.' Significantly the collection of Allen Funt was deemed worthy enough by the Metropolitan Museum to be exhibited there in March and April of 1973. Christopher Forbes wrote the catalogue which provided for the first time since 1910 a large number of Tadema illustrations. Later that year Russell Ash's fully illustrated catalogue for the Sotheby's Belgravia sale of Funt's collection offered the public an opportunity to view his work illustrated in colour. Also in 1973 Ash produced the first book since 1910 on the life of Alma-Tadema. He brought together a large quantity of reference material thus making his book a mine of information on the artist.

Currently with the general resurgent popularity in academic painting, Alma-Tadema is playing an important role in the criticism of Victorian and academic art. The present reappraisal of the artist is typified by the latest exposure he is receiving. The first European exhibitions of his work since the poorly-attended memorial exhibition of 1913 were staged in Rotterdam and Leeuwarden in Holland in 1974, and in April 1976 at Auburn University, Alabama, the author organized the largest Tadema exhibition outside New York. Later in 1976 the Sheffield City Art Gallery organized an excellent exhibition of Alma-Tadema's work which helped to focus attention to Tadema outside London, where it had previously been concentrated. Finally, under the author's direction, the Brigham Young University Art Museum, Provo, Utah, has begun a collection of Tadema's work. As the only institution actively to collect his work, Brigham Young University plans to provide museum space for the study of late nineteenth-century academic art using Alma-Tadema as the focal point. The author is also preparing a complete catalogue raisonné of Alma-Tadema's paintings, and would be grateful for any additional information which can be addressed to him c/o his publishers.

COLOUR PLATES

1

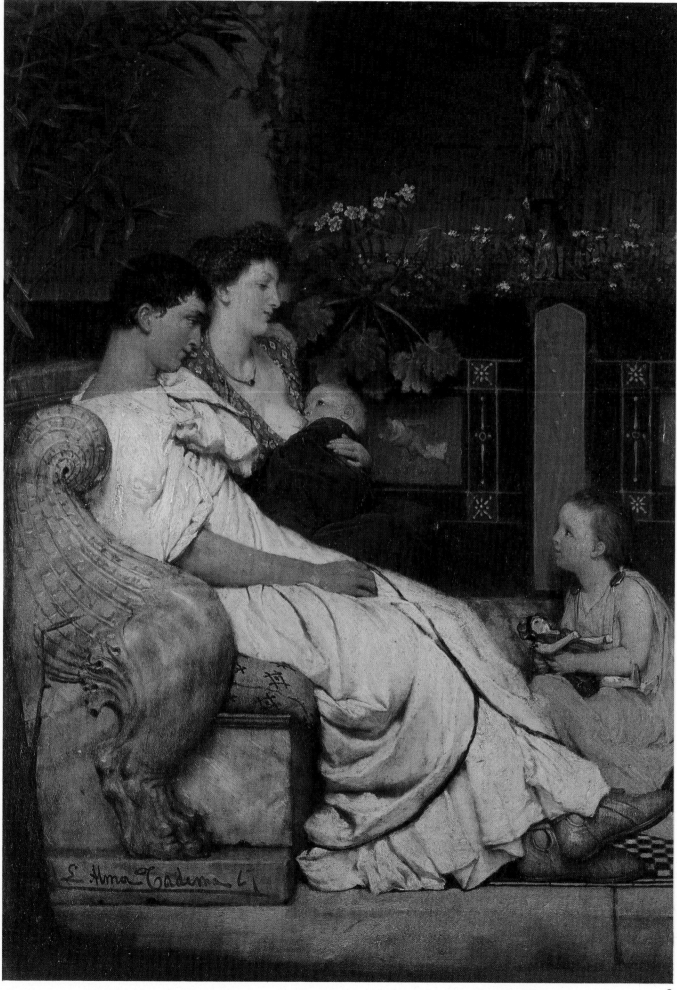

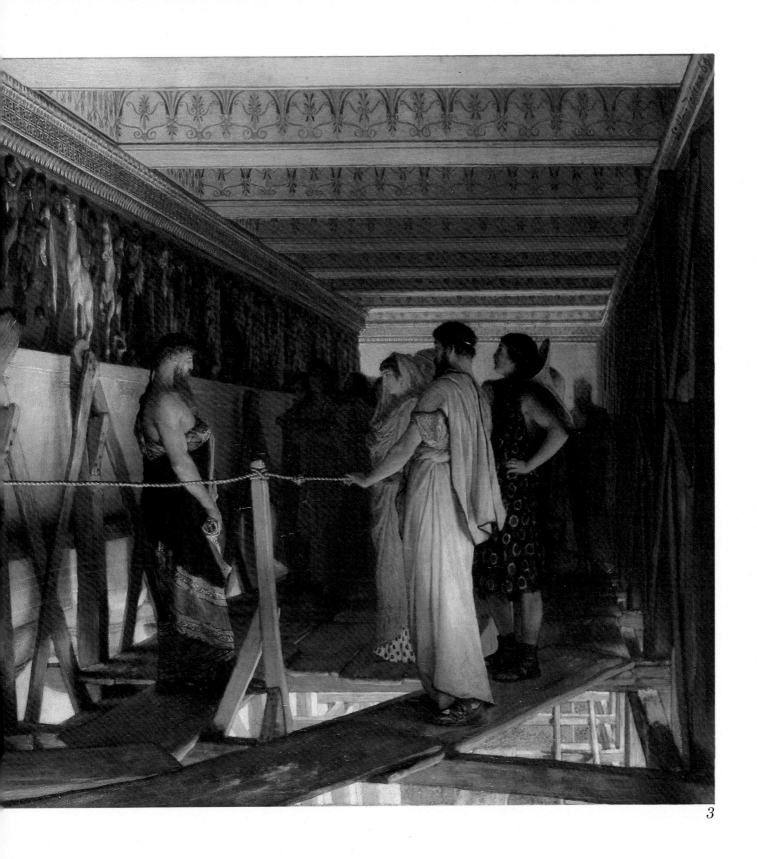

3

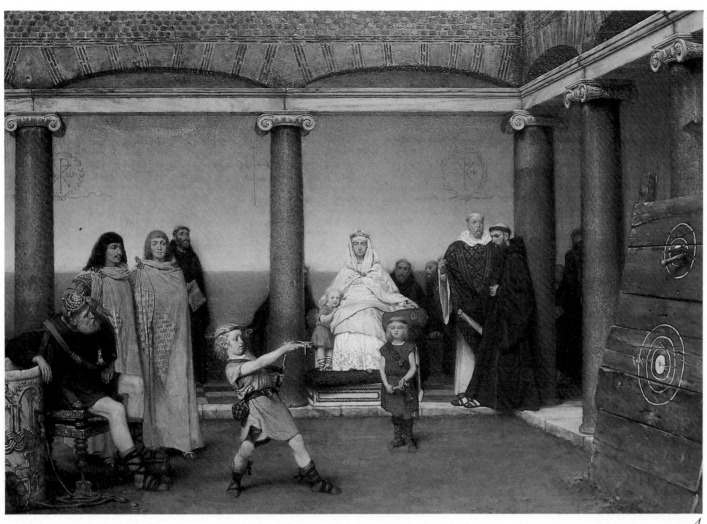

4

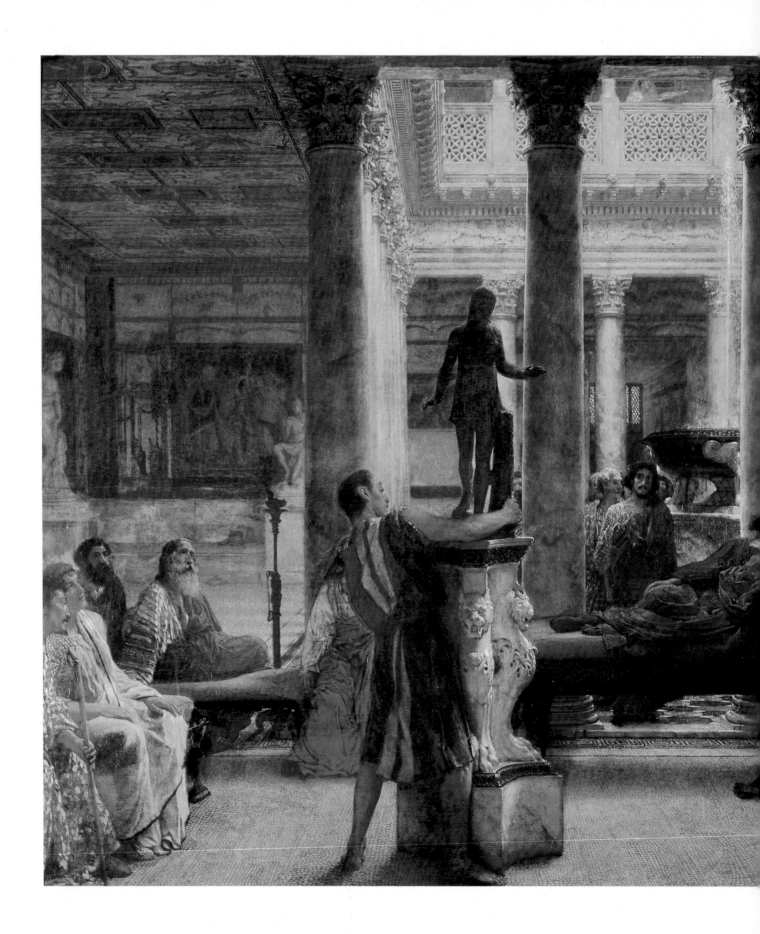

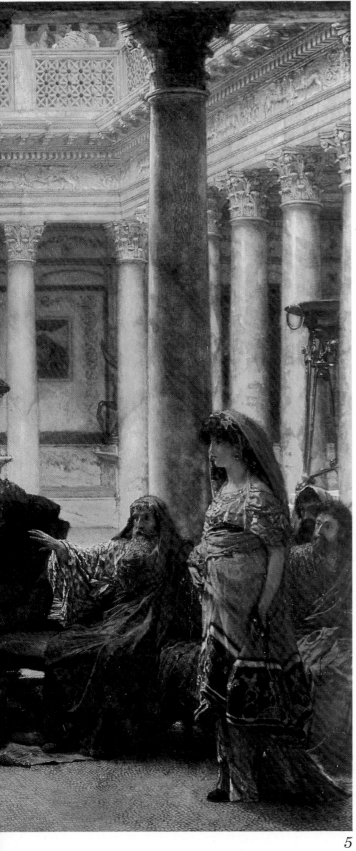

5

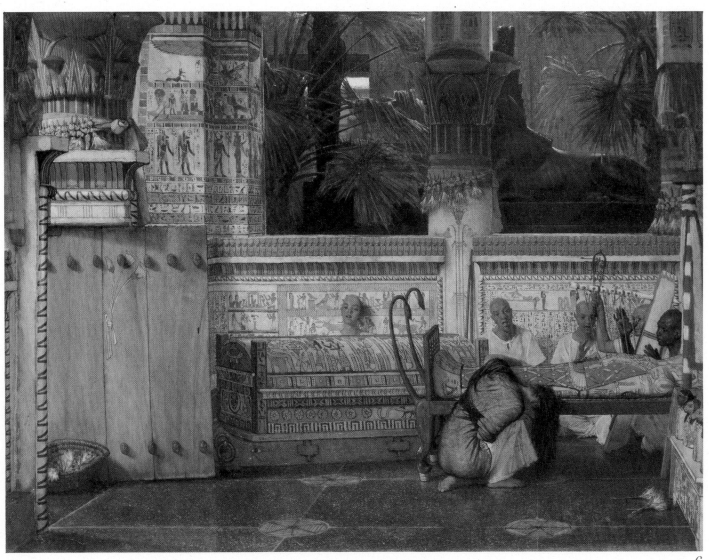

6

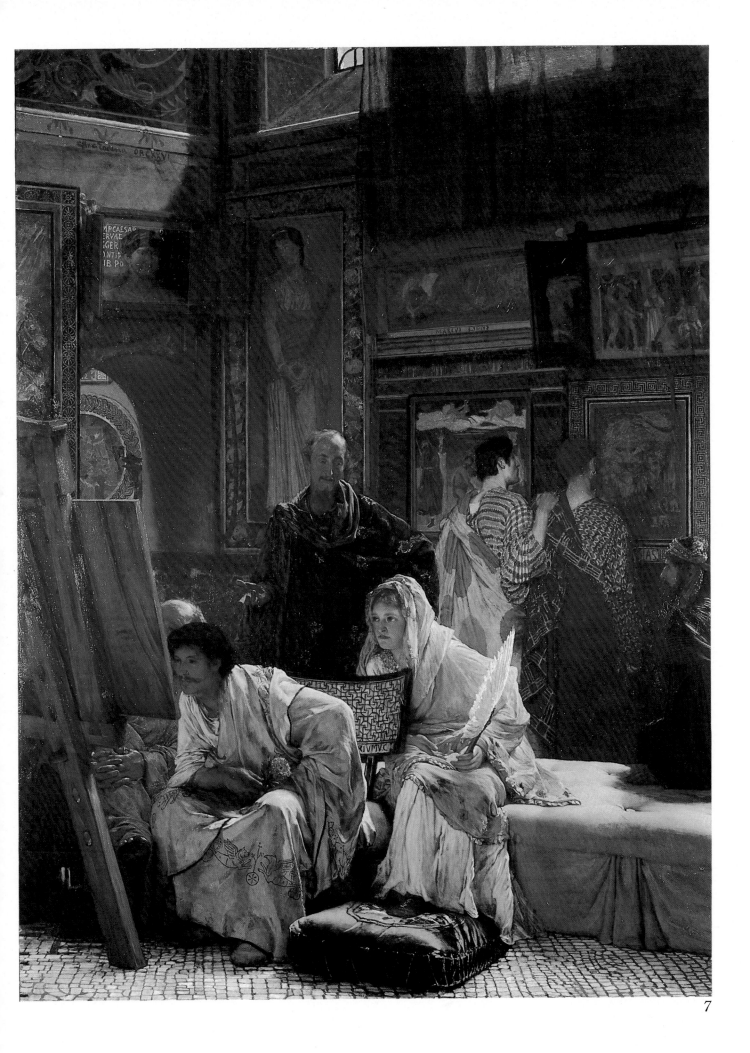

7

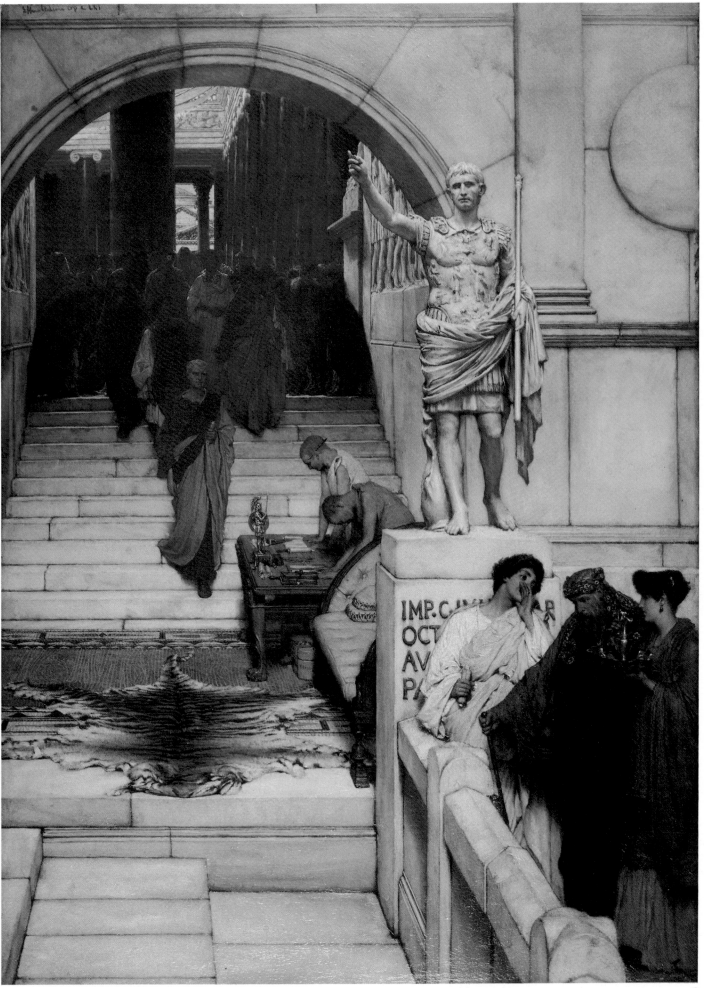

8

9

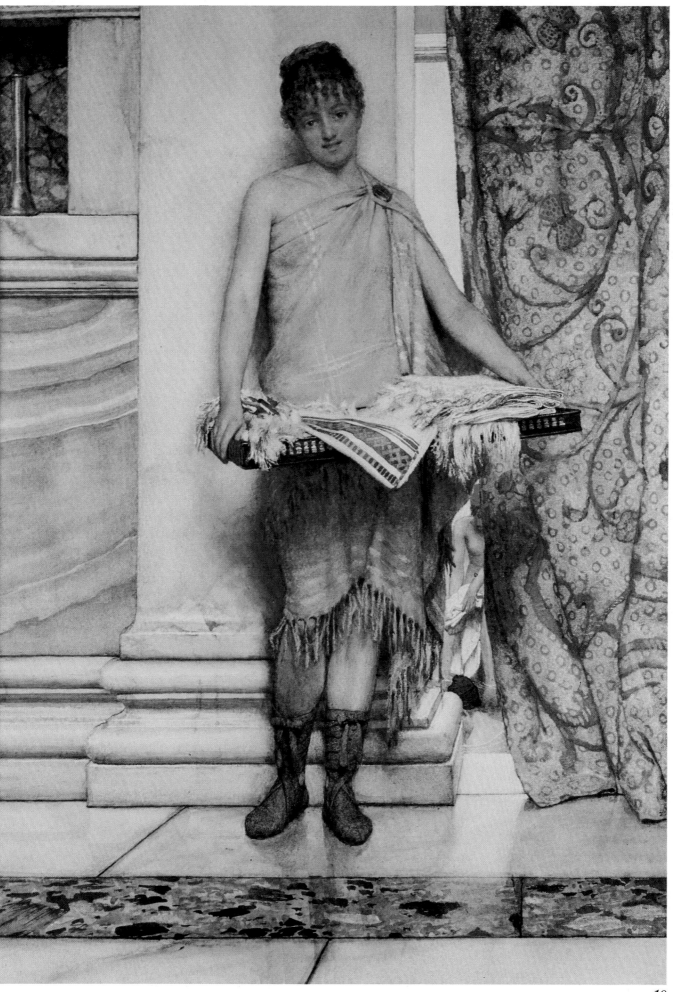

10

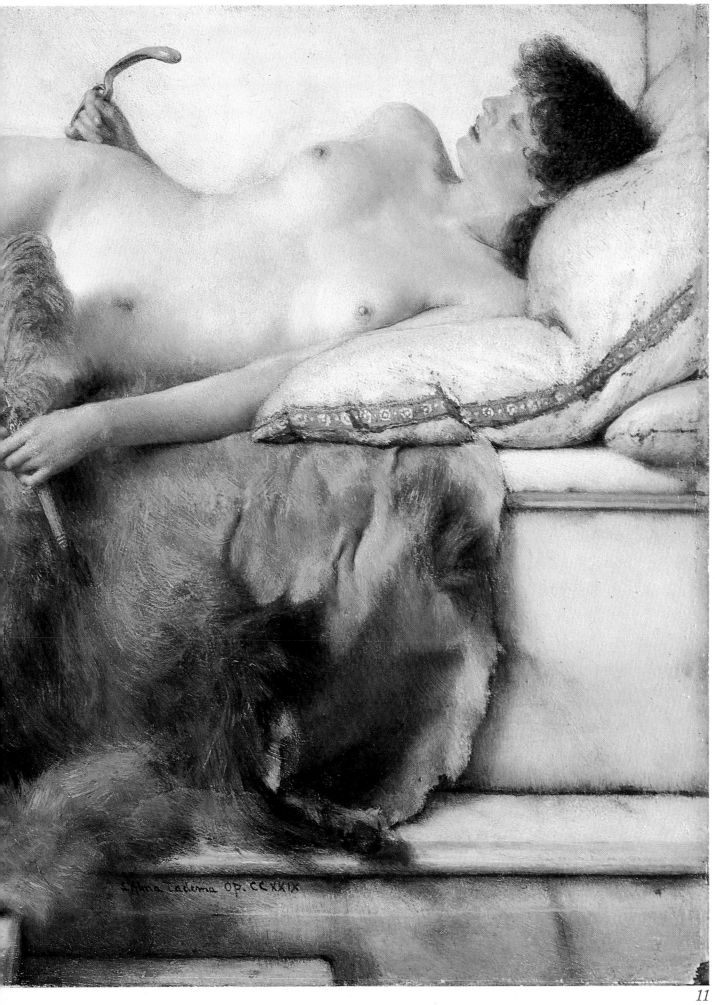

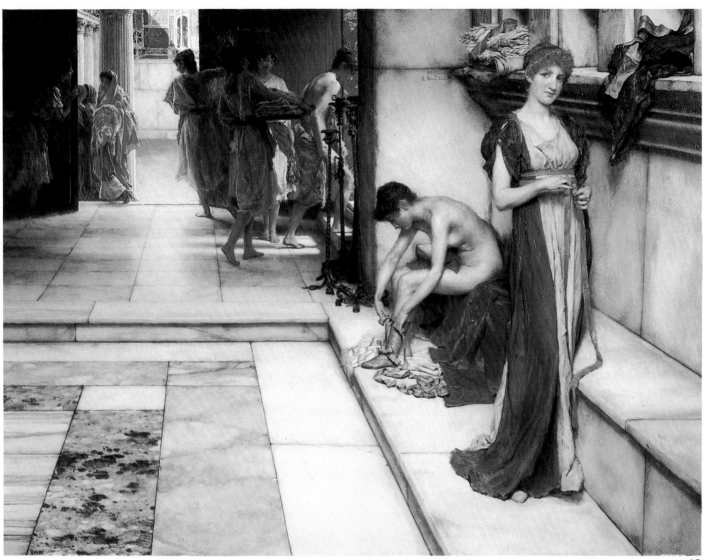

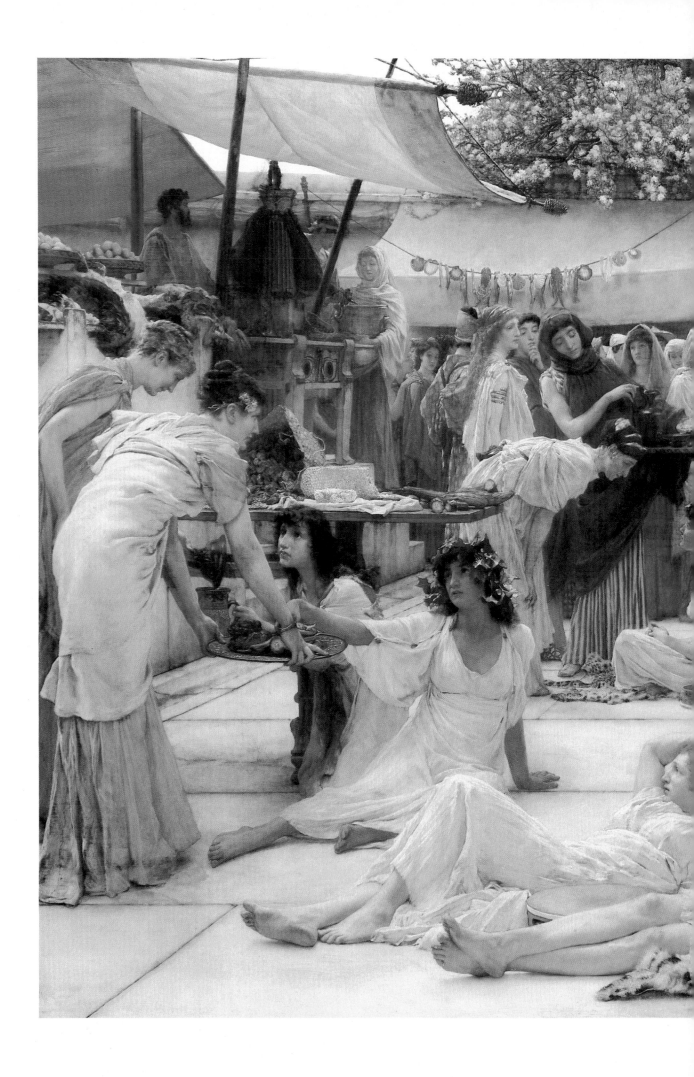

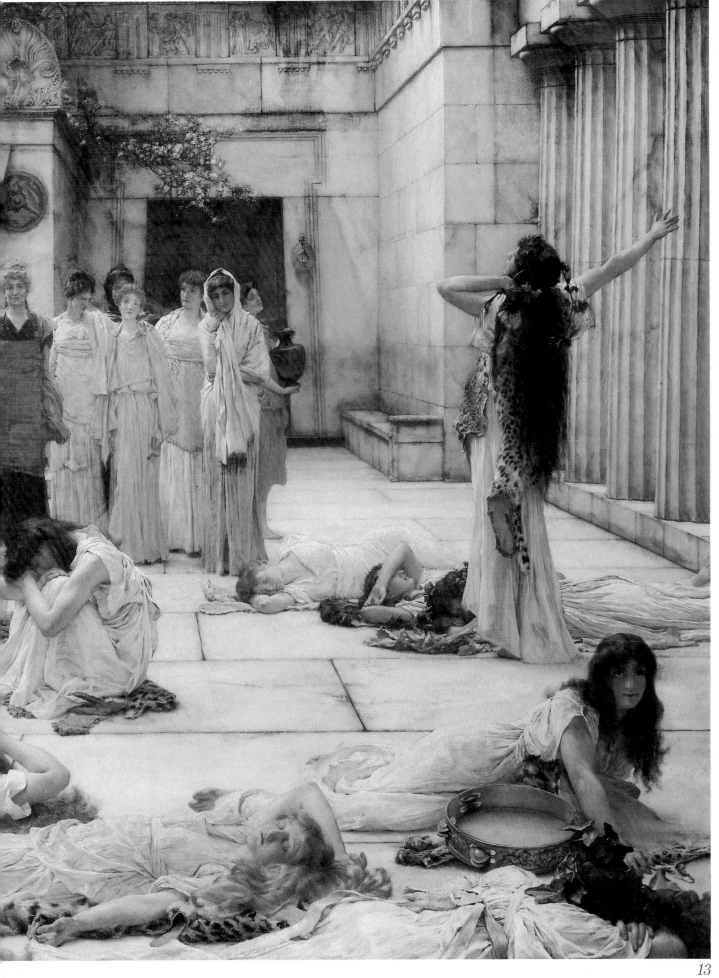

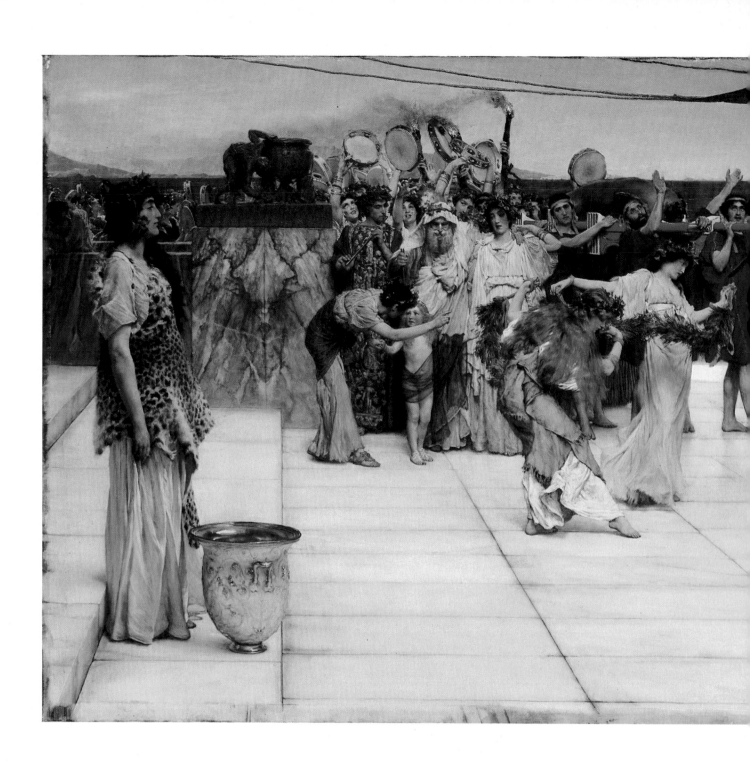

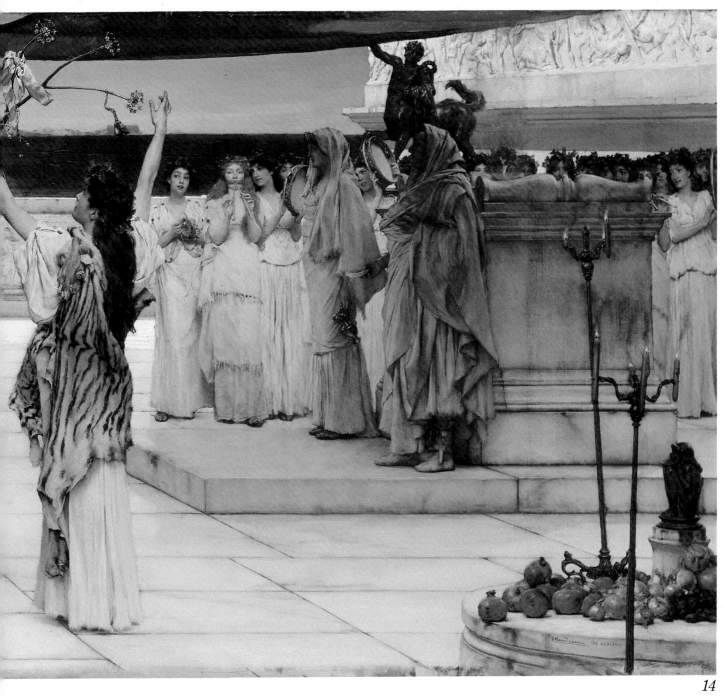

14

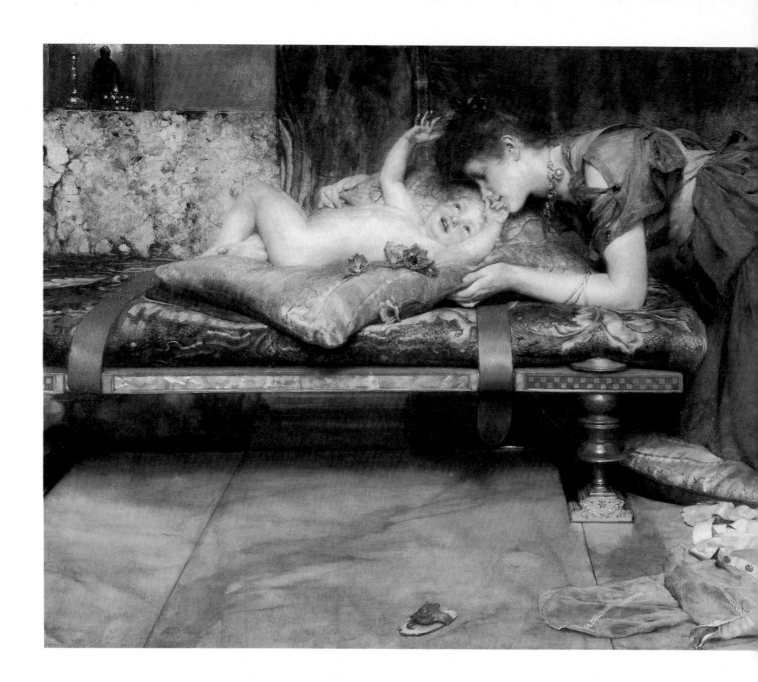

15

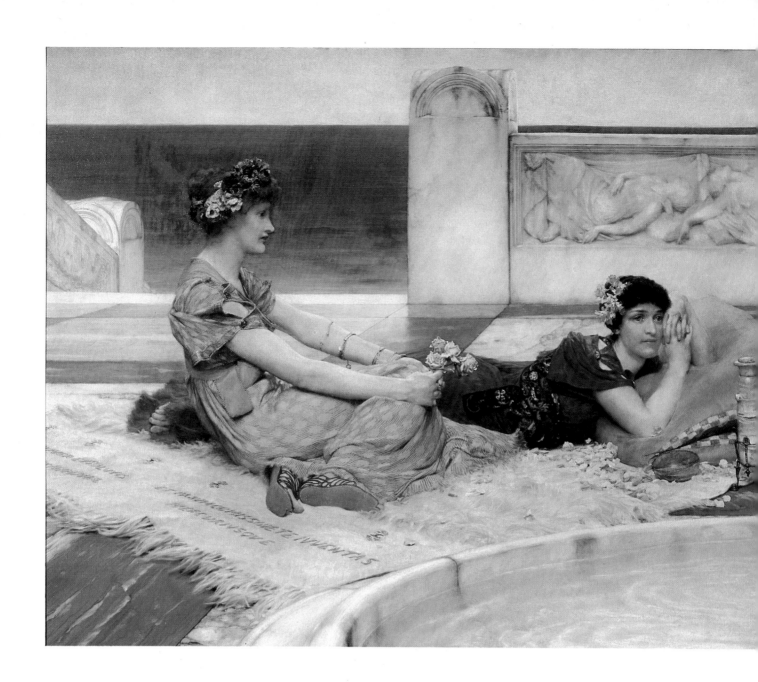

16

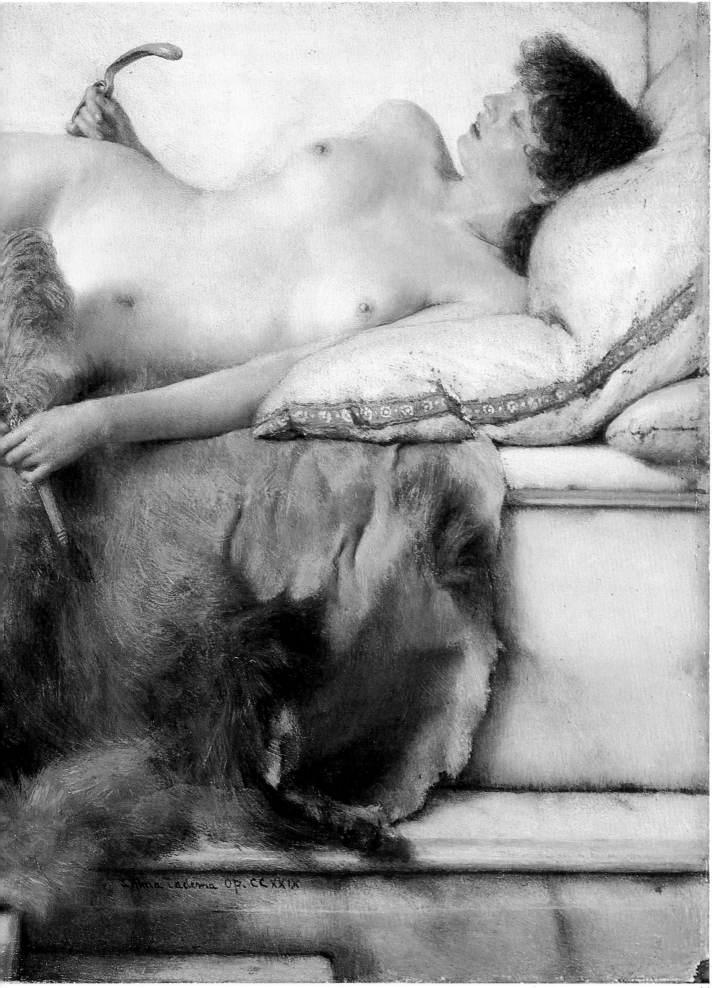

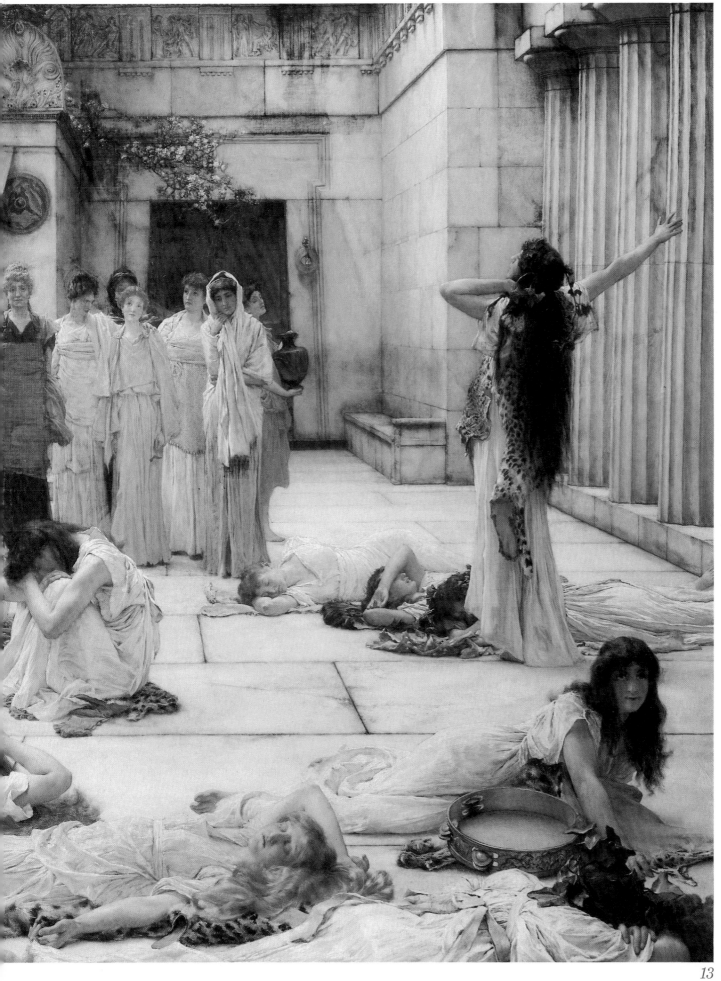

13

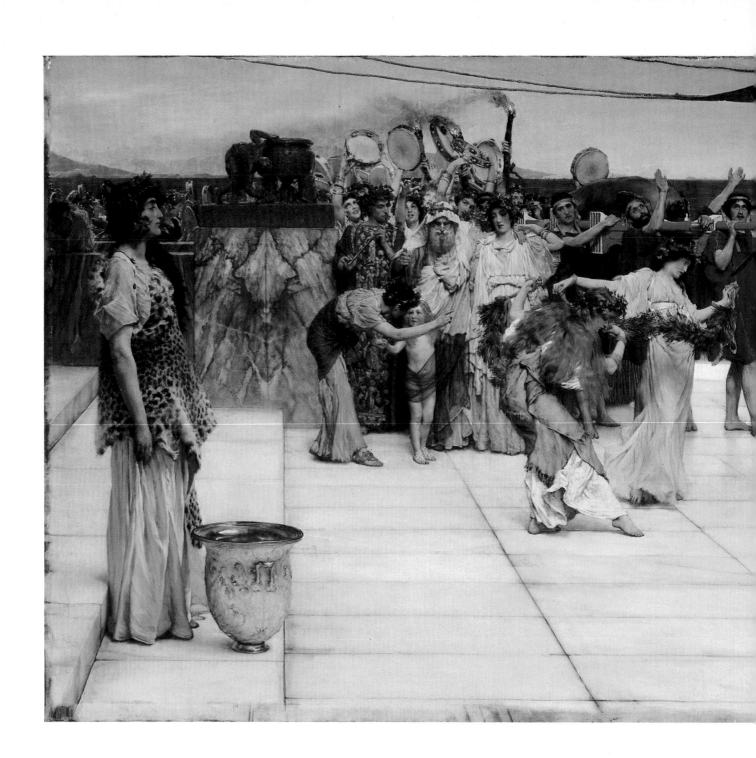

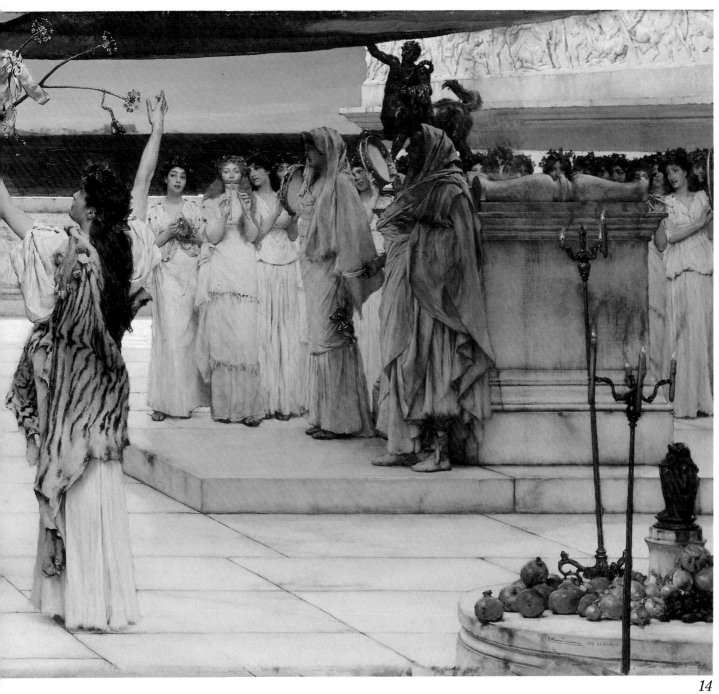

14

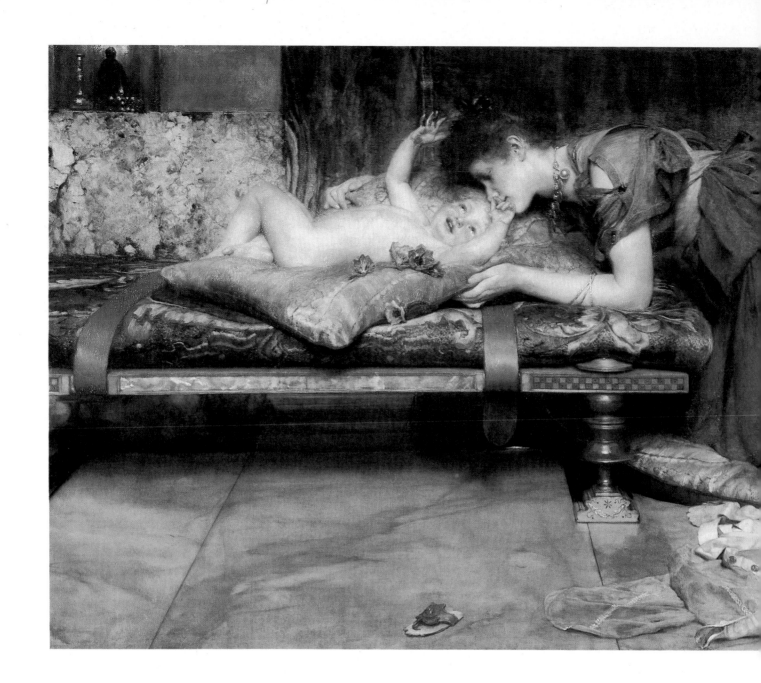

15

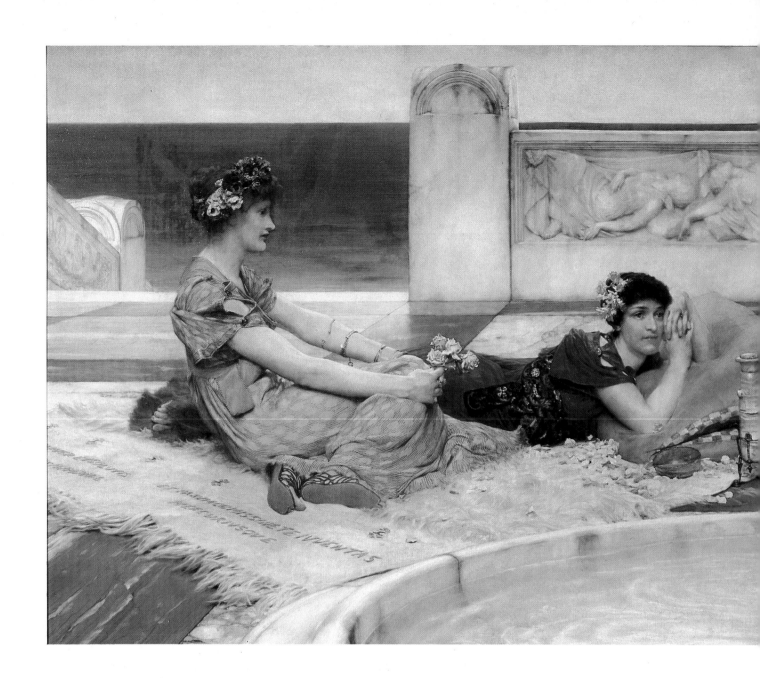

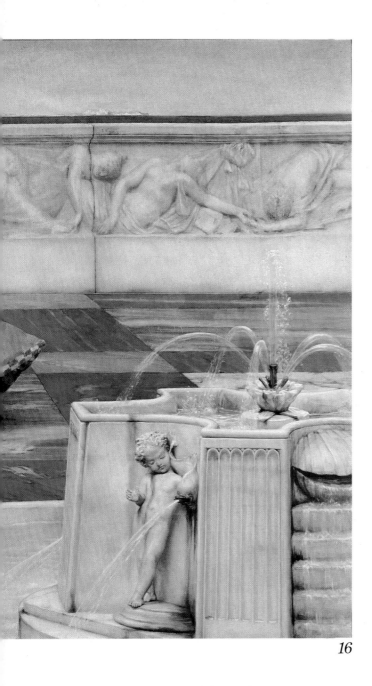

16

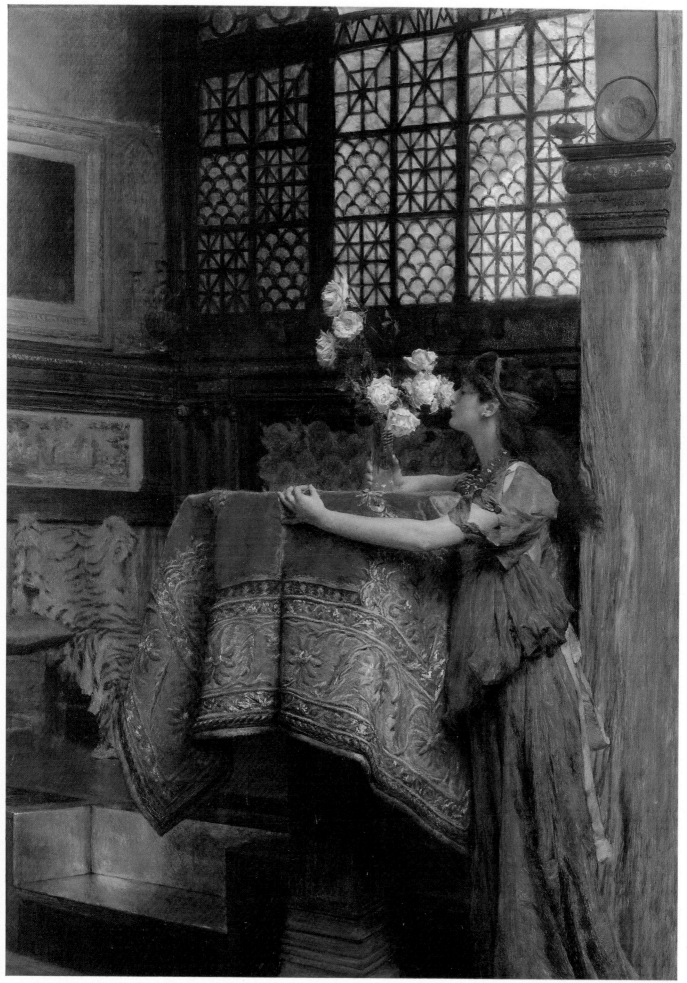

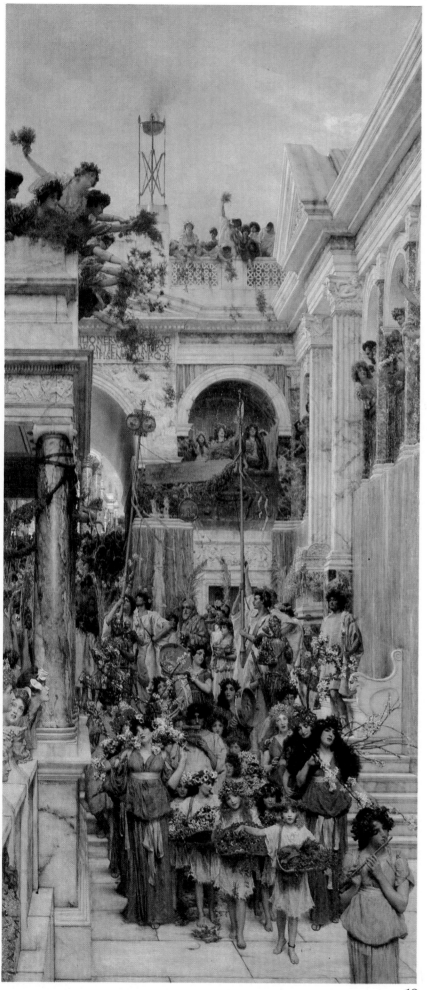

18

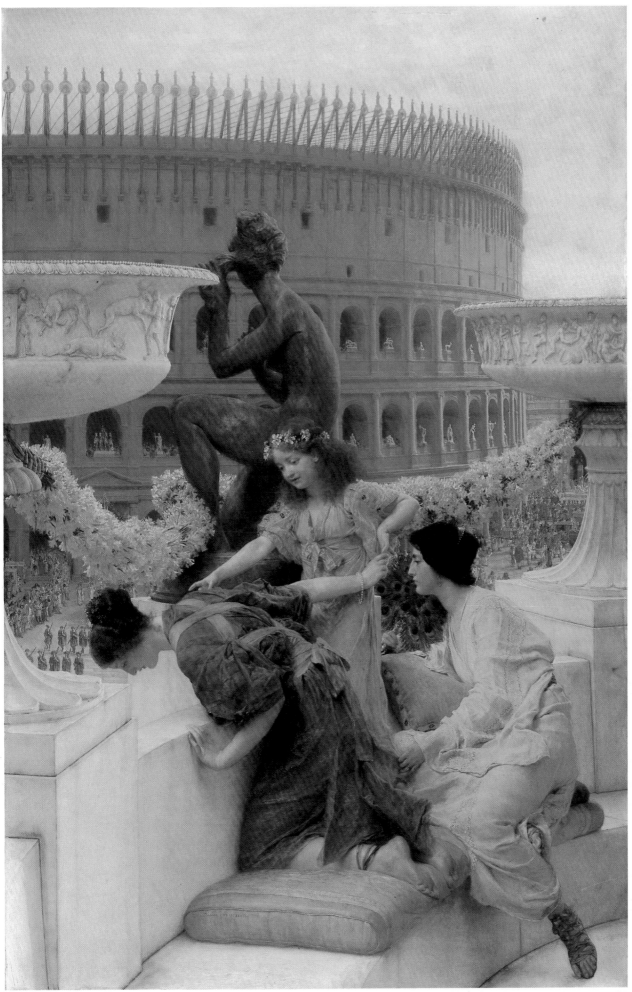

19

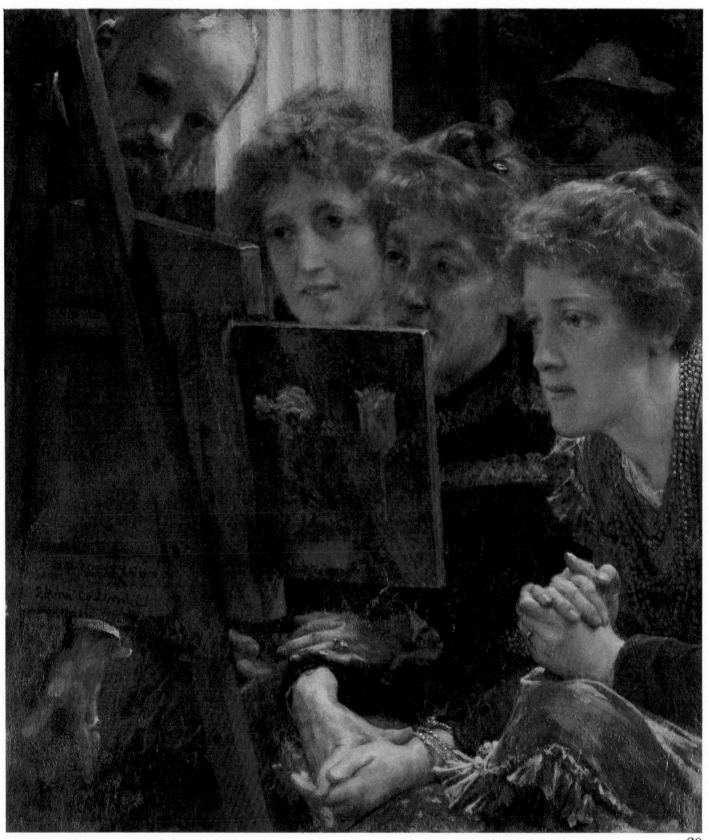

20

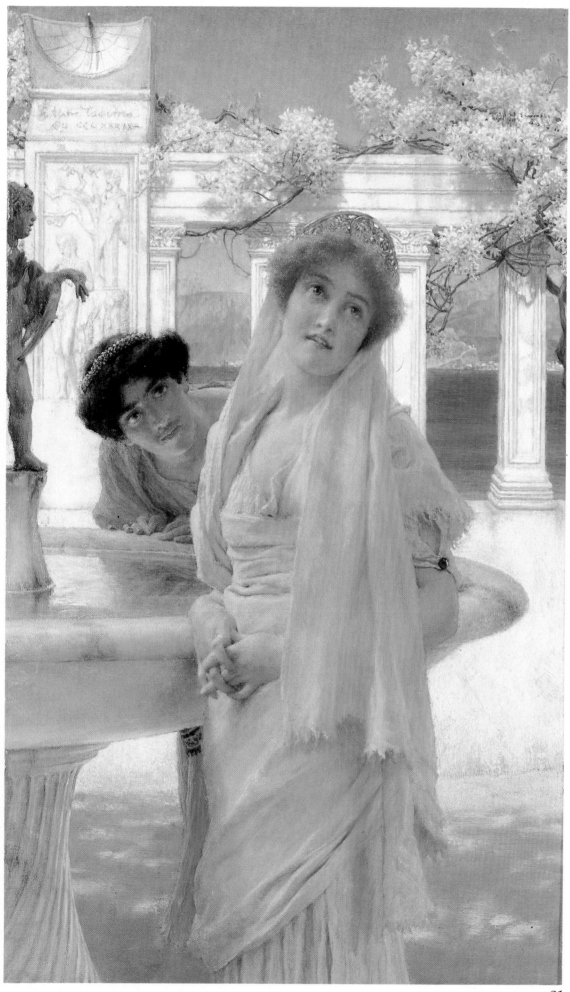

21

22

23

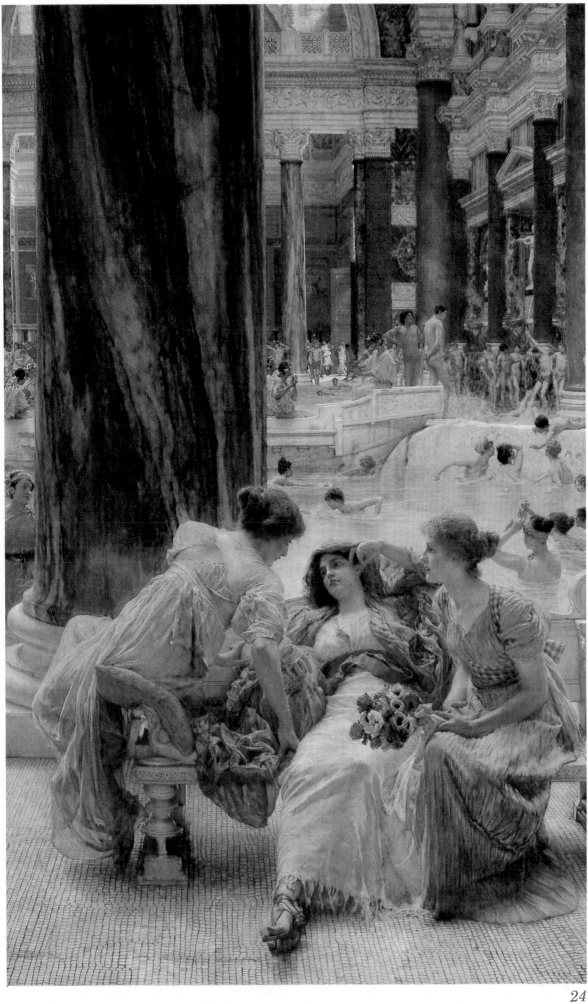

24

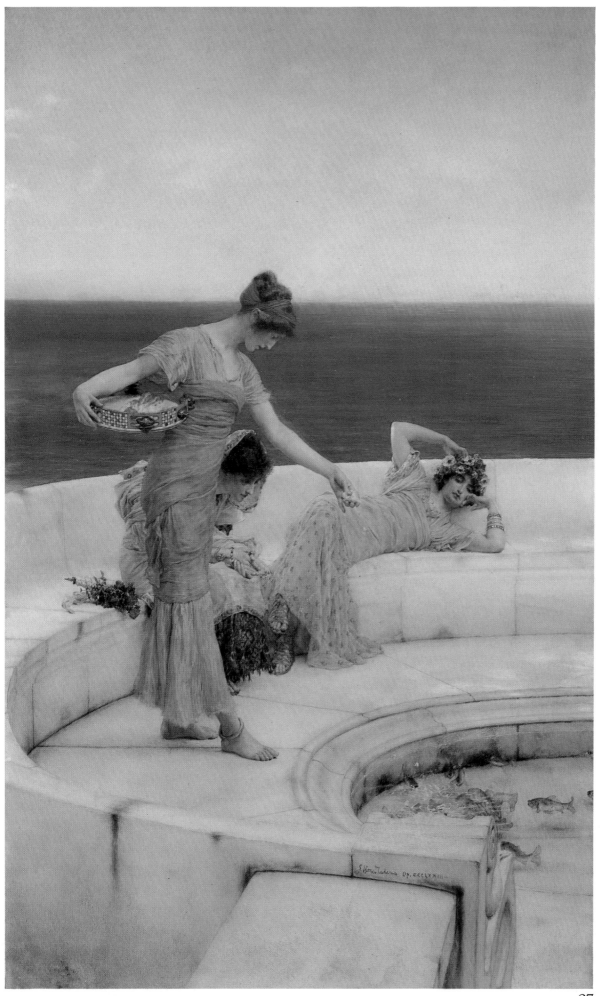

27

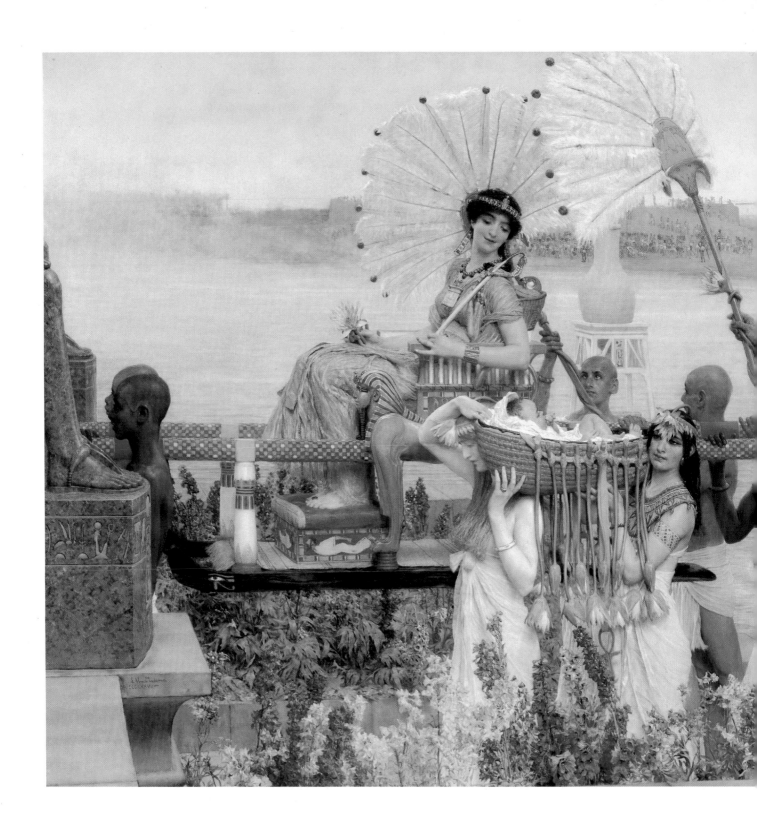

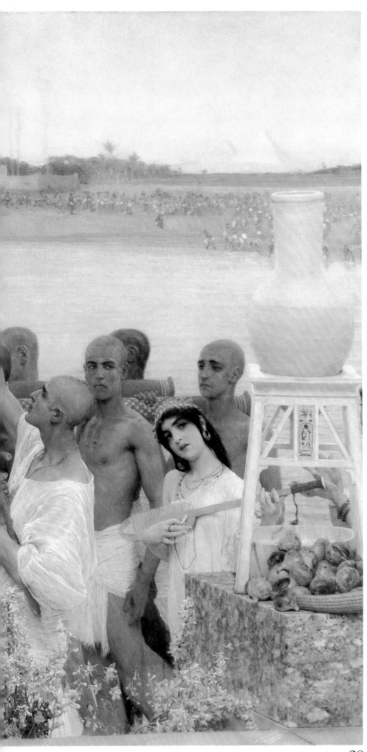

28

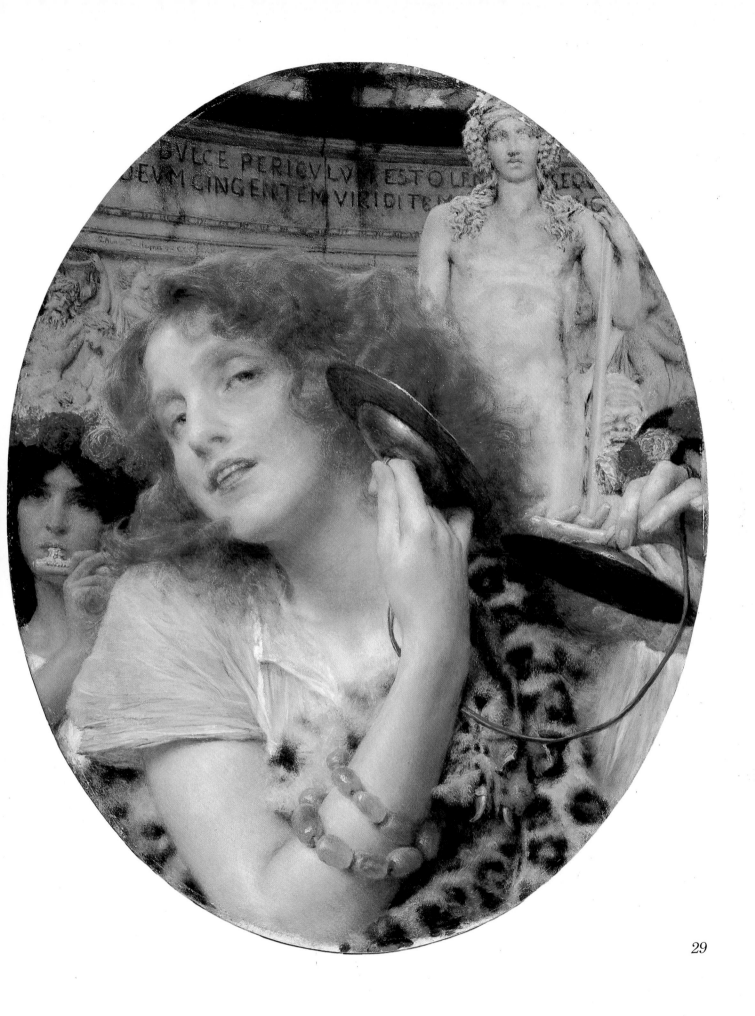

29

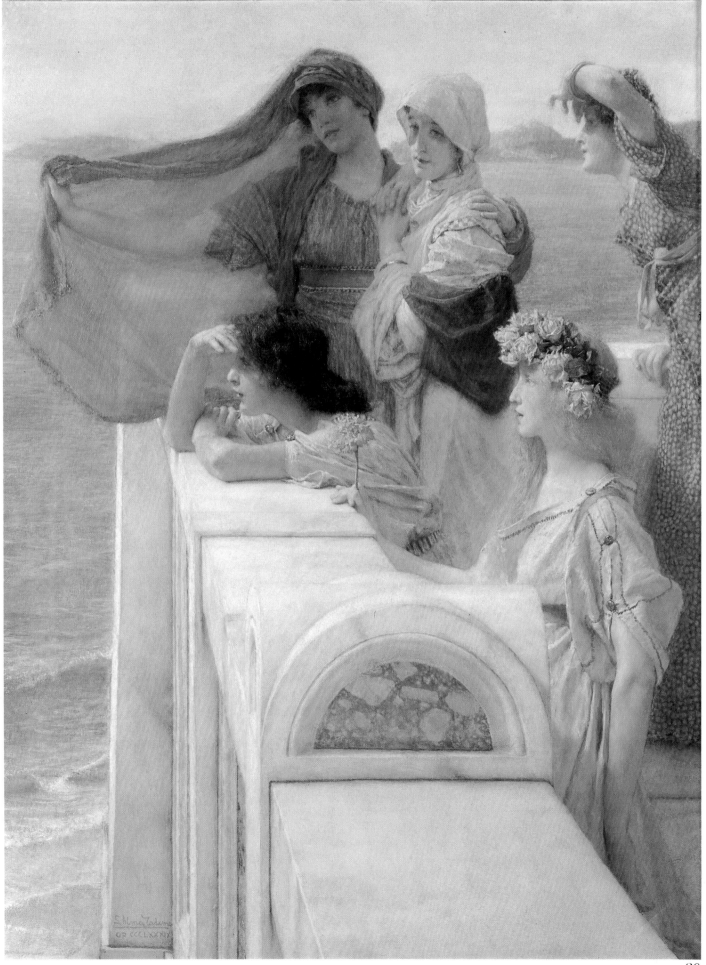

30

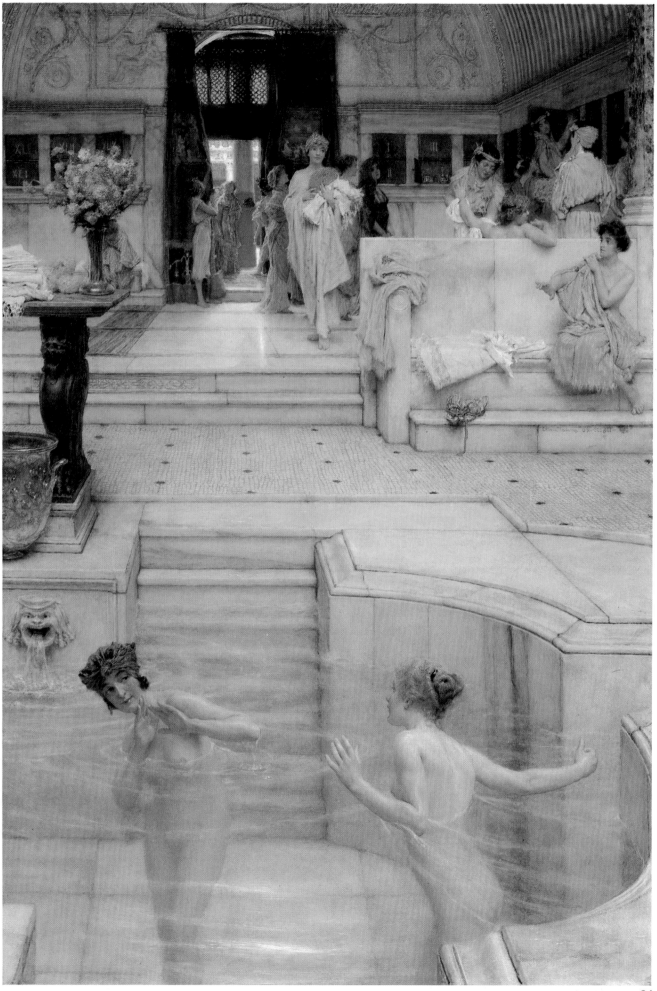

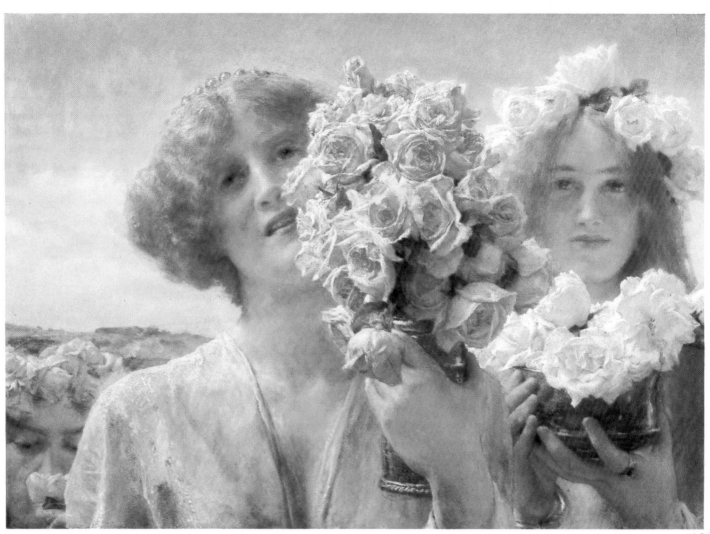

32

COLOUR PLATE CAPTIONS

Plate 1
Faust and Marguerite
(Opus VII, 1857) Watercolour, 18 x 19¾ (45.7 x 50.1)
One of Tadema's first pictures painted at the Antwerp Academy, it exemplifies his abilities as a watercolourist. It depicts Faust meeting Marguerite as she leaves church, and was painted at the time when he belonged to a group of students of German history and literature. (See pp. 10; 21)
(John Constable Esq., England)

Plate 2
A Roman family
(Opus LII, 1867) Oil on panel, 19 x 13¾ (48.2 x 35)
Typical of Tadema's early sombre 'Pompeian' works, it portrays himself with his first wife, Pauline. She is breast-feeding their daughter, Anna, while Laurence plays with a doll.
(Private Collection, England; Photo: Sotheby's Belgravia)

Plate 3
Phidias and the Parthenon
(Opus LX, 1868) Oil on panel, 28⅜ x 43½ (72 x 110.5)
Although criticized for showing the Parthenon frieze in garish colour, Alma-Tadema was archaeologically correct in so doing. The characters seen viewing Phidias' sculptures include Pericles, Aspasia, Alcibiades, Socrates and other eminent Greek philosophers. Tadema saw the Elgin Marbles on his first visit to London in 1862. (See pp. 12; 16)
(Birmingham Museums and Art Gallery)

Plate 4
The education of the children of Clovis
(Opus LXIV, 1868) Oil on panel, 25½ x 35¾ (64.8 x 90.9)
An example from Tadema's short-lived Merovingian period, in which Queen Clotilde, wife of King Clovis, is shown teaching her children martial arts in order to avenge the deaths of her parents. This is a later version of Opus XIV. (See p. 12)
(Messrs. M. Knoedler & Co., New York)

Plate 5
Roman art lover (the runner)
(Opus LXXIX, 1870) Oil on panel, 29 x 40 (73.5 x 101.6)
One of many paintings set in the home of a wealthy Roman connoisseur. He is seen examining a bronze statue of an Amazon runner. Behind the figure on the left can be seen the Venus de Medici. (See p. 43)
(Milwaukee Art Center, Milwaukee, Wisconsin)

Plate 6
An Egyptian widow
(Opus XCIX, 1872) Oil on panel, 29 x 38½ (73.9 x 98.1)
An ancient genre scene created by assembling a range of appropriate props—accurately rendered painted columns, a statue of Pasht and other items of furniture—with a group of mourners. (See p. 13)
(Rijksmuseum, Amsterdam)

Plate 7
A picture gallery
(Opus CXXVI, 1874) Oil on canvas, 86½ x 65½ (219.7 x 166)
Commissioned by Gambart for the then enormous sum of £10,000 it was extremely popular and was selected for showing at the Royal Jubilee Exhibition in Manchester in 1887. It includes representations of a number of well documented Roman paintings, including the figure of Medea by Timomachus, which was bought by Julius Caesar for 20 talents. (See p. 23)
(Burnley Borough Council, Towneley Hall Art Gallery and Museums; Photo: Bucentaur Gallery, London)

Plate 8
An audience at Agrippa's
(Opus CLXI, 1876) Oil on canvas, 35¾ x 24¾ (90.8 x 62.8)
The Roman general and statesman, Marcus Vipsanius Agrippa (c.63-12 BC) is seen descending a flight of stairs followed by a group of petitioners. A statue of the Emperor Augustus appears on the right. Tadema jocularly painted a sequel, *After the audience*, in which we see the back of Agrippa as he ascends the staircase. (See pp. 21; 22)
(Dick Institute, Kilmarnock)

Plate 9
94 degrees in the shade
(Opus CLXIV, 1876) Oil on canvas, 14 x 8½ (35.4 x 21.5)
Herbert Thompson, the son of Tadema's friend and physician, Sir Henry Thompson, was the model for this unusually Impressionistic work which was painted in a cornfield at Godstone, Surrey. (See pp. 17; 43)
(Reproduced by permission of the Syndics of the Fitzwilliam Museum, Cambridge)

Plate 10
Balneatrix
(Opus CLXIX, 1876) Watercolour, 14½ x 10½ (36.9 x 26.8)
Alma-Tadema frequently painted scenes in Roman public baths. Here he employs his often repeated technique of offering the spectator a glimpse through an opening to another set of images beyond.
(Setton Collection Paris; Photo: Sotheby's Belgravia)

Plate 11
In the tepidarium
(Opus CCXXIX, 1881) Oil on panel, 9½ x 13 (24.2 x 33)
Here reproduced slightly larger than the original, this painting displays Alma-Tadema's consummate skill as a miniaturist.

One of his most sensuous works, it depicts a woman reclining in a tepidarium—the room between the hot and cold rooms of a Roman bath. She holds a strigil or body scraper in one hand and an ostrich feather fan in the other. (See p. 50)
(Lady Lever Art Gallery, Port Sunlight)

Plate 12
An apodyterium
(Opus CCLXXIV, 1886) Oil on panel, 17½ x 23½ (44.5 x 59.5)
Voted 'Picture of the Year' by the *Pall Mall Gazette*—John Singer Sargent's *Vickers Sisters* being voted the worst—it shows the apodyterium or dressing room of a ladies' bath. The nudity was regarded as acceptable because the setting was obviously classical; Victorians might not disport themselves in this way, but they knew that Ancient Romans did.
(Mr and Mrs Joseph M. Tanenbaum, Toronto)

Plate 13
The women of Amphissa
(Opus CCLXXVIII, 1887) Oil on canvas, 48 x 72 (121.8 x 182.8)
The Greek city of Amphissa, or Salona, destroyed by Philip of Macedonia in 338 BC, was a major centre of the cult of Dionysus. In this sumptuous painting, exhausted bacchantes, followers of the cult, awake after a night of revels and are tended by local women.
(Private collection, England)

Plate 14
A dedication to Bacchus
(Opus CCXCIII, 1889) Oil on canvas, 30½ x 69¾ (77.5 x 177.5)
In a temple beside the sea a child is about to be dedicated to Bacchus. F.G. Stephens produced a pamphlet explaining the archaeological detail; so popular was the painting that about 40,000 copies were sold. The work is a good example of Tadema's re-use of elements, such as the silver crater which reappears in *A favourite custom* (Plate 31). (See pp. 27; 53)
(Hamburger Kunsthalle)

Plate 15
An earthly paradise
(Opus CCCVII, 1891) Oil on canvas, 34 x 65 (86.5 x 165.1)
Alma-Tadema's reversible Pompeian/Egyptian sofa—now in the Victoria & Albert Museum—appears in this and many other paintings, including *The Baths of Caracalla* (Plate 24). Inspired by a poem by Algernon Swinburne, the painting was described in *The Athenaeum* as '...a subtle and refined exercise in blue and its allies ... tints which, severally, are most tender and delicate, and as a whole, combined charmingly in every respect'.
(Private collection, Japan; Photo: Sotheby's Belgravia)

Plate 16
Love's votaries
(Opus CCCVIII, 1891) Oil on canvas, 34½ x 65¼ (87.6 x 165.7)
Also called *Love in idleness*, this painting displays a typical contrast of white marble against a sapphire sea, with suitable archaeological detail—on the rug, for instance, is a verse from Horace's *Odes*.
(Laing Art Gallery, Newcastle-upon-Tyne)

Plate 17
In my studio
(Opus CCCXIX, 1893) Oil on canvas, 23½ x 17½ (59.8 x 44.5)
Sometimes called *In the corner of my studio*, it was painted in exchange for Lord Leighton's *Psyche*, which was presented to Alma-Tadema for his 'Hall of Panels'. It shows such details of Tadema's lavishly appointed studio as a brass step, Mexican onyx windows and the tiger skin which appears in several

works, including *An audience at Agrippa's* (Plate 8). (See p.24)
(Location unknown; Photo: Charles Jerdein Esq.)

Plate 18
Spring
(Opus CCCXXVI, 1894) Oil on canvas, 70½ x 31½ (179.2 x 80.3)
One of Tadema's most famous and ambitious works and the culmination of infinite labour and extensive revisions, it depicts the festival of Cerealia in a Roman street. The models for many of the participants and spectators were Tadema's friends and members of his family. (See pp. 43; 56)
(J. Paul Getty Museum, Malibu)

Plate 19
The Coliseum
(Opus CCCXXXVI, 1896) Oil on panel, 44 x 29 (112 x 73.6)
The Coliseum features in several of Alma-Tadema's paintings, including *Preparations* (p. **35**) and *Caracalla and Geta* (p. **46**). This picture, showing two women and a girl watching a procession, was well received, the critic in *The Athenaeum* writing, 'It would be difficult to do justice to the breadth, brilliance and homogeneity—in spite of its innumerable details—of this splendid picture'. (See pp. 38; 50)
(Private collection, USA)

Plate 20
A family group
(Opus CCCXXXVII, 1896) Oil on panel, 12 x 11 (30.5 x 28)
The group includes Laura Alma-Tadema, her brother, Dr Washington Epps, and their sisters, Mrs Williams and the wife of Edmund Gosse, the critic and one of Tadema's biographers. The symbolic union of the Dutch tulip and English rose, seen also in the Tademas' wedding portrait (p.30) reappears on the panel.
(Royal Academy, London; Photo: Angelo Hornak)

Plate 21
A difference of opinion
(Opus CCCXXXIX, 1896) Oil on panel, 15 x 9 (38 x 22.9)
Increasingly in his later years Tadema painted dazzlingly brilliant scenes such as this, often depicting a courting couple, and incorporating the elements for which he became famous—a vaguely classical setting with white marble contrasting with pink blossom and a deep blue sea and sky.
(Private collection, England)

Plate 22
Self-portrait
(Opus CCCXLI, 1896) Oil on canvas, 25½ x 21 (65.7 x 53.5)
Presented to the Uffizi Gallery, which invited many eminent nineteenth-century artists to donate self-portraits, Tadema portrays himself as the world also viewed him—a successful gentleman painter in pince-nez, suit and with a jewelled tie clasp.
(Uffizi Gallery, Florence)

Plate 23
'Nobody asked you, sir!' she said
(Opus CCCXLIII, 1896) Watercolour, 14 x 10½ (35.5 x 26.7)
Tadema's skill in rendering in watercolour such difficult textures as fur and marble is exemplified in this work. The wooden seat was part of his studio furniture and appears in several paintings. Anna and Laurence are sitting on it in the engraving of his piano (p. **26**).
(Art Gallery of South Australia, Adelaide)

Plate 24

The Baths of Caracalla

(Opus CCCLVI, 1899) Oil on canvas, 60 x 37½ (152.5 x 95)

When first exhibited, the *Art Journal* critic informed his readers that, 'Mr. Alma-Tadema has once more built up a fascinating picture of Roman life, wonderful in its classical faithfulness and truth to archaeological detail. He has restored on canvas the famous bath of Caracalla . . .' (See pp. 38; 44)

(Private collection, England; Photo: Sotheby's Belgravia)

Plate 25

A flag of truce

(Opus CCCLVIII, 1900) Oil on panel, 17½ x 8¾ (44.5 x 22.2)

Donated by the artist to Christies' Artists War Fund sale of 1900, it is typical both of Tadema's ability in depicting flowers and his love of oblique titles; often they imply an epic event, but turn out to show some homely theme— *Venus and Mars*, for example, shows a child holding a statuette of Mars.

(Mr & Mrs Harold H. Stream, New Orleans)

Plate 26

Caracalla

(Opus CCCLXX, 1902) Oil on panel, 9¼ x 15½ (23.5 x 39.5)

The distant view of Caracalla entering the Baths in *The Baths of Caracalla* (Plate 24) was the basis for this picture. Tadema often took a detail from a popular painting and reworked it as a new picture; *Preparations* (p. 35), for example, is a revision of the right-hand section of *Caracalla and Geta* (p. 46).

(Private collection, England; Photo: Sotheby's Belgravia)

Plate 27

Silver favourites

(Opus CCCLXXIII, 1903) Oil on panel, 27¼ x 16⅝ (69.1 x 42.2)

An outstanding example of Tadema's juxtaposition of deep blue sea and gleaming white marble, this painting posed numerous technical difficulties which he was still attempting to resolve on the day the purchaser collected it. (See pp. 30; 50; 54)

(City of Manchester Art Galleries)

Plate 28

The finding of Moses

(Opus CCCLXXVII, 1904) Oil on canvas, 54⅛ x 84 (137.7 x 213.4)

Among Tadema's most spectacular large scale works, it was commissioned by Sir John Aird in whose party he had visited Egypt in 1902. It includes a number of archaeologically precise objects and inscriptions, the results of Tadema's diligent research in museums, in Egypt and his own extensive reference library. (See pp. 29; 43)

(Private collection, England; Photo: Sotheby's Belgravia)

Plate 29

Bacchante

(Opus CCCLXXXIV, 1907) Oil on panel, 16⅜ x 13¼ (41.5 x 33.5)

Bacchantes playing cymbals feature in several of Alma-Tadema's paintings, such as *In the temple* (Opus LXXXIX, 1871). This picture is a companion to the less sensuous and untypically Christian subject, *Orante* (Opus CCCLXXXIII, 1907).

(Private collection, England; Photo: Sotheby's Belgravia)

Plate 30

At Aphrodite's cradle

(Opus CCCLXXXIX, 1908) Oil on canvas, 19½ x 15 (49.6 x 38)

Originally titled *The ever-new horizon* (Opus CCCLXXV, 1903), it was repainted and retitled. Like *A coign of vantage* (p. 39) it is a remarkable exercise in perspective with Tadema's typical contrast of sea and marble.

(Dr & Mrs Irving Warner, California)

Plate 31

A favourite custom

(Opus CCCXCI, 1909) Oil on panel, 26 x 17¾ (66 x 45)

Alma-Tadema generally avoided attack from critics in his painting of nudes as most were acceptably 'classical'. In this painting, however, although the trappings are obviously classical, the subject matter veers toward coyly risqué Edwardian humour.

(The Tate Gallery, London)

Plate 32

Summer offering

(Opus CCCCIII, 1911) Oil on panel, 14 x 20½ (35.5 x 52.1)

An unusual symbolic work comprising idealized portraits of Tadema's daughters, Laurence and Anna—then both in their forties—holding beautiful flowers, while Laura, who died two years previously, appears in the background holding wilting blooms. (See pp. 30; 48)

(Dr George Nicholson, Oregon)

SIR L ALMA TADEMA R A

BIBLIOGRAPHY

Alma-Tadema, Lawrence, 'An address on sculpture, April 7th 1888', *Guild and School of Handicrafts Transactions*, I, 1890

Alma-Tadema, Lawrence, 'Art in its Relation to Industry', *Magazine of Art*, XVI, 1893

Alma-Tadema, Lawrence, *Last Will and Testament of me, Lawrence Alma-Tadema* (typescript), London, 1 January 1898

Alma-Tadema, Sir Lawrence and Brindley, W., 'Marbles: their ancient and modern application', *Royal Institute of British Architects Journal*, 3rd series, XIV, 1907

Amaya, Mario, 'The Painter who inspired Hollywood', *Sunday Times Magazine*, London, 18 February 1968

Amaya, Mario, 'The Roman World of Alma-Tadema', *Apollo*, December 1962

Anonymous, 'Alma-Tadema', *English Illustrated Magazine*, I, 1884

Anonymous, 'Alma-Tadema, Royal Gold Medalist', *The American Architect*, XC, 1906

Anonymous, 'Alma-Tadema', *Illustriete Zeitung*, August 1878

Anonymous, 'Alma-Tadema', *Literary Digest*, XLV, 20 July 1912

Anonymous, 'Alma-Tadema', *The Windsor Magazine*, 1904

Anonymous, 'The Archaeologist of Artists', *Nation*, XLIII, 16 September 1886

Anonymous 'An Artist's Pianoforte', *Graphic*, 1873

Anonymous, 'Biographical Sketch of L. Alma-Tadema', *Magazine of Art*, 1913

Anonymous, 'Contemporary Portraits', *University Magazine*, December 1879

Anonymous, 'Current Art Notes', *Connoisseur*, XXXV, February 1913

Anonymous, 'How Alma-Tadema Paints', *Review of Reviews*, XI, 1895

Anonymous, 'Lowenstam the Anarchist', *The Westminster Budget*, 20 April 1894

Anonymous, 'Six Popular Painters of the Royal Academy', *Review of Reviews*, IX, 1894

Anonymous, 'Some Glimpses of Artistic London', *Harper's Magazine*, LXVII, 1883

Anonymous, 'The Works of Laurence Alma-Tadema, R.A.', *Art Journal*, March 1883

Anonymous, (untitled article on Alma-Tadema), *Magazine of Art*, IV, 1880

Arndt, Augustin, *Die Bibel in Der Kunst*, Verlag Von Kercheim, Mainz, 1905

Art Gallery of New South Wales, *Victorian Olympians*, Sydney, 1975

Artist Gallery Series, *L. Alma-Tadema R.A.*,

D. Lothrop Co., Boston, 1886

Ash, Russell, *Alma-Tadema, An illustrated life of Sir Lawrence Alma-Tadema 1836-1912*, Shire Publications, Aylesbury, 1973

Ash, Russell, 'The Sale of the Allen Funt Collection of Paintings by Sir Lawrence Alma-Tadema', *Art at Auction: The Year at Sotheby Parke Bernet 1973-74*, Sotheby Parke Bernet Publications, London, 1974

Ash, Russell, Maclean, Jamie and Nahum, Peter, *Sir Lawrence Alma-Tadema, O.M., R.A. A Catalogue of Thirty-Five Paintings and Watercolours*, Sotheby's Belgravia, London, 1973

Baldry, Alfred Lys, *Albert Moore: his life and works*, G. Bell & Sons, London, 1894

Bastet, Frédéric Louis, *Mr. Carel Vosmaer*, Bert Bakker/Daamen, Den Haag, 1967

Beavington, Atkinson J., 'Contemporary Art—Poetic and Positive: Dante Gabriel Rossetti and Alma-Tadema', *Blackwood's Magazine*, CXXXIII, March 1883

Bell, Arthur Clive Heward, *Landmarks in Nineteenth-Century Painting*, Chatto & Windus, London, 1927

Bell, Malcolm Henry, 'Sir Lawrence Alma-Tadema', *Dictionary of National Biography*, Oxford University Press, London, 1912-21

Bell, Nancy R. E. (Mrs Arthur), *Representative Painters of the Nineteenth Century*, Sampson Low & Co., London, 1899

Bell, Quentin, *Victorian Artists*, Routledge & Kegan Paul, London; Harvard University Press, Cambridge, Mass., 1967

Bell-Scott, William, *Autobiographical Notes*, Osgood, McIlvaine & Co., London, 1892

Bertram, Cyril Anthony George, *A Century of British Painting, 1851-1951*, Studio Publications, London and New York, 1951

Billung, Hermann, Alma-Tadema', *Zeitschrift für bildende Kunst*, XIV, 1879

Blackburn, Henry George, *Academy Notes*, Chatto & Windus, London, 1875-1907

Blackburn, Henry George, *Grosvenor Notes*, Chatto & Windus, London, 1878-1888

Blackburn, Henry George, *New Gallery Notes*, Chatto & Windus, London, 1888-1895

Blackburn, Henry George, 'The Works of L. Alma-Tadema', *Grosvenor Gallery Winter Exhibition*, London, 1882/3

Braam, Frederick A. Van, *Art Treasures in the Benelux Countries*, Vol. I, *The Netherlands*, Ysel Press, Deventer 1958

Brock, A. Clutton, Alma-Tadema', *Burlington Magazine*, XXII, 1913

Burne-Jones, Georgina, *Memorial of Edward Burne-Jones*, Macmillan & Co., London, 1904

Carr, Alice, *J. Comyns Carr: Stray Memories. By his wife*, Macmillan & Co., London, 1920

Carr, Joseph William Comyns, *Coasting Bohemia*, Macmillan & Co., London, 1914

Carr, Joseph William Comyns, *Some Eminent Victorians*, Duckworth & Co., London, 1908

Carr, Philip, 'Alma-Tadema and His Friends', *The Listener*, London, 9 December 1954

Chesneau, Ernest, *The English School of Painting*, Cassell & Co., London, 1885

Clapp, Jane, *Art Censorship: A Chronology of Proscribed and Prescribed Art*, The Scarecrow Press Inc., Metuchen, New Jersey, 1972

Collier, John, 'The Art of Alma-Tadema', *Living Age*, CCLXXVII, 1913

Collier, John, 'The Art of Alma-Tadema', *Nineteenth Century*, LXXIII, March 1913

Collier, John, *A Manual of Oil Painting*, Cassell & Co., London, 1886

Collier, Sir Laurence, *Remembrances* (unpublished manuscript), 1950

Collier, Mary, *A Victorian Diarist*, John Murray, London, 1944, 46

Cook, Clarence, *Art and Artists of Our Time*, III, Selmar Hess, New York, 1888

Cordova, Rudolph de, 'Sir Lawrence Alma-Tadema', *Cassell's Magazine*, 1902

Cordova, Rudolph de, 'The Hall of Panels', *Scribner's Magazine*, XVIII, December 1895

Cordova, Rudolph de, 'The Panels in Sir Lawrence Alma-Tadema's Hall', *The Strand Magazine*, XXIV, December 1902

Crane, Walter, *An Artist's Reminiscences*, Methuen & Co., London, 1907

Crommelin, Van Wickevoort, 'Laurens Alma-Tadema', *Elseviers Geïllustreerd Maandschrift* II, August 1891

Cundall, Herbert Minton, *A History of British Water Colour Painting*, John Murray, London, 1908

Dafforne, James, 'The Works of Lawrence Alma-Tadema', *Art Journal*, 1875

Davis, T. 'Resurrected Reputations', *Country Life*, CLIV, 20 December 1973

Deyssel, Lodewijk Van, *Verbeeldingen*, Amsterdam, 1908

Dircks, Rudolf, *The Later Works of Sir Lawrence Alma-Tadema O.M., R.A. (Art Journal*, Christmas issue), London, 1910

Dolman, Frederick, 'Sir Lawrence Alma-Tadema', *The Strand Magazine*, XVIII, December 1899

Ebers, George Moritz, 'Lorenz Alma-Tadema', *Westermann's Monatschefte*, November/

December 1885—translated and published as:—

Ebers, Georg Moritz, *Lorenz Alma-Tadema, his life and works*, translated by Mary J. Safford, W. S. Gottsberger, New York, 1886

Ebers, Georg Moritz, *Egypt*, Cassell & Co., London, 1880, 83

Ebers, Georg Moritz, *Homo Sum*, London, 1878; Appleton & Co., New York, 1892

Editor, The 'The Death of Alma-Tadema', *Fine Arts Journal*, XXVII, August 1912

Edmonds, Fred, 'The Boyhood of Alma-Tadema', *Boys Own Paper*, 1 March 1890

Eyre, Alan Montgomery, *Saint John's Wood*, Chapman & Hall, London, 1913

Ferretti, Fred, 'The Anatomy of an Art Sale: Profiting on "Worst" Painter', *The New York Times*, 16 November 1973

Fildes, Luke Val, *Luke Fildes, R.A. A Victorian Painter*, Michael Joseph, London, 1968

The Fine Art Society, *Lady Alma-Tadema Memorial Exhibition*, London, 1910

Forbes, Christopher, *Victorians in Togas* (Exhibition Catalogue), Metropolitan Museum of Art, New York, 1973

Forbes-Robertson, Sir Johnston, *A Player under Three Reigns*, T. Fisher Unwin, London, 1925

Fredericksen, Burton B., *Alma-Tadema's 'Spring'*, The J. Paul Getty Museum, Malibu, California, 1976

Fry, Roger, 'The Case of the Late Sir Lawrence Alma-Tadema, O.M.', *Nation*, 18 January 1913

Fry, Roger, *Letters of Roger Fry*, edited by Denys Sutton, Chatto & Windus, London, 1972

Gaunt, William, *The Aesthetic Adventure*, Jonathan Cape, London, 1945

Gaunt, William, *Victorian Olympus*, Jonathan Cape, London, 1952

Gosse, Sir Edmund William, *Lawrence Alma-Tadema, R.A.*, Chapman & Hall, London, 1882

Gosse, Ellen, 'Laurens Alma-Tadema', *Century Magazine*, XLVII, February 1894

Graaf, M.H. de, 'Laurens Alma-Tadema', *Overgedrukt Vit Het Leestrabinet*, August 1883

Graves, Algernon, *A Century of Loan Exhibitions, 1813-1912*, Algernon Graves, London, 1913-15

Graves, Algernon, *A Dictionary of Artists who have exhibited works in the principal London exhibitions of oil paintings, from 1760 to 1880*, G. Bell & Sons, London, 1884

Graves, Algernon, *The Royal Academy of Arts: a complete dictionary of exhibitors and their work from its foundation in 1769 to 1904*, Henry Graves & Co. and George Bell & Sons, London, 1905-06

Hamerton, Philip Gilbert, *Man in Art: Studies in Religious and Historical Art, Portrait and Genre*, Macmillan & Co., London, 1892

Hampton & Sons, *Catalogue of the well-known and interesting collections of Antique Furniture and Objets d'Art formed by the Late Sir Lawrence Alma-Tadema, O.M., R.A., including Valuable Pictures and the Archaeological Library*, London, 1913

Hampton & Sons, *Sir Lawrence Alma-Tadema's Famous House: A Palace of the beautiful* (Sale Catalogue), London, 1912

Hansen, Hans Jürgen (ed.), *Late Nineteenth Century Art*, McGraw Hill, New York, 1972; David & Charles, Newton Abbot, 1973

Harker, Joseph, *Studio and Stage*, Nisbet & Co., London, 1924

Hartrick, Archibald Standish, *A Painter's Pilgrimage through Fifty Years*, Cambridge University Press, Cambridge, 1939

Haweis, Mary Eliza, *Beautiful Houses; being a description of certain well-known artistic houses*, Sampson Low & Co., London, 1882

Hawthorne, Julian, *Shapes that Pass*, John Murray, London, 1928

Henschel, Sir George, *Musings and Memories of a Musician*, Macmillan & Co., London, 1918

Henschel, Helen, *When Soft Voices Die*, John Westhouse, London, 1944

Hillier, Bevis, 'Panel games', *The Times*, London, 18 December 1976

Hitchcock, James Ripley, *Art of the World*, D. Appleton & Co., New York, 1893-94

Hoenderdos, Pieter, *Ary Scheffer, Sir Lawrence Alma-Tadema, Charles Rochusen de Vergankelijkheid van de Roem*, Rotterdamsche Kuntstichting, Rotterdam, 1974

Holiday, Henry, *Reminiscences of my Life*, William Heinemann, London, 1914

Horsley, M., 'Alma-Tadema Memorial Library', *Architectural Review*, XXI, February 1916

Isaacson Gallery, *Exhibition Commemorating the Fiftieth Anniversary of the Death of Sir L. Alma-Tadema*, New York, 1962

Knoef, Jan, *Een Eeuw Nederlandse Schilderkunst*, E. Querido, Amsterdam, 1948

Ladd, Henry Andrews, *The Victorian Morality of Art*, R. Long & R. R. Smith, New York, 1932

Landau, Rom, *Paderewski*, I. Nicholson & Watson, London, 1934

Leslie, George Dunlop, *The Inner Life of the Royal Academy*, John Murray, London, 1914

Maas, Jeremy, *Gambart*, Barrie & Jenkins, London, 1975

Maas, Jeremy, 'Gambart and the missing de Keyser Pictures', *Connoisseur*, October 1975

Maas, Jeremy, *Victorian Painters*, Barrie & Rockliff, London, 1969; G.P. Putnam's Sons, New York, 1969

Macer-Wright, Philip, *Brangwyn: A Study of Genius at Close Quarters*, Hutchinson & Co., London, 1940

Malkowsky, Georg, 'Laurence Alma-Tadema', *Moderne Kunst*, 1895

Marillier, Henry Currie, *"Christie's", 1766-1925*, Constable & Co., London, 1926; Houghton Mifflin Co., Boston & New York, 1926

Marius, G. Hermione, *Dutch Painting in the Nineteenth Century*, Alexander Moring, London, 1908

Marsh, Janet, 'The Eminent Victorians', *The Financial Times*, London, 3 November 1973

McKenna, Ethel M., 'Alma-Tadema and his Home and Pictures', *New McClure's Magazine*, VIII, November 1896

Mellow, James R., 'Alma-Tadema's "Victorian in Togas"', *New York Times*, 17 March 1973

Meynell, Wilfred, 'Mr Alma-Tadema Seven Years Ago and Now', *Magazine of Art*, IV, 1881

Meynell, Wilfred, 'Our Living Artists', *Magazine of Art*, II, 1879

Monkhouse, William Cosmo, *British Contemporary Artists*, William Heinemann, London, 1899

Monkhouse, William Cosmo, 'Laurens Alma-Tadema, R.A.', *Scribner's Magazine*, XVIII, December 1895

Moore, George, *Modern Painting*, Charles Scribner's Sons, New York, 1893

Mullaly, Terence, 'In-depth view of Victorian painter', *Daily Telegraph*, London, 2 November 1973

N., N., 'Alma-Tadema', *The Nation*, XCVI, 30 January 1913

N., N., 'The Grosvenor Gallery and Alma-Tadema', *The Nation*, XLIX, 17 June 1889

National Gallery of Canada, *Exhibition of Victorian Paintings*, Ottawa, 1962

Naylor, Leonard Edwin, *The Irrepressible Victorian*, Macdonald, London, 1965

Nisbet, Hume, *Where Art Begins*, Chatto & Windus, London, 1892

Norman, Geraldine, 'Victorian fantasies in demand', *The Times*, London, 7 November 1973

O'Connor, T. P. (ed.), *In the Days of My Youth... Containing the Autobiographies of thirty-four well known Men & Women of today*, C. A. Pearson, London, 1901

Ormond, Leonée, *George Du Maurier*, Routledge & Kegan Paul, London, 1969

Ormond, Leonée, and Ormond, Richard, *Lord Leighton*, Yale University Press for the Paul Mellon Centre for Studies in British Art, London, 1976

Ormond, Richard, 'Diploma paintings from 1840 onwards at the Royal Academy', *Apollo*, January 1969

Ormond, Richard, 'Victorian Paintings and Patronage in Birmingham', *Apollo*, April 1968

Orpen, Sir William (ed.), *The Outline of Art*, George Newnes, London, 1923, 24; G.P. Putnam's Sons, New York, 1924

Pach, Walter, *Ananias; or the False Artist*, Harper Bros., New York and London, 1928

Patterson, Jerry E. 'The Norman Rockwell of the Pagans, or the Return of Alma-Tadema: The Candid Cameraman Collects', *Auction*, 1971

Piper, David Towry, *Painting in England, 1500-1870*, The Book Society, London, 1960; Penguin Books, London & Baltimore, 1965

Preyer, David Charles, *The Art of the Netherland Galleries*, George Bell & Sons, London, 1908

Quilter, Harry, *Preferences in Art, Life and Literature*, Swan Sonnenschein & Co., London, 1892

Ranitz, Irma de, 'Het Huis von Sir Lawrence Alma-Tadema', *Ons Huis Oud en Nieuw*, 1911

Reavell, George, 'Sir Lawrence Alma-Tadema's Studio', *American Architect and Building News*, XXXVII, 18 June 1913

Reitlinger, Gerald, *The Economics of Taste*, Barrie & Rockliff, London, 1961

Reynolds, Arthur Graham, *Victorian Painting*, Studio Vista, London, 1966; Macmillian & Co., New York, 1966

Richmond, Sir William Blake, 'A Great Artist and his Little Critics', *National Review*,

February 1913

Roberts, William, *Memorials of Christies: A Record of Art Sales from 1766 to 1896*, Bell & Sons, London, 1897

Robertson, Walford Graham, *Time Was*, Hamish Hamilton, London, 1931

Roe, Frederic Gordon, *The Nude from Cranach to Etty and beyond*, F. Lewis, Leigh-on-Sea, 1944; Hastings House, New York, 1965

Romijn, Jaap, 'De wereld van Alma-Tadema', *Antiek*, Lochem, April 1974

Romijn, Jaap *L. Alma-Tadema* (Exhibition Catalogue), Gemeentelijk Museum Het Princessehoff, Leeuwarden, July/September 1974

Rooses, Max, *Dutch Painters of the Nineteenth Century*, Sampson Low & Co., London, 1898-1901

Rose, Barbara, 'Two Women: Real and More Real', *Vogue*, New York, May 1973

Rosenfeld, Sybil, 'Alma-Tadema's Designs for Henry Irving's *Coriolanus*', *Deutsche Shakespeare-Gesellschaft Jahrbuch*, 1974

Royal Academy, *Exhibition of Works by the Late Sir Lawrence Alma-Tadema R.A. O.M.*, London, 1913

'Royal Academy Pictures', Supplement to: *The Magazine of Art*, Cassell & Co., London, 1880-1902

Rush, Richard Henry, *Art as an Investment*, Prentice-Hall, Englewood Cliffs, N.J., 1962

Ruskin, John, *Academy Notes*, London, 1875

Ruskin, John, *The Art of England*, George Allen, Orpington, 1884

Saarinen, Aline Bernstein Louchheim, *The Proud Possessors*, Random House, New York, 1958

Sayre, C.F., 'Sir Lawrence Alma-Tadema's *A Roman Amateur*', *Yale University Art Gallery Bulletin* 34, June 1973

Sheffield City Art Galleries, *Sir Lawrence Alma-Tadema O.M., R.A. 1836-1912*, Sheffield, 1976

Simcox, George Augustus, 'Alma-Tadema', *Portfolio*, V, 1874

Sizeranne, Robert de la, *English Contemporary Art* (translated by H.M. Poynter), Archibald, Constable & Co., London, 1898

Slade, William, *Centenary appreciation of Sir L. Alma-Tadema* (typescript), 1936

Smith, M.H. Stephen, *Art and Anecdote. Recollections of William Frederick Yeames, R.A. His Life and His Friends*, Hutchinson & Co., London, 1921

Speaight, Robert, *William Rothenstein*, Eyre & Spottiswoode, London, 1962

Spencer, Charles, 'Il Neoclassicismo di Alma-Tadema: Cecil B. De Mille alla corte della Regina Vittoria', *Bolaffiarte*, No. 37, Vol. 5, February 1974

Spielmann, Marion Harry, 'The Alma-Tadema Celebration', *Magazine of Art*, XXIV, January 1900

Spielmann, Marion Harry, 'Lawrence Alma-Tadema, R.A.: A Sketch', *Magazine of Art*, 1896/7

Spiers, Richard Phene, 'Archaeological Research in the Paintings of Sir Lawrence Alma-Tadema', *Architectural Review*, XXXIII, March 1913

Spiers, Richard Phene, *The Architecture of 'Coriolanus' at the Lyceum Theatre*, London, 1901

Staley, John Edgcumbe, *Lord Leighton of Stretton, P.R.A.*, Scott Publishing Co., London, 1906

Standing, Percy Cross, *Sir Lawrence Alma-Tadema, O.M., R.A.*, Cassell & Co., London, 1905

Standing, Percy Cross, 'Sir Lawrence Alma-Tadema, R.A., and his Art', *Windsor Magazine*, August 1904

Starkweather, William, 'Alma-Tadema, Artist and Archaeologist', *Mentor*, XII, 1924

Steegman, John, *The Rule of Taste: From George I to George IV*, Macmillan & Co., London, 1968

Stephens, Frederick George, *Artists at Home*, Sampson Low & Co., London, 1884

Stephens, Frederick George, *Lawrence Alma-Tadema, R.A.*, Berlin Photograhic Co., London, 1895

Stephens, Frederick George, *Selected Works of Sir Lawrence Alma-Tadema, O.M., R.A.*, Virtue & Co., London, 1901

Stirling, Anna Maria Diana Wilhelmina, *Victorian Sidelights*, Ernest Benn, London, 1954

Strahan, Edward, 'The Masterpieces of The Centennial International Exhibition',

Fine Art, I, 1876

Swanson, Vern Grosvenor, *An Exhibition of British and American Paintings*, Auburn University, Auburn, Alabama, April 1976

Teall, Gardner, 'The Art of Alma-Tadema', *Hearst's International*, XXII, August 1912

Towner, Wesley, *The Elegant Auctioneers*, Hill & Wang, New York, 1970; Gollancz, London, 1971

Viardot, Louis, *Wonders of European Art*, Charles Scribner's Sons, New York, 1885

Vosmaer, Carel, *The Amazon*, T. Fisher Unwin, London, 1884

Vosmaer, Carel, *Catalogue Raisonné of Lawrence Almã-Tadema* (manuscript), Leiden, c.1885

Vosmaer, Carel, 'Eene Schilderij van Alma-Tadema', *De Nederlandsche Spectator*, 1886

Vosmaer, Carel, 'Laurens Alma-Tadema', *Onze Hedenaagsche Schilders*, Stemberg, Den Haag, 1881-84

White, Harrison Collyer and White, Cynthia Alice, *Canvasses and Careers*, John Wiley & Sons, New York, 1965

Wilde, Oscar, *The Letters of Oscar Wilde* (edited by Rupert Hart-Davis), Rupert Hart Davis, London, 1962

Wilson, Michael I., 'The Case of the Victorian Piano', *Victoria & Albert Museum Yearbook*, 1972

Woermann, Carl, *Geschichte der Kunst*, Bibliographiches Institut, Leipzig, 1915-22

Wood, Christopher, *Dictionary of Victorian Painters*, Antique Collectors Club, Woodbridge, 1971

Woodward, John, *British Painting*, Vista Books, London, 1962

Woolf, Virginia, *Roger Fry. A biography*, The Hogarth Press, London, 1940

Wurzbach, Alfred von, *Niederlandisches Kunstler-Lexicon*, Leipzig, Wien, 1904-11

Zimmern, Helen, *The Great Modern Painters*, Goupil & Co., Paris, 1886

Zimmern, Helen, 'Lawrence Alma-Tadema', *Our Continent*, II, 6 December 1882

Zimmern, Helen, 'The life and work of L. Alma-Tadema', *Art Annual*, 1886

Zimmern, Helen, *Sir Lawrence Alma-Tadema R.A.*, Bell & Sons, London, 1902

CATALOGUE OF NUMBERED WORKS

Notes:
Title: Alma-Tadema's original title is given in all cases. Those originally titled in Dutch or French are as translated in the catalogue published by Rudolf Dircks in *The Later Works of Sir Lawrence Alma-Tadema* (Art Journal, 1910). Alternative titles are also included.

Medium: Oil unless otherwise stated.
Size: In inches (cm in brackets), height before width.
Location: Given as at time of publication. Those works in private collections and in the hands of dealers may change location. The publishers would be grateful to receive any revisions.

Roman Numerals:

I	1	VIII	8	XC	90
II	2	IX	9	C	100
III	3	X	10	CC	200
IV	4	XX	20	CCC	300
V	5	XXX	30	CCCC	400
VI	6	XL	40		
VII	7	L	50		

1851
I **Portrait of my sister Atje** Canvas, size unknown. Location unknown.

1852
II **Self portrait** Canvas, 22 x 19 (55.9 x 48.3) Fries Museum, Leeuwarden, The Netherlands

III **Portrait of my mother** Canvas, 9½ x 7½ (24.5 x 19.2) oval Fries Museum, Leeuwarden, The Netherlands

1856
IV **The Alm** Panel, 17¾ x 11¾ (44 x 30). Location unknown

1857
V **The inundation of the Biesbosch in 1421** Canvas, 21½ x 25½ (54.8 x 64.7) Location unknown

VI **The destruction of Terdoest Abbey in 1571** Canvas, size unknown, destroyed by 1859

VII **Faust and Marguerite** Watercolour, 18 x 19¾ (45.7 x 50.1) John Constable Esq., England

1858
VIII **Clotilde at the tomb of her grandchildren** Canvas, 31½ x 43 (80.1 x 109.2) Location unknown

IX **Marius on the ruins of Carthage** Watercolour, size unknown. Location unknown

1859
X **The sad father or the unfavourable oracle (Death of the first-born, first version)** Canvas, existing fragment 27 x 34 (68.6 x 86.4) Johannesburg Art Gallery, Johannesburg, South Africa

XI **The death of Attila, 453 AD** Watercolour, size unknown. Location unknown

1860
XII **Triumphal return of Sir Willem Van Saeftingen** Canvas, 36 x 26 (91.5 x 66) Mr and Mrs J. B. Ward, Ohio, USA.

XIII **The death of Hippolyte** Watercolour, 17 x 22½ (43.2 x 57.1) Dr and Mrs S. Craig Barton, California, USA

1861
XIV **The education of the children of Clovis (first version)** Canvas, 50 x 69½ (127 x 176.8) Location unknown

1862
XV **Venantius Fortunatus reading his poems to Radagonda** Canvas, 25½ x 32¾ (65 x 83.1) Dordrechts Museum, Dordrecht, The Netherlands

XVI **Gunthram Bose and his daughters, AD 572: the Ambuscade** Canvas, 27 x 39 (68.6 x 99) Location unknown

1863
XVII **A medieval Flemish interior** Canvas, 24 x 29 (61 x 73.5) Location unknown

XVIII **Pastimes in Ancient Egypt: 3,000 years ago** Canvas, 39 x 53½ (99.1 x 135.8) Harris Museum and Art Gallery, Preston, England

XIX **Interior of the Church San Clemente, Rome: a study** Canvas, 24¾ x 19⅝ (63.5 x 51) Fries Museum, Leeuwarden, The Netherlands

1864
XX **Queen Fredegonda at the deathbed of Bishop Praetextatus (first version)** Canvas, 39 x 53½ (99 x 135.8) Fries Museum, Leeuwarden, The Netherlands

XXI **Leaving Church in the fifteenth century** Canvas, 21½ x 15½ (54.3 x 39.2) Location unknown

1865
XXII **Egyptian game (first version)** Canvas, size unknown. Location unknown

XXIII **Birthday presents: sixteenth century** Canvas, size unknown. Location unknown

XXIV **Gallo-Roman women** Size unknown. Location unknown

XXV **Entering Church in the fourteenth century** Panel, 16 x 20 (40.6 x 51) Location unknown

XXVI **An Egyptian at his doorway in Memphis** Panel, 22 x 15½ (56 x 39.2) Mr and Mrs K. J. Kane, New York, USA

XXVII **Catullus at Lesbia's** Panel, 15⅝ x 21½ (39.5 x 54.5) Private collection, England

XXVIII **The discourse: A chat** Panel, 16 x 10¾ (40.5 x 27.3) Private collection, England

XXIX **A Roman scribe writing despatches** Panel, 21½ x 15½ (54.5 x 39.2) Location unknown

XXX **A soldier of Marathon** Panel, 22¼ x 15½ (56.5 x 39.2) Dr Edglon, England

XXXI **Home from market** Panel, 16 x 22½ (40.5 x 57) Location unknown

XXXII **The death of Galeswinthe** Panel, 12¾ x 9¾ (32.4 x 24.6) Mr Barry Friedman, New York, USA

1866
XXXIII **Making wreaths for festivities in a Pompeian house** Size unknown. Location unknown

XXXIV **Vespasian hearing of the taking of Jerusalem by Titus** Canvas, 20 x 15 (51 x 38.1) Location unknown

XXXV **Entrance to a Roman theatre** Canvas, 27¾ x 38¾ (70.4 x 98.4) Haussner's Restaurant, Baltimore, Maryland, USA

XXXVI **In the peristyle** Panel, 23 x 16⅛ (58.5 x 41) Leger Gallery, London, England

XXXVII **Agrippina visiting the ashes of Germanicus** Panel, 10¾ x 14¾ (27.3 x 37.5) Kurt E. Schon Ltd., New Orleans, Louisiana

XXXVIII **Tibullus at Delia's** Panel, 17¼ x 26 (43.9 x 66) Museum of Fine Arts, Boston, Massachusetts

XXXIX **A Roman dance** Panel, 16¼ x 23 (41 x 58.5) J. Mason Esq., England

XL **Lesbia weeping over a sparrow** Panel, 25 x 19 (63.5 x 48.3) Isidore Ostrer, England

XLI **The armourer's shop in Ancient Rome** Panel, 16¾ x 23⅛ (42.5 x 58.5) Hartnoll & Eyre Ltd., London, England

1867
XLII **The mummy: Roman period: Egyptians lamenting their dead** Canvas, 31 x 51 (78.8 x 129.7) Location unknown

XLIII **The honeymoon** Panel, 36½ x 25 (92.7 x 63.5) Location unknown

XLIV **Cuckoo** Panel, 22½ x 15⅞ (57.2 x 40.3) Location unknown

XLV **My family: The aesthetic view: Madame Dumoulin, Pauline, and Laurence** Panel, 16¾ x 21¼ (42.5 x 54) Groningen Museum Voor Stad En Lande, Groningen, The Netherlands

XLVI **Glaucus and Nydia** Panel, 15½ x 25⅜ (39.5 x 65.5) Mr and Mrs Noah Butkin, Ohio, USA

XLVII **Portrait of Mr A. Bonnefoy** Canvas, size unknown. Location unknown

XLVIII **Proclaiming Claudius Emperor (first version)** Panel, 18⅜ x 23⅞ (46.8 x 60.7) Mr Charles F. Stein, Baltimore, Maryland, USA

XLIX **A sculpture gallery in Rome at the time of Augustus** Panel, 24½ x 18½ (61.5 x 46.9) Location unknown

L **A collector of pictures at the time of Augustus** Panel, 28 x 18¼ (71 x 46.4) Mr H. E. Finsness, England

LI **Tarquinius Superbus before Galba** Panel, 22½ x 15 (57.1 x 38.1) Prof. and Mrs Martin Werner, Pennsylvania, USA

LII **A Roman family** Panel, 19 x 13¾ (48.2 x 35) Private collection, England

LIII **Italian women** Panel, size unknown. Location unknown

LIV **Portrait of Madame Bonnefoy and Mr Puttemans** Panel, 14 x 20½ (35.5 x 52.2). Location unknown

1868
LV **The siesta (first version)** Drawing, size unknown. Location unknown

LVI **The embarkation** Canvas, 32¾ x 22 (83.3 x 56) Rijksmuseum H. W. Mesdag, The Hague, The Netherlands

LVII **The siesta (second version)** Canvas, life sized, Prado Museum, Madrid, Spain

LVIII **A Roman art lover** Panel, 21 x 31½ (53.3 x 80) Yale University Art Gallery, New Haven, Connecticut, USA

LIX **Woman and flowers** Panel, 19½ x 14½ (49.5 x 36.8) Museum of Fine Arts, Boston, Massachusetts, USA

LX **Phidias and the Parthenon** Panel, 28⅜ x 43½ (72 x 110.5) Birmingham City Art Gallery, Birmingham, England

LXI **The flower girl** Panel, 7¼ x 15½ (18.3 x 39.2) Location unknown

LXII **A Roman flower market: Pompeii** Panel, 16½ x 22¾ (42 x 58) Manchester City Art Gallery, Manchester, England

LXIII **Egyptian game (second version)** Watercolour, 14⅜ x 21¼ (36.6 x 54) Location unknown

LXIV **Education of the children of Clovis (second version)** Panel, 25½ x 35¾ (64.8 x 90.9) Messrs M. Knoedler & Co., New York, USA

LXV **A Roman art lover (silver statue)** Panel, 32⅜ x 22 (82.3 x 55.8) Glasgow Art Gallery, Glasgow, Scotland

LXVI **Egyptian dancing girls** Watercolour, size unknown. Location unknown

1869
LXVII **Catalina** Panel, 20 x 13¾ (51 x 34.9) Location unknown

LXVIII **The visit: Sunday morning before churching (first version): a birth chamber, seventeenth century** Panel, 19¼ x 25½ (49 x 64.8) Victoria and Albert Museum, London, England

LXIX **The Pyrrhic dance** Panel, 16 x 32 (40.6 x 81.3) Guildhall Art Gallery, London, England

LXX **The Grand Chamberlain of King Sesostris the Great** Canvas, size unknown. Location unknown

LXXI **The convalescent** Panel, 27½ x 17½ (69.9 x 44.5) Location unknown

LXXII **Confidences** Panel, 21¾ x 14¾ (55.3 x 37.6) Walker Art Gallery, Liverpool, England

LXXIII **A Greek woman** Panel, 23⅝ x 18½ (60.7 x 47.1) Messrs A. Staal, Amsterdam, The Netherlands

LXXIV **At the wine shop** Panel, 14½ x 18½ (36.7 x 46.9) Guildhall Art Gallery, London, England

LXXV **An exedra (first version)** Panel, 15 x 23½ (38 x 59.8) Vassar College Collection, Poughkeepsie, New York, USA

1870
LXXVI **Portrait of Master Ernest Angeley** Canvas, size unknown. Location unknown.

LXXVII **A juggler** Canvas, 31 x 19¼ (78.7 x 48.8) Location unknown

LXXVIII **A nurse, seventeenth century: Sunday morning (second version)** Watercolour, 13½ x 8⅞ (34.2 x 22.5) Walker Art Gallery, Liverpool, England

LXXIX **Roman art lover (the runner)** Panel, 29 x 40 (73.5 x 101.6) Milwaukee Art Center, Milwaukee, Wisconsin, USA

LXXX **Anacreon reading his poems at Lesbia's house** Panel, 15½ x 19 (39.3 x 48.2) Location unknown

LXXXI **The vintage festival (first version)** Canvas, 30¼ x 68½ (77 x 177) Hamburger Kunsthalle, Hamburg, West Germany

LXXXII **The first whisper of love** Size unknown. Location unknown

LXXXIII **The letter: from an absent one (first version)** Size unknown, destroyed 1873

LXXXIV **A staircase (first version)** Panel, 16¼ x 3¼ (41.2 x 8.2) Location unknown

LXXXV **Hush, she sleeps** Panel, 16 x 11 (40.5 x 28) Location unknown

1871
LXXXVI **The letter: from an absent one (second version)** Watercolour, 15½ x 10½ (39.2 x 26.7) Location unknown

LXXXVII **The vintage festival** Panel, 20 x 47 (51 x 119.4) National Gallery of Victoria, Melbourne, Australia

LXXXVIII **A Roman Emperor (second version)** Canvas, 33 x 68⅜ (83.8 x 174.2) Walters Art Gallery, Baltimore, Maryland, USA

LXXXIX **In the temple (first version)** Panel, 35⅝ x 20½ (91 x 52.4) Dr J. Jackson, Oregon, USA

XC **Portrait of Miss Laura Theresa Epps** Canvas, (unfinished), 15¾ x 19¾ (40 x 50.3) Mr Mario Amaya, Virginia, USA

XCI **A Bacchic dance** Panel, 16½ x 32½ (42.1 x 82.5) Location unknown

XCII **Fredegonda and Praetextatus (second version)** Canvas, 26 x 36¼ (66.1 x 92) Museum of Fine Arts (Pushkin Museum), Moscow, USSR

XCIII **Portrait study for Mrs H. W. Mesdag** Panel, 10⅛ x 4¾ (25.8 x 12) Rijksmuseum H. W. Mesdag, The Hague, The Netherlands

XCIV **Greek potters** Panel, 15½ x 10¾ (39.2 x 27.3) H. Shickman Gallery, New York, USA

XCV **An exedra (second version)** Watercolour, 15½ x 25 (39.2 x 63.5) Location unknown

XCVI **Sunday morning: the two sisters (third version)** Panel, 15¾ x 13 (40 x 33) The Tate Gallery, London, England

1872
XCVII **In the temple (second version)** Watercolour, 37½ x 20¾ (95.2 x 52.8) Aberdeen Art Gallery, Aberdeen, Scotland

XCVIII **The first reproach** Canvas, size unknown. Location unknown

XCIX **An Egyptian widow** Panel, 29 x 38½ (73.9 x 98.1) Rijksmuseum, Amsterdam, The Netherlands

C **Improvisatore** Panel, 25½ x 17½ (64.7 x 44.4) Royal Academy, London, England

CI **A halt (first version)** Panel, 6 x 23 (15.2 x 58.5) Destroyed by fire in 1873 at J. Mossons', London, England

CII **The last roses** Panel, 18 x 15 (45.8 x 38.2) Location unknown

CIII **The death of the first-born (second version)** Canvas, 29½ x 48 (74.9 x 122) Rijksmuseum, Amsterdam, The Netherlands

CIV **Portrait of Dr Franz and Mrs Catherine Hueffer 'When I am dead, oh dearest sing'** Panel, 11½ x 18½ (29.1 x 47) Cynthia Hardy, Surrey, England

CV **The nurse** Panel, 17⅛ x 23½ (43.5 x 59.5) Location unknown

CVI **Greek wine (first version)** Panel, 6½ x 14 (16.5 x 35.5) Location unknown

CVII **Goldfish (first version)** Panel, 7¼ x 15½ (18 x 39.5) Repainted by Tadema for Arthur Tooth & Co as Opus CCCLIX

CVIII **On a Roman staircase (second version)** Watercolour, 17½ x 4 (44.5 x 10.2) Location unknown

CIX **Hercules** Panel, 7½ x 16⅛ (18.9 x 41) Location unknown

1873
CX **Portrait of Miss Kate Thompson** Panel, 19 x 15½ (48.5 x 39.2) Location unknown

CXI **The dinner (first version)** Panel, 6½ x 23 (16.5 x 58.5) William Morris Gallery, Walthamstow, London, England

CXII **The siesta (third version)** Panel, 6½ x 18½ (16.5 x 47) Location unknown

CXIII **A visit to the studio (second version)** Watercolour, 26½ x 15¾ (67.4 x 40.1) Location unknown

CXIV **Cherries** Canvas, 31⅛ x 50½ (79 x 129) Koninklijk Museum Voor Schone Kunsten, Antwerp, Belgium

CXV **Greek wine (second version)** Watercolour, 6⅝ x 14⅛ (17.2 x 36) Location unknown

CXVI **This is our corner** Panel, 22¼ x 18½ (56.4 x 47.1) Mrs Elizabeth Wansbrough, England

CXVII **A picture gallery (third version)** Panel, 30½ x 23¼ (77.5 x 59) Walter P. Chrysler Jr., New York, USA

CXVIII **The last roses (second version)** Watercolour, size unknown. Location unknown

CXIX **Fishing (first version)** Panel, 7½ x 16 (19 x 40.6) Hamburger Kunsthalle, Hamburg, West Germany

CXX **Music hath charms** Watercolour, 13¾ x 10 (34.8 x 25.5) Owens Art Gallery, Mount Allison University, Sackville, New Brunswick, Canada

CXXI **Counting the passers-by** Watercolour, 7¾ x 17¾ (19.9 x 45) Location unknown

CXXII **Portrait of Mrs Frederick George Stephens** Panel, 16 x 11¼ (40.6 x 28.3) Location unknown

1874
CXXIII **Two heads from 'The Picture Gallery': A visit to the studio by Charles W. Deschamps and his wife (first version)** Watercolour (diamond shaped), 16½ x 16½ (42 x 42) Location unknown

CXXIV **Joseph, overseer of Pharaoh's granaries** Canvas, size unknown. Location unknown

CXXV **A sculpture gallery (first version)** Canvas, 86½ x 66 (219.7 x 167.8) Hopkins Center Art Galleries, Dartmouth College, Hanover, New Hampshire, USA

CXXVI **A picture gallery in Rome at the time of Augustus (fourth version)** Canvas, 86½ x 65½ (219.7 x 166) Towneley Hall Art Gallery and Museum, Burnley, England

CXXVII **Portrait of Charles W. Deschamps and his wife (second version)** Canvas, 12 x 12 (30.5 x 30.5) Location unknown

CXXVIII **Autumn** Watercolour, 9¾ x 23 (24.8 x 58.5) Walker Art Gallery, Liverpool, England

CXXIX **Reflections: fishing (second version)** Panel, 9⅞ x 7⅛ (25 x 18) Koninklijk Huisarchief (Soestdijk Palace), Soestdijk, The Netherlands

CXXX **A Roman artist** Watercolour, 11¾ x 11¾ (29.8 x 29.8) Location unknown

CXXXI **Good friends** Watercolour, 4½ x 7¼ (11.3 x 18.5) Hackley Art Gallery, Muskegon, Michigan, USA

CXXXII **On the steps of the Capitol (first version)** Panel, 9⅛ x 17⅛ (23 x 43.5) Private collection, England

CXXXIII **Water pets: goldfish (second version)** Canvas, 25½ x 56 (65 x 142.2) Private collection, Australia

CXXXIV **Munster Cathedral** Canvas, 9¼ x 13½ (23.5 x 34.2) Location unknown

CXXXV **Landscape near Munster** Canvas, 8½ x 13½ (21.7 x 34.2) Location unknown

CXXXVI **Antistius Labeon, AD 75: A Roman amateur artist** Panel, 25½ x 37½ (64.7 x 95.3) Dr and Mrs Richard Whitten, California, USA

CXXXVII **Sunny days** Canvas, 8½ x 13½ (21.5 x 34.2) William Collier Esq., England

CXXXVIII **Spring flowers: garland seller on the steps of the Capitol (second version)** Watercolour, 7⅜ x 15⅝ (18.3 x 39.1) Fine Art Society, London, England

CXXXIX **Through an archway** Panel, 11½ x 8½ (29.3 x 21.6) Dienst Voor's Rijks Verspreide Kunstvoorwerpen, The Hague, The Netherlands

CXL (A,B) **Decoration for my piano: 'Serious and merry music'** Panel, A: 4¼ x 11 (10.8 x 27.9) B: 4¼ x 13¾ (10.8 x 35) Location unknown

CXLI **Reverie** Canvas, 13¼ x 8 (34.2 x 20.2) Location unknown

CXLII **The Roman architect** Size unknown. Location unknown

CXLIII **Sunflowers** Panel, 12½ x 5 (31.7 x 12.7) Private collection, England

1875
CXLIV **Landscape: carriage drive by the outskirts of a wood, Penhill Castle** Canvas, 8½ x 13½ (21.5 x 34.2) Location unknown

CXLV **A peep through the trees** Canvas, 8½ x 13¾ (21.5 x 34.9) Singer Museum, Laren, The Netherlands

CXLVI **Cleopatra (first version)** Canvas, 21½ x 26¼ (54.6 x 66.7) Art Gallery of New South Wales, Melbourne, Australia

CXLVII (a,b,c) **The tragedy of an honest wife** Watercolour, a: 20 x 18¼ (51 x 46.5); b: 14¾ x 12¾ (37.4 x 32); c: 12¼ x 12¼ (31.2 x 31.2) Fogg Art Museum, Harvard University, Cambridge, Massachusetts, USA

CXLVIII **The architect of the Coliseum** Watercolour, 11½ x 11¾ (29.2 x 30) Location unknown

CXLIX **Fishing (third version)** Watercolour, 9 x 17½ (24.1 x 44.4) Auckland City Art Gallery, Auckland, New Zealand

CL **Cherry blossoms** Canvas, 13¾ x 8¾ (35 x 22.2) Location unknown

CLI **Water pets: goldfish (third version)** Canvas, 13¼ x 28½ (33.7 x 72.5) Location unknown

CLII **'There he is!'** Panel, 10½ x 7¾ (26.7 x 19.6) Walker Art Gallery, Liverpool, England

CLIII **Play** Panel, 10½ x 35½ (26.7 x 90.1) Location unknown

CLIV **Portrait of Miss Thackeray's 'Elizabeth'** Panel, 15½ x 19 (39.3 x 48.5) William Morris Gallery, Walthamstow, London, England

CLV **A nymphaeum of the Villa Aldobrandini at Rome** Panel, 22¾ x 11½ (57.9 x 29.5) Location unknown

CLVI **Haystacks** Canvas, 8½ x 13¾ (21.5 x 34.8) Location unknown

CLVII **A sculpture gallery (second version)** Panel, 30¼ x 23¼ (77 x 59.1) Walter P. Chrysler Jr., New York, USA

CLVIII **After the dance: a bacchanal** Canvas, 23 x 5½ (58.5 x 14) Location unknown

CLIX **Landscape: a breezy day in August near Innsbruck** Canvas, 8½ x 13¾ (21.5 x 35) Location unknown

CLX **The service** Panel, 6½ x 18 (16.5 x 45.7) Location unknown

CLXI **An audience at Agrippa's (first version)** Canvas, 35¾ x 24¾ (90.8 x 62.8) Dick Institute, Kilmarnock, Scotland

1876
CLXII **Portrait of my wife** Canvas, 19½ x 16 (49.5 x 40.5) Williamson Art Gallery, Birkenhead, England

CLXIII **Between hope and fear** Canvas, 30¾ x 50½ (78.1 x 128.2) Private collection, England

CLXIV **94 degrees in the shade** Canvas, 14 x 8½ (35.4 x 21.5) Fitzwilliam Museum, Cambridge, England

CLXV **An antique custom** Panel, 11 x 2½ (28 x 8) Hamburger Kunsthalle, Hamburg, West Germany

CLXVI **Portrait of Jules Dalou, his wife, and his daughter** Canvas, 33 x 12 (84 x 30.5) Centre Georges Pompidou, Paris, France

CLXVII **Pleading (first version)** Panel, 8½ x 14 (21.5 x 35.5) Guildhall Art Gallery, London, England

CLXVIII **Hide and seek** Canvas, 13¾ x 8½ (34.9 x 21.5) Location unknown

CLXIX **Balneatrix** Watercolour, 14½ x 10½ (36.9 x 26.8) Setton Collection, Paris, France

1877

CLXX **A mirror** Panel, 13¾ x 8½ (34.8 x 21.5) Location unknown

CLXXI **An interesting scroll** Watercolour, 14½ x 10½ (37 x 26.7) Location unknown

CLXXII **Winter** Canvas, 29½ x 15½ (74.9 x 39.2) Location unknown

CLXXIII **Autumn—vintage festival** Canvas, 29½ x 15 (74.9 x 38) Birmingham City Art Gallery, Birmingham, England

CLXXIV **Summer** Canvas, 29½ x 15 (74.9 x 38) Rosenback Foundation Museum, Philadelphia, Pennsylvania

CLXXV **Spring in the gardens of the Villa Borghese (first version)** Canvas, 29½ x 15 (74.9 x 38), destroyed during World War II

CLXXVI **A Balneator** Watercolour, 14½ x 10 (36.9 x 25.5) Location unknown

CLXXVII **Painting in Ancient Rome** Panel, 11½ x 11⅔ (29.5 x 30) Location unknown

CLXXVIII **A Balneatrix** Panel, 17¾ x 6½ (44.9 x 16.5) Location unknown

CLXXIX **The sculptor's model (Venus Esquilina)** Canvas, 77 x 33 (195.6 x 84), lost during World War II

CLXXX **The sculptor's studio in ancient Rome** Panel, 12¼ x 12½ (31.1 x 31.7) Mr George Wildenstein, New York, USA

CLXXXI **Architecture in ancient Rome** Panel, 12¼ x 12½ (31.1 x 31.7) Mr George Wildenstein, New York, USA

CLXXXII **Cleopatra (second version)** Canvas, 7½ x 10½ (19 x 26.7) Auckland City Art Gallery, Auckland, New Zealand

CLXXXIII **Spring in the gardens of the Villa Borghese (second version)** Canvas on panel, 13½ x 8½ (34.2 x 21.4) The Madison Art Center, Madison, Wisconsin, USA

CLXXXIV **Panel for H. W. Mesdag's studio door: Spring in the gardens of the Villa Borghese (third version)** Canvas on panel, 8 x 21 (20.2 x 53.5) Rijksmuseum H. W. Mesdag, The Hague, The Netherlands

CLXXXV **A question (second version)** Panel, 6½ x 15 (16.5 x 38) Alain Lesieutre, France

CLXXXVI **A kitchen garden** Canvas, 14 x 8¼ (35.5 x 21) Location unknown

CLXXXVII **Flora: Spring in the gardens of the Villa Borghese (fourth version)** Watercolour, 11½ x 8 (29.2 x 20.4) Private collection, England

1878

CLXXXVIII **A silent counsellor** Watercolour, 5½ x 12 (14 x 30.5) Location unknown

CLXXXIX **A solicitation** Watercolour, 8½ x 17 (21.5 x 43.2) Location unknown

CXC **A hearty welcome** Canvas, 12 x 36½ (30.5 x 92.7) Ashmolean Museum, Oxford, England

CXCI **A landscape** Canvas, 8½ x 13½ (21.5 x 34.2) Location unknown

CXCII **In the time of Constantine** Panel, 12¾ x 6¼ (32.2 x 16) William Morris Gallery, Walthamstow, London, England

CXCIII **A love missile** Panel, 26½ x 17½ (67.3 x 44.5) Location unknown

CXCIV **Fredegonda and Galswintha, AD 594** Canvas, 55 x 50¾ (139.8 x 129) Kunsthistorisches Museum, Vienna, Austria

CXCV **A safe confidant** Canvas, 12½ x 8½ (31.7 x 21.5) Location unknown

1879

CXCVI **After the audience (second version)** Panel, 36 x 25½ (91.5 x 64.7) Location unknown

CXCVII **Strigils and sponges** Watercolour, 12½ x 5½ (31.7 x 14) The British Museum, London, England

CXCVIII **A Pomona festival** Panel, 12¼ x 20½ (31.2 x 52) Location unknown

CXCIX **Prose** Panel, 14 x 9¼ (35.5 x 24.2) National Museum of Wales, Cardiff, Wales

CC **Going down to the river** Canvas, 32½ x 68 (82.5 x 172.8) Location unknown

CCI **The Roman wine tasters** Watercolour, 16½ x 7½ (42 x 19) Location unknown

CCII **Portrait of the singer; George Henschel Esq. at the piano** Canvas, 19 x 13½ (48.3 x 34.2) Location unknown

CCIII **Poetry** Panel, 13¾ x 9½ (34.8 x 24.2) National Museum of Wales, Cardiff, Wales

CCIV **A well-protected slumber** Panel, 8¼ x 6¼ (21.1 x 16) Location unknown

CCV **A garden altar** Panel, 15 x 6¼ (38.1 x 16) Aberdeen Art Gallery and Museum, Aberdeen, Scotland

CCVI **Beauties** Panel, 19½ x 15¾ (49.5 x 40) Location unknown

CCVII **Portrait of Thekla Friedländer** Medium unknown, 4½ x 3¼ (11.5 x 8.2) Location unknown

CCVIII **On the road to the Temple of Ceres: A spring festival** Canvas, 35 x 20¾ (89 x 53.1) Forbes Magazine Collection, New York, USA

CCIX **Autumn (third version)** Pencil, 6¾ x 22½ (17 x 57.3) Location unknown

CCX **'Not at home'** Panel, 16 x 12⅜ (40.5 x 31.5) Walters Art Gallery, Baltimore, Maryland, USA

CCXI **An old bachelor after the bath** Watercolour, 11 x 6½ (28 x 16.5) Location unknown

1880

CCXII **The first course: The dinner (second version)** Panel, 17¼ x 7½ (44 x 18.4) Location unknown

CCXIII **Interrupted** Panel, 17 x 12 (43.2 x 30.5) Location unknown

CCXIV **Grapes** Watercolour and ink, 5½ x 7 (14 x 17.7) Location unknown

CCXV **A pastoral** Canvas on panel, 8½ x 13¾ (21.5 x 35.1) Andrew Christie-Miller Esq., Wiltshire, England

CCXVI **A portrait of Dr Felix and Mrs August Redeker Semon** Panel, 11¾ x 5½ (29.9 x 14) Location unknown

CCXVII **Ave Caesar! Io Saturnalia! (third version)** Panel, 8⅕ x 18 (20.5 x 45.5) Akron Art Institute, Akron, Ohio, USA

CCXVIII **A prize for the artists corps** Panel, 17½ x 8½ (44.5 x 21.5) Location unknown

CCXIX **The departure (first version)** Panel, 12 x 5½ (30.5 x 14) Location unknown

CCXX **A harvest festival** Panel, 12 x 9¼ (30.5 x 24) Forbes Magazine Collection, New York, New York, USA

CCXXI **'Your carriage stops the way'** Panel, 6¾ x 3½ (17 x 8.4) Private collection, England

1881

CCXXII **The torch dance** Canvas, 16 x 8½ (40.6 x 21.5) Location unknown

CCXXIII **Sappho and Alcaeus** Canvas, 26 x 48 (66 x 122) Walters Art Gallery, Baltimore, Maryland, USA

CCXXIV **A kiss** Watercolour, 4¼ x 3⅛ (10.8 x 7.7) Location unknown

CCXXV **A Bacchante dancing before the thymele** Watercolour, 18 x 12 (45.7 x 30.5) Location unknown

CCXXVI **An audience** Panel, 9½ x 5¾ (24.2 x 14.6) Walters Art Gallery, Baltimore, Maryland, USA

CCXXVII **Portrait of Dr Hans Richter** Canvas, 27 x 23 (68.5 x 58.5) Location unknown

CCXXVIII **Pandora** Watercolour, 9 x 7½ (22.9 x 19) Society of Painters in Water-Colours, London, England

CCXXIX **In the tepidarium** Panel, 9½ x 13 (24.2 x 33) Lady Lever Art Gallery, Port Sunlight, Cheshire, England

CCXXX **Quiet pets** Panel, 9½ x 6 (24 x 15.3) J. A. Volcker Van Soelen, Doue la Fontaine, France

CCXXXI **A priestess of Apollo** Watercolour, 12 x 5 (30.5 x 12.7) Location unknown

CCXXXII **A difficult line from Horace (first version)** Panel, 6 x 9½ (15.2 x 24) Corcoran Gallery of Art, Washington, D.C., USA

CCXXXIII **A stranger in my studio** Panel, (one of a pair, with Opus CCXLI), 20½ x 4¼ (52.2 x 10.7) Location unknown

CCXXXIV **Amo te ama me** Panel, 6⅞ x 15 (17.5 x 38) Private collection, England

1882
CCXXXV **Young affections** Panel, 15 x 9¼ (38 x 23.3) Location unknown

CCXXXVI **A difficult line from Horace (second version)** Drawing, 6 x 9½ (15.3 x 24.1) Location unknown

CCXXXVII **Portrait of John F. Whichcord Esq., PRIBA, FSA** Canvas, 36 x 30 (91.5 x 76.2) Royal Institute of British Architects, London, England

CCXXXVIII **Portrait of Ludwig Barnay as Mark Antony** Canvas, 26⅔ x 25½ (67.8 x 64.7) Location unknown

CCXXXIX **The way to the temple** Canvas, 40 x 21 (101.5 x 53.5) Royal Academy, London, England

CCXL **The parting kiss** Panel, 44½ x 29 (112.5 x 73.5) Private collection, Japan

CCXLI **Reflections** Panel (one of a pair, with Opus CCXXXIII), 20½ x 4¼ (52.2 x 10.7) Location unknown

CCXLII **Between Venus and Bacchus** Watercolour, 22¾ x11½ (58 x 29.3) Walters Art Gallery, Baltimore, Maryland, USA

CCXLIII **Dolce far niente (first version)** Watercolour, 9½ x 6½ (23.8 x 16.5) Location unknown

CCXLIV **Dolce far niente (second version)** Panel, 9¼ x 6¼ (23.5 x 16) Private collection, USA

CCXLV **An oleander** Panel, 36½ x 25½ (92.8 x 64.7) Dr James Jackson, Oregon, USA

1883
CCXLVI **The meeting of Antony and Cleopatra** Panel, 25¾ x 36¼ (65.5 x 92.2) Galerne Royale, British Columbia, Canada

CCXLVII **Portrait of Catherine, Duchess of Cleveland** Canvas, 25½ x 20½ (64.7 x 52.1) The Bowes Museum, Barnard Castle, County Durham, England

CCXLVIII **Portrait of my daughter, Anna Alma-Tadema** Canvas, 44 x 30 (112 x 76.2) Royal Academy, London, England

CCXLIX **Shy** Panel, 18⅛ x 11½ (46 x 29.2) Mr and Mrs Harold H. Stream, Louisiana, USA

CCL **Portrait of His Excellency Count Van Bylandt** Canvas, size unknown. Location unknown

CCLI **Una Carita: The three graces: Laura, Laurence, and Anna** Canvas on panel (diamond-shaped, with circular predella), 25 x 25 (63.5 x 63.5) Location unknown

CCLII **Portrait of Leopold Lowenstam, the etcher** Canvas, 20½ x 25½ (52.1 x 64.7) Private collection, England

CCLIII **Portrait of Lady Thompson** Canvas, 25½ x 20½ (64.7 x 52.1) Location unknown

CCLIV **Portrait of Professor Giovanni Battista Amendola** Canvas, 28½ x 20½ (72.3 x 52.1) Location unknown

CCLV **'Der alte menander ist doch nicht gestorben!': Paulus and Hermas** Drawing, 13 x 20½ (33 x 52.1) Location unknown

CCLVI **A street altar** Watercolour, 13¾ x 6¾ (34.6 x 17.1) Cecil Higgins Art Gallery, Bedford, Bedfordshire, England

CCLVII **Welcome footsteps: Well-known footsteps** Canvas, 16½ x 21½ (41.9 x 54.7) Location unknown

CCLVIII **A declaration: an old, old story** Watercolour, 8½ x 18¼ (21.5 x 46.1) British Museum, London, England

CCLIX **Xanthe and Phaon** Watercolour, 17¾ x 12¾ (45.1 x 32.5) Walters Art Gallery, Baltimore, Maryland, USA

CCLX **Self-portrait** Canvas, 12 x 10 (30.5 x 25.5) Aberdeen Art Gallery and Museum, Aberdeen, Scotland

1884
CCLXI **Hadrian in England: visiting a Roman-British pottery** Canvas, 86½ x 66½ (219.8 x 169) Cut into three pieces in 1886-87

CCLXI (A) **A Roman-British pottery** Canvas, 30 x 47 (76.2 x 119.4) Koninklijk Huisarchief Museum (Soestdijk Palace), Soestdijk, The Netherlands

CCLXI (B) **Emperor Hadrian's visit to a British pottery** Canvas, 62 x 67¼ (159 x 171) Amsterdams Historisch Museum, Stedelijk Museum, Amsterdam, The Netherlands

CCLXI (C) **A Roman-British potter** Canvas, 60 x 31½ (152.5 x 80) Centre Georges Pompidou, Paris, France

CCLXII **Portrait of Miss Alice Lewis** Canvas, 33 x 21½ (84 x 54.6) The Zanesville Art Center, Zanesville, Ohio, USA

CCLXIII **Who is it?** Panel, 10¼ x 8½ (26.1 x 21.4) Victor Hammer Galleries, New York, New York, USA

CCLXIV **Portrait of Moses Ezekiel** Canvas, size unknown. Location unknown

CCLXV **Portrait of Sir Francis Powell,** Canvas, size unknown. Location unknown

1885
CCLXVI **Expectations** Panel, 8¾ x 17¾ (22.5 x 45.1) Private collection, Japan

CCLXVII **A reading from Homer** Canvas, 36 x 72⅜ (91.4 x 183.8) Philadelphia Museum of Art, Philadelphia, Pennsylvania, USA

CCLXVIII **Portrait of Dr Washington Napoleon Epps: My doctor** Panel, 12 x 11 (30.5 x 28) Location unknown

CCLXIX **The triumph of Titus: The Flavians** Panel, 17½ x 11½ (44.4 x 29.2) Walters Art Gallery, Baltimore, Maryland, USA

CCLXX **Ariadne** Oil, size unknown. Location unknown

CCLXXI **Portrait of Mrs W. M. Baker** Canvas, lifesize. Location unknown

CCLXXII **Rose of all roses** Panel, 14¾ x 9 (37.5 x 23) M. Newman Ltd., London, England

CCLXXIII **A foregone conclusion** Panel, 12¼ x 9 (31.1 x 23) Tate Gallery, London, England

1886
CCLXXIV **An apodyterium** Panel, 17½ x 23½ (44.5 x 59.5) Mr and Mrs Joseph M. Tanenbaum, Toronto, Canada

CCLXXV **Portrait of James Reid Esq.** Canvas, size unknown. Location unknown

CCLXXVI **Portrait of Mrs Frank D. Millet** Canvas, 25½ x 20 (64.7 x 50.8) John Bradford Millet MD, New Hartford, New York, USA

1887
CCLXXVII **A secret** Panel, 16 x 21½ (40.5 x 54.7) Brighton Art Gallery, Brighton, Sussex, England

CCLXXVIII **The women of Amphissa** Canvas, 48 x 72 (121.8 x 182.8) Private collection, England

CCLXXIX **A new dress** Watercolour, 7½ x 9⅜ (19 x 23.8) Royal collection, Windsor Castle, England

CCLXXX **'He loves me, he loves me not'** Canvas, 25 x 18 (63.4 x 45.7) Destroyed by fire in 1910

CCLXXXI **Illuminated letter 'W' for the Royal Academy address to Queen Victoria** Watercolour, size unknown. Location unknown

CCLXXXII **Portia** Canvas, 23 x 18½ (58.5 x 47) Location unknown

1888
CCLXXXIII **The roses of Heliogabalus** Canvas, 52 x 84⅛ (132.1 x 213.9) Private collection, France

CCLXXXIV **Fair tresses; a sketch** Panel, 8¾ x 14½ (22.2 x 37) Repainted in 1901 as Opus CCCLXVI

CCLXXXV **Midday slumbers** Watercolour, 25¾ x 9¾ (65.5 x 24.8) Minneapolis Institute of Art, Minneapolis, Minnesota, USA

CCLXXXVI **Portrait of the Rev. Adama Van Scheltema** Canvas, 25 x 20 (63.5 x 51), destroyed during World War II

CCLXXXVII **Venus and Mars** Panel, 23 x 11½ (58.5 x 29.2) Location unknown

CCLXXXVIII **Portrait of Jules de Soria** Canvas, size unknown. Location unknown

CCLXXXIX **At the shrine of Venus** Panel, 21½ x 27¼ (54.6 x 69.3) New Orleans Museum of Art, New Orleans, Louisiana, USA

CCXC **The favourite poet** Panel, 14½ x 19½ (36.9 x 49.6) Lady Lever Art Gallery, Port Sunlight, Cheshire, England

1889
CCXCI **Sisters** Canvas, 20½ x 25½ (52.2 x 64.7) Location unknown

CCXCII **Cloaked in yellow** Panel, 15½ x 8½ (39.2 x 21.5) Location unknown

CCXCIII **A dedication to Bacchus (first version)** Canvas, 30½ x 69¾ (77.5 x 177.5) Hamburger Kunsthalle, Hamburg, West Germany

CCXCIV **A dedication to Bacchus (second version)** Panel, 21 x 49½ (53.5 x 125.7) Sir Richard Proby, Bart., MC, Elton Hall, Northamptonshire, England

CCXCV **Portrait of Mrs Ralph Sneyd** Canvas, 12 x 9⅜ (30.5 x 24) Michael D. Coe, New Haven, Connecticut, USA

CCXCVI **Portrait of Miss MacWhirter (Mrs Charles Sims)** Panel, 12½ x 4 (31.7 x 10.2) Location unknown

CCXCVII **Portrait of Master John Parsons Millet** Canvas, 9½ x 7½ (24.1 x 19) John Bradford Millet, MD, New Hartford, New York, USA

CCXCVIII **In a rose garden** Canvas, 14¾ x 19½ (37.5 x 49.5) Private collection, England

CCXCIX **A silent greeting** Panel, 12 x 9 (30.5 x 23) Tate Gallery, London, England

CCC **Portrait of Sir Ernest A. Waterlow Esq., RA** Canvas, 24 x 18 (61 x 45.7) Royal Academy, London, England

1890
CCCI **Eloquent silence** Size unknown. Location unknown

CCCII **The frigidarium** Panel, 17¾ x 23½ (45 x 59.7) J. B. Panchard, Switzerland

CCCIII **Promise of Spring** Panel, 14¾ x 8¾ (37.4 x 22.2) Museum of Fine Arts, Boston, Massachusetts, USA

CCCIV **Portrait of Miss Agnes Marks** Panel, 9½ x 5 (22.9 x 12.8) Location unknown

CCCV **Reverie: a sketch** Panel (a sketch in oil), 9¾ x 5¼ (25 x 13.2) Mr Frank Phillips, England

1891
CCCVI **Portrait of the Right Hon. Arthur James Balfour** Canvas, 50 x 36¼ (127 x 92.2) National Portrait Gallery, London, England

CCCVII **An earthly paradise** Canvas, 34 x 65 (86.5 x 165.1) Private collection, Japan

CCCVIII **Love's votaries: Love in idleness** Canvas, 34½ x 65¼ (87.6 x 165.7) Laing Art Gallery, Newcastle-upon-Tyne, Northumberland, England.

CCCIX **Portrait of the Venerable Archdeacon Watkins of Durham, DD** Canvas, 25½ x 20½ (65 x 52.1) Location unknown

CCCX **Portrait of Alfred Waterhouse Esq., RA** Canvas, 25½ x 20½ (64.7 x 52.1) Location unknown

CCCXI **Portrait of Ignacy Jan Paderewski** Canvas, 18 x 23 (45.7 x 58.4) National Museum, Warsaw, Poland

CCCXII **The kiss** Panel, 18 x 24¾ (45.7 x 62.9) Location unknown

1892
CCCXIII **Calling the worshippers** Watercolour, 11½ x 11½ (29.2 x 29.2) Location unknown

CCCXIV **The poet Gallus dreaming** Panel, 9¼ x 6½ (23.5 x 16.3) Location unknown

CCCXV **The proposal: Courtship** Canvas, 15½ x 14 (39.3 x 35.6) Brighton Art Gallery, Brighton, Sussex, England

CCCXVI **Comparisons** Canvas, 18 x 24 (45.7 x 61) Cincinnati Art Museum, Cincinnati, Ohio, USA

CCCXVII **The inner sanctuary** Size unknown. Location unknown

1893
CCCXVIII **Portrait of Dr Joseph Joachim** Canvas, size unknown, Private collection, West Germany

CCCXIX **In the corner of my studio** Canvas, 23½ x 17½ (59.8 x 44.5) Location unknown

CCCXX **Portrait of Mrs Charles Wyllie** Canvas, size unknown. Location unknown

CCCXXI **Unconscious rivals** Canvas, 18 x 25 (45.7 x 63.6) City Art Gallery, Bristol, Avon, England

CCCXXII **God speed** Panel, 10 x 5 (25.5 x 12.7) Royal collection, Sandringham, England

CCCXXIII **Portrait of Mrs Theyre Smith** Canvas, size unknown. Location unknown

1894
CCCXXIV **At the close of a joyful day** Canvas, 32½ x 13½ (82.7 x 34.2) Location unknown

CCCXXV **The benediction** Panel, 20¾ x 4¾ (53 x 12.2) Location unknown

CCCXXVI **Spring** Canvas, 70½ x 31½ (179.2 x 80.3) J. Paul Getty Museum, Malibu, California, USA

CCCXXVII **Past and present generations** Size unknown Location unknown

1895
CCCXXVIII **Love's jewelled fetter** Canvas, 25 x 18 (63.5 x 45.7) Location unknown

CCCXXIX **Fortune's favourite** Panel, 21 x 14½ (53.5 x 37) Location unknown

CCCXXX **Portrait of Mrs Roland Hill and her children** Canvas, 18 x 24 (45.8 x 61) Location unknown

CCCXXXI **Portrait of George Simmonds and family** Canvas, size unknown. Location unknown

CCCXXXII **Unwelcome confidence** Panel, 18 x 11½ (45.7 x 29.4) Location unknown

CCCXXXIII **A coign of vantage** Panel, 25 3/16 x 17½ (64 x 44.5) J. M. S. Scott Esq., England

CCCXXXIV **Portrait of Mrs Marcus Stone** Panel, 12 x 9 (30.5 x 23.3) Location unknown

1896
CCCXXXV **Whispering noon** Canvas, 22 x 15½ (56 x 39.3) Mr and Mrs Harold H. Stream, Louisiana, USA

CCCXXXVI **The Coliseum** Panel, 44 x 29 (112 x 73.6) Private collection, USA

CCCXXXVII **Family group** Panel, 12 x 11 (30.5 x 28) Royal Academy, London, England

CCCXXXVIII **Portrait of Miss Onslow Ford** Panel, 15 x 11 (38.1 x 27.9) Private collection, England

CCCXXXIX **A difference of opinion** Panel, 15 x 9 (38 x 22.9) Private collection, England

CCCXL **Portrait of Maurice Sons Esq. playing the violin in Alma-Tadema's studio** Panel, 20 x 5 (50.8 x 12.7) Location unknown

CCCXLI **Self-portrait** Canvas, 25½ x 21 (65.7 x 53.5) Uffizi Gallery, Florence, Italy

CCCXLII **'Nobody asked you sir!' she said** Watercolour, 14 x 10½ (35.5 x 26.7) The Art Gallery of South Australia, Adelaide, South Australia

1897
CCCXLIII **Portrait of J. M. Zarifi Esq.** Canvas, size unknown. Location unknown

CCCXLIV **Watching and waiting** Panel, 26 x 17¾ (66.3 x 45) Location unknown

CCCXLV **'Her eyes are with her thoughts, and they are far away'** Panel, 9 x 15 (22.9 x 38) Location unknown

CCCXLVI **Wandering thoughts** Size unknown. Location unknown

CCCXLVII **Melody on a Mediterranean terrace** Panel, 18 x 26 (45.8 x 66.1) Location unknown

CCCXLVIII **Roses, love's delight** Canvas, size unknown, Museum of Pavlovsk Palace, Leningrad, USSR

1898

CCCXLIX **Portrait of Lady Sydney (Margaret) Waterlow** Canvas, 8½ x 6 (21.5 x 15.2) Location unknown

CCCL **The conversion of Paula by St. Jerome** Panel, 21 x 44 (53.5 x 111.8) Location unknown

CCCLI **Portrait of Tine Son-Maris** Panel, 9 x 4¾ (23 x 12) Haags Gemeentemuseum, The Hague, The Netherlands

CCCLII **Hero** Panel, 15¼ x 9¾ (39.3 x 24.7) Location unknown

1899

CCCLIII **Portrait of Mrs George Lewis and her daughter Elizabeth** Panel, 9¾ x 8¾ (24.8 x 22.2) Mrs Elizabeth Wansbrough, England

CCCLIV **The listeners** Panel, 13¾ x 10¾ (34.8 x 27.2) Dr R. H. Mandelbaum, New York, USA

CCCLV **Attracted: watchers** Watercolour (circular), diameter 8⅝ (21.9) Royal collection, Windsor Castle, England

CCCLVI **The Baths of Caracalla (Thermae Antoninianae)** Canvas, 60 x 37½ (152.5 x 95) Private collection, England

CCCLVII **Bluebells** Size unknown. Location unknown

1900

CCCLVIII **A flag of truce** Panel, 17½ x 8¾ (44.5 x 22.2) Mr and Mrs Harold H. Stream, Louisiana, USA

CCCLIX **Goldfish (fourth version)** Panel, 7¼ x 15½ (18.4 x 39.5) (repainted from Opus CVII, 1872) Location unknown

CCCLX **Portrait of Mrs Armour of Princeton** Canvas, size unknown. Location unknown

CCCLXI **Portrait of George Aitchison, PRIBA, RA** Canvas, 46 x 36 (116.8 x 91.5) Royal Institute of British Architects, London, England

CCCLXII **Vain courtship** Canvas, 30½ x 16¼ (77.5 x 41.1) Private collection, England

1901

CCCLXIII **Under the roof of blue Ionian weather** Panel, 19 x 46 (48.3 x 116.8) Location unknown

CCCLXIV **Death of the first born (third version)** Drawing, 14⅛ x 21 (36 x 53.4) Location unknown

CCCLXV **A priestess of Hymen** Watercolour, size unknown. Location unknown

CCCLXVI **Fair tresses** Panel, 8¾ x 14½ (22.2 x 37) (repainted from Opus CCLXXXIV, 1888) Location unknown

CCCLXVII **Impatient** Watercolour, size unknown. Location unknown

CCCLXVIII **Portrait of Sir Max Waechter, High Sheriff of Surrey** Canvas, 36 x 46 (91.5 x 116.8) Location unknown

1902

CCCLXIX **The year's at the spring, all's right with the world** Panel, 13½ x 9½ (34.2 x 24.1) Private collection, England

CCCLXX **Caracalla, AD 217** Panel, 9¼ x 15½ (23.5 x 39.5) Private collection, England

CCCLXXI **A crown** Watercolour, size unknown. Location unknown

CCCLXXII **Among the ruins** Panel, 9½ x 15⅜ (24.1 x 39.1) Location unknown

1903

CCCLXXIII **Silver favourites** Panel, 27¼ x 16⅝ (69.1 x 42.2) Manchester City Art Gallery, Manchester, England

CCCLXXIV **A peaceful wooing** Panel, 22 x 10 (56 x 25.5) Location unknown

CCCLXXV **The ever-new horizon** Canvas, 19¼ x 18 (49 x 45.7) (repainted as Opus CCCLXXXIX, 1907)

1904

CCCLXXVI **Thalia's homage to Aesculapius** Drawing, 9½ x 13⅛ 24.1 x 33.3) Centre Georges Pompidou, Paris, France

CCCLXXVII **The finding of Moses** Canvas, 54⅛ x 84 (137.7 x 213.4) Private collection, England

1905

CCCLXXVIII **A world of their own** Panel, 5⅛ x 19¾ (13.1 x 50.2) Taft Museum, Cincinnati, Ohio, USA

1906

CCCLXXIX **Ask me no more** Canvas, 31½ x 45½ (80.1 x 115.7) Location unknown

1907

CCCLXXX **Entering the Coliseum (first version)** Watercolour, size unknown. Location unknown

CCCLXXXI **Geta and his sister** Drawing, size unknown. Location unknown

CCCLXXXII **Caracalla and Geta** Panel, 48½ x 60½ (123.2 x 153.7) Location unknown

CCCLXXXIII **Orante** Panel (oval, one of a pair), 16⅜ x 13 (41.5 x 33.5) Private collection, Japan

CCCLXXXIV **Bacchante** Panel (oval, one of a pair), 16⅜ x 13¼ (41.5 x 33.5) Private collection, England

CCCLXXXV **Melodie del mare e dell'amore** Watercolour, 18½ x 11½ (47 x 29.2) Location unknown

CCCLXXXVI **Youth** Watercolour, 7¼ x 12¼ (18.2 x 30.9) Location unknown

CCCLXXXVII **Portrait of myself for the R. Accademia Romana di San Luca** Canvas, 24 x 18 (61 x 46) (repainted as Opus CCCCVII, 1912)

CCCLXXXVIII **The golden hour** Canvas, 14 x14 (35.5 x 35.5) Private collection, Japan

1908

CCCLXXXIX **At Aphrodite's cradle** Canvas on panel, 19½ x 15 (49.6 x 38) Dr and Mrs Irving Warner, California, USA

1909

CCCXC **A message of love** Panel, 19½ x 15 (49.6 x 38) Location unknown

CCCXCI **A favourite custom** Panel, 26 x 17¾ (66 x 45) Tate Gallery, London, England

CCCXCII **Splashing** Drawing, 12½ x 20½ (31.7 x 52.1) Location unknown

CCCXCIII **Portrait of Mrs Washington Epps** Drawing, 9½ x 7½ (24.1 x 19.1) Mrs Denis M. Smart, Sussex, England

CCCXCIV **Hopeful** Panel, 13⅜ x 5½ (34 x 14) Sterling & Francine Clark Art Institute, Williamstown, Virginia, USA

CCCXCV **Portrait of Dr J. M. W. Van der Poorten-Schwartz (Maarten Maartens)** Pencil, 12½ x 8½ (13.7 x 21.5) Maarten Martenshuis, Doorn, Utrecht, The Netherlands

CCCXCVI **Portrait of Ilona Eibenschutz** Canvas, 20 x 25½ (50.8 x 64.7) Private collection, England

1910

CCCXCVII **The voice of spring** Panel, 19⅛ x 45¼ (48.8 x 115) Mr and Mrs Joseph Tanenbaum, Toronto, Canada

CCCXCVIII **Principal figure of 'The voice of spring'** Pencil, size unknown. Location unknown

CCCXCIX **A border for the King's letter to the nation** Pencil, 18 x 23 (45.7 x 58.5) Location unknown

CCCC **Heading: the Royal Academy address to HM King George V on his accession to the throne** Watercolour, 8½ x 14 (21.5 x 35.5) Location unknown

1910 or 1911

CCCCI **Title unknown** Medium and size unknown. Location unknown

1911

CCCCII **When flowers return** Panel (one of a pair), 14 x 20 (35.5 x 50.8) Location unknown

CCCCIII **Summer offering** Panel (one of a pair), 14 x 20½ (35,5 x 52.1) Dr George Nicholson, Oregon, USA

CCCCIV **Title unknown** Medium unknown, size unknown. Location unknown

CCCCV **Entering the Coliseum (second version)** Panel, 9½ x 15½ (24.1 x 39.3) Location unknown

CCCCVI **Portrait of William Whitaker Thompson Esq.** Canvas, 29¼ x 24 (74.2 x 61) Greater London Council, London, England

1912

CCCCVII **Portrait of myself for the R. Academia Romana di San Luca** Canvas, 24 x 18 (61 x 46) (repainted from Opus CCCLXXXVII) R. Academia Romana di San Luca, Rome, Italy

CCCCVIII **Preparations in the Coliseum** Canvas, 60½ x 31½ (154 x 80) Private collection, USA

INDEX